DEGAS
IMPRESSIONS OF A GREAT MASTER

GERHARD GRUITROOY

NEW LINE BOOKS

DEDICATION
THIS BOOK IS DEDICATED TO NETHANEL AND DINA KALUJNY.

Fax: (888) 719-7723
e-mail: info@newlinebooks.com

Printed and bound in Singapore

ISBN 1-59764-080-8

Visit us on the web!
www.newlinebooks.com

Author: Gerhard Gruitrooy

Publisher: Robert M. Tod
Book Designer: Mark Weinberg
Production Coordinator: Heather Weigel
Photo Editor: Ede Rothaus
Editors: Mary Forsell, Joanna Wissinger, & Don Kennison
DTP Associates: Jackie Skroczky, Adam Yellin
Typesetting: Mark Weinberg Design, NYC

CONTENTS

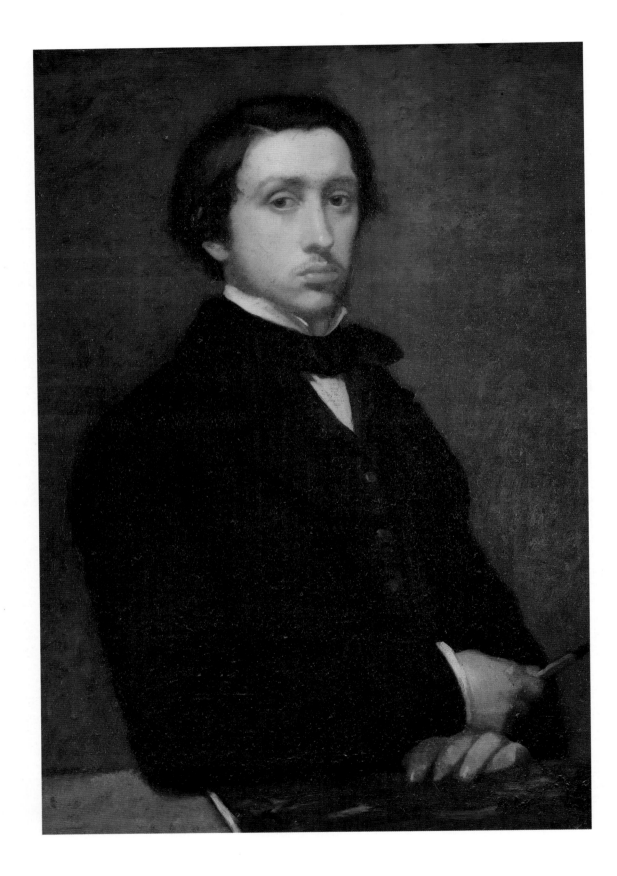

Self-portrait
1854-1855; *Oil on canvas*; 31 7/8 x 25 1/4 in. (81 x 64 cm.). Paris, Musée d'Orsay.
*This is the largest and most ambitious of all self-portraits by Degas, who painted his own likeness
at least eighteen times in the 1850s. Here, at the age of twenty, he showed himself as a
bourgeois gentleman rather than as an artist—except for the charcoal holder in his right hand. The
motif of this half-length portrait with the slightly twisted body is based on a self-portrait by Ingres.*

INTRODUCTION

PARIS, 1834 TO 1917

Reflecting on the work of Edgar Degas, one soon comes to the realization that his entire oeuvre has an elusive quality. Yet there are features that can be found consistently in almost all his paintings and drawings, the most important being his fascination with equilibrium. Be it a dancer or a circus artist, a jockey on his horse or a portrait, Degas always attempted to achieve a balance that binds the figures into their surrounding space. Gravity and the relationship of man to the earth are essential characteristics of the artist's works.

Degas's personality has been described by friends and members of his own family as that of a heavy-handed, down-to-earth person. Indeed, he was once affectionately called "the little bear" because of his frequent grumbling and growling. His relationship to his own body was free of embarrassment. In fact, his bathtub, which one finds in so many of his later paintings of women bathing, was boldly placed at the center of his studio. He was also known as a gifted mimic or clown, which the poet Paul Valéry attributed to the artist's Italian ancestry.

Edgar Degas (originally De Gas) was born on July 19, 1834 in Paris. His family had recently moved there from Naples. His father, Auguste De Gas, was a banker, like his own father before him. These family ties proved to be influential, in particular during Edgar's formative years, beginning at his Parisian lycée, Louis-le-Grand. There he studied drawing with three professors. After leaving the lycée in 1853, he registered immediately as copyist at the Louvre, but he also enrolled at the faculty of law later the same year to appease his father. Eventually, the young Degas informed his father that he could not go on with law and was allowed to continue his vocation as an artist.

Early Influences

Degas entered the École des Beaux-Arts in April of 1855, ranking thirty-third in the entrance competition. He chose Louis Lamothe (1822-1869), a follower of Jean-Auguste-Dominique Ingres, as his teacher. Lamothe had a passion for drawing and admired Italian masters of the fifteenth and sixteenth centuries, whom Degas had already been copying in the Louvre. During Degas's brief encounter with Ingres, the old master reportedly told him to "draw lines, lots of

The Absinthe Drinker
detail; 1875-1876;
Paris, Musée d'Orsay.
Although Degas has asked one of his models, Hélène Andrée, to pose for this figure, he achieved a degree of 'realism' which makes this image of human misery strikingly expressive.

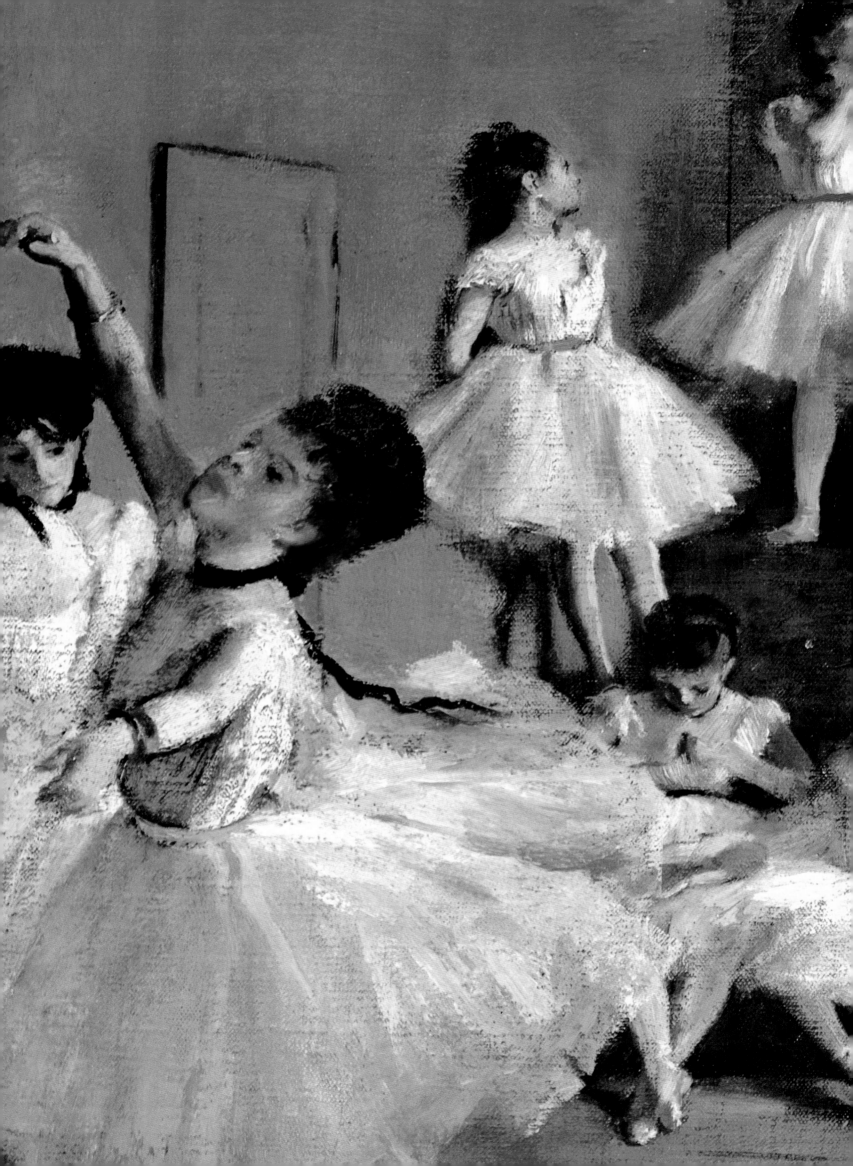

lines, and you will become a good artist." The potentially desiccative effects of the strict academic principles of Lamothe—and also of Hippolyte Flandrin, Ingres's favorite disciple—were tempered, however, by Auguste De Gas's connections to collector friends, to whose homes he sometimes took his son after school. There he saw also the works of Jean-Baptiste-Camille Corot and engravings of Flemish and Dutch engravers of the seventeenth century.

When Degas left for Naples in July of 1856, he already enjoyed a solid training, despite his young age of twenty-two. The purpose of his visit was to see his Italian relatives, but mostly to undertake the traditional tour like almost all French artists. Although his interests were still clearly influenced by Ingres, his early works, such as his self-portrait, are already notably different from that tradition and demonstrate his independent mind.

Curiously, Italy and its artistic heritage turned out to be less influential than Degas himself had expected. What affected his development most decisively instead was the encounter with the French painter Gustave Moreau in early 1858 in Rome, probably at the French Academy. The Villa Medici, as the institution is also known, welcomed all French artists, including those who were not pensioners, and admitted them to the evening life drawing classes. The tightly knit community of French artists had almost no contact with the Italian society or Italian artists. Degas did not show any particular readiness to participate in Italian life either, despite his family connections.

Moreau, eight years older than Degas, was undoubtedly a gifted teacher and responded very

Dance Class
detail; 1874;
New York, Metropolitan Museum of Art
(Harry Payne Bingham Bequest, 1986).
At the center of a dance classroom, this young girl is momentarily rehearsing alone in front of the ballet master, who is watching over her. Her self-assured, elegant pose makes her the star of the painting.

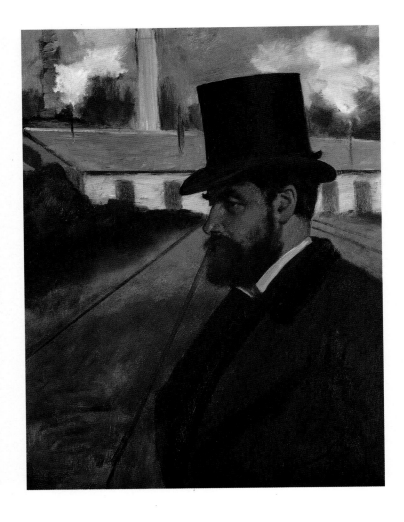

Henri Rouart in Front of His Factory

1875, c.; *Oil on canvas; 25 5/8 x 19 3/4 in. (65.1 x 50.2 cm.).* Pittsburgh, Pennsylvania, The Carnegie Museum of Art. *The format of this portrait, with the sitter shown bust-length and in profile, is based on an Italian fifteenth-century formula well known to the artist. The strong and expressive face of Rouart, who was a friend of Degas's, is placed off center, while railway tracks converge dizzily, in perspective, behind his back.*

receptively to Italy. Interested in artists as diverse as Raphael, Michelangelo, Correggio, and the Venetians—in particular Titian and Paolo Veronese—Moreau attempted to reproduce their colors as faithfully as possible, rather than the "details" (drawing and composition) of their works. To that end he experimented with various painting techniques, including watercolor and pastel. Degas owed a good part of his curiosity about such things to Moreau and possibly also his introduction to pastels, which he used predominantly in his later years. Eventually, he also developed his own paint medium, which he called "essence," using turpentine as a thinner. Using this medium, he achieved a surface with the dryness and delicacy of an eggshell.

Return To Paris

After a three-year stay in Italy, Degas returned to Paris in 1859. At that point, Moreau's influence upon him became obvious. Dismissing Lamothe and largely ignoring the Ingres tradition, Degas focused his attention on works by Eugène Delacroix, which are composed on the basis of coloristic values. While still maintaining close ties with Moreau into the early 1860s, Degas gradually distanced himself from his mentor in later years, minimizing the critical role Moreau had played in his own education. Critics have frequently considered Degas's early works as having been created by a "Degas before Degas," not recognizing that his years of training and experimentation are crucial to the understanding of his later artistic production.

After his return Degas set out to become a quintessential Parisian painter. He left his father's apartment, taking a new, large studio on Rue de Laval in the 9th Arondissement, a neighborhood in which he remained for his entire life. Becoming somewhat sedentary, he undertook only few and infrequent travels. He worked very hard on these paintings, "slaving away," as his brother René remarked in a letter of April 22, 1864. "What is fermenting in that head is frightening," René continued, alluding to Degas's continuous search for improvement. Frequently he would work on canvases for years without really finishing them, while on other occasions he managed to execute elaborate studies amid a bustling, noisy household. This gave rise to some uncertainties among his relatives as to the young artist's gifts. His father, in particular, observed ironically that "our Raphael is still working, but has not produced anything that is really finished," while René was convinced that he had "not only talent, but genius." It was not until Degas painted *The Orchestra of the Opéra* for Désiré Dihau, the bassoonist and model of the central figure, that the Degas family was finally satisfied. Dihau had taken the painting off to Lille, thus making any further retouching impossible. "It's thanks to you that he has finally produced a finished work, a real painting," the family told the musician.

First Successes

During the 1860s Degas remained still largely unknown to the public, unlike his friends Moreau and Édouard Manet. Some of his works were exhibited at the annual exhibitions of the Salons between 1865 and 1870, but they were often unmentioned by the critics or received at best mixed reviews. What is more, Degas sold almost nothing, although he was in the privileged position to live off the fortune of his family. Among a limited number of artist's circles, however, he enjoyed an undeniable reputation for his manners, cultivation, the urbanity of his conversation, and a peculiar charm mixed with brusqueness—which earned him a certain respect. He changed his alliances, replacing Moreau with James Tissot. Along with Manet, he became a leading figure of a group of mostly Impressionist artists that convened at the Café Guerbois, among them Auguste Renoir, Alfred Sisley, Claude Monet, and Paul Cézanne.

It was only in 1872, when the established art dealer Paul Durand-Ruel sold three of his works, that Degas began to feel more confident about his own talents. Once again, he embraced Ingres's influence on his drawing, while at the same time retaining his fondness for Delacroix's colors. An insatiable curiosity broadened the artist's interests, and he inspected the works of Gustave Courbet, Ernest Meissonier, and James Abbott McNeill Whistler, among others. During the first twenty years of his career, Degas produced an uninterrupted flow of masterpieces and tackled so many different subjects, styles, and techniques that, without prior knowledge of their provenance, the viewer would hesitate to attribute all of these works to the same artist.

Preferred Genres

In Degas's body of work, portraits outnumber by far all other genres. Other favorite subjects were contemporary life, landscapes, and various other groups. The preponderance of portraits might in part have been nurtured by his father, who cautioned his son that this genre would enable him to earn an adequate living. Although Degas expressed occasional boredom with painting portraits, he actually demonstrated unflagging interest in this genre from the very outset in Lamothe's studio. Until his return from Italy, most portraits are of members of his family, besides several self-portraits. Certain reservations notwithstanding, he eventually completed large, ambitious group portraits.

Degas's chief concern in this genre for the first twenty years remained the treatment of the background and the relationship of the figures to their surrounding space. A plain, dark background, such as that in the early *Self-portrait* of 1855, was followed by more complex solutions. In some cases Degas added attributes of the sitter's social status (*Henri Rouart in Front of His Factory*) or included elaborate interior settings, as in *The Collector of Prints*.

The genre of history paintings occupied the artist for some

Henri Leri in His Studio
1873, c.; *Oil on canvas; 16 1/4 x 10 5/8 in. (41 x 27 cm.).* Lisbon, Calouste Gulbenkian Museum. *This somewhat mysterious portrait of the painter Leri in his studio has long been thought to be a self-portrait of Degas. The sitter is standing almost in the corner of the room, looking out at the viewer. Below him is an almost lifelike mannequin, but with disjointed limbs. The painting conveys an atmosphere of unresolved tension.*

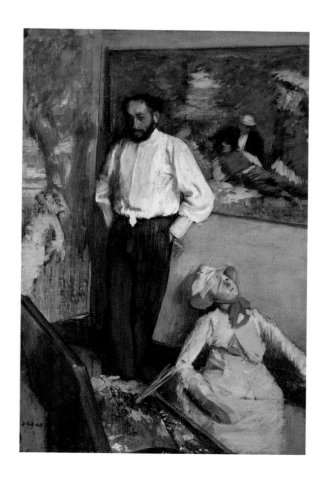

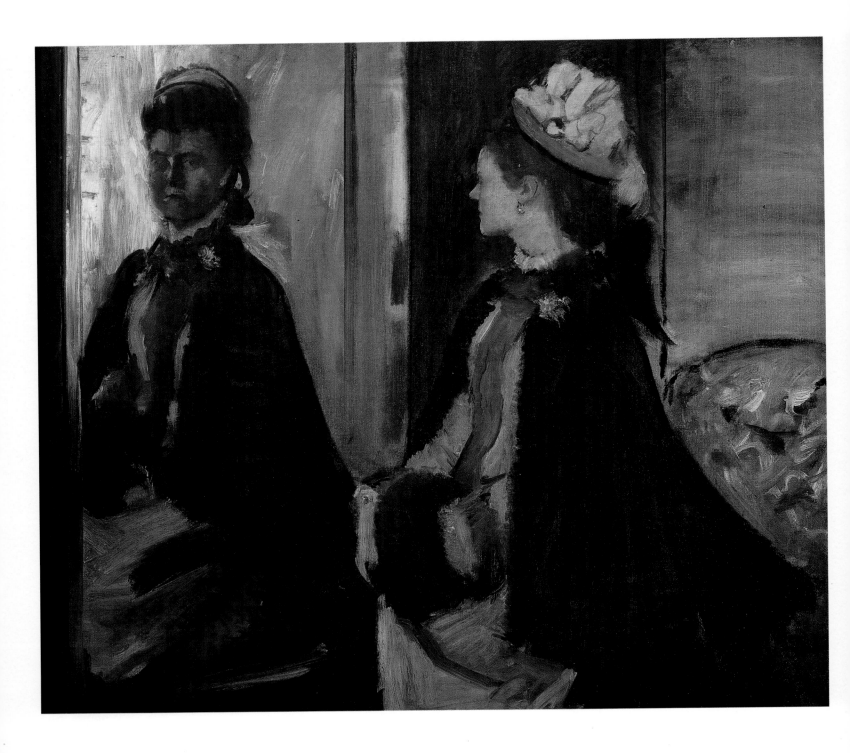

Portrait of Mme. Jeantaud at the Mirror

1875; *Oil on canvas; 27 1/2 x 33 in. (70 x 84 cm.).* Paris, Musée d'Orsay.

The wife of one of Degas's friends, Madame Jeantaud is seen here both in profile and from the front through the device of a mirror—used by artists since the Renaissance to allow for a complex spatial rendering. The model's decorative hat and her elegant pose seem to foreshadow The Millinery Shop, *painted a couple of years later.*

time, but he actually never finished any of these works, although he had made many preparatory drawings and oil sketches for them. For example, in *Young Spartans Exercising*, he disregarded archaeological correctness in favor of a different and decisively contemporary presentation of a subject from ancient history. In *Semiramis Building Babylon*, Degas created a disturbingly original work, but seemed unsure of his direction. Such works have prompted talk of Degas's failure or inadequacy in this genre. Yet it should not be overlooked that in just a few canvases he proposed independent solutions to a problem that other artists had failed to imbue with their own visions.

Realism

Degas wanted his works to be as "realistic" or "naturalistic" as possible. Although these two terms were often interchangeable in those days, Naturalism was in fact a more progressive form of Realism, as it was updated with the most recent discoveries in science. The writer and journalist Edmond Duranty, a close friend, kept urging artists to follow the discoveries of science and to embrace change in order to secure a position for their art in the future.

The way Degas approached this scientific Realism can be illuminated by his position regarding the display of art works. Rejecting the traditional, crowded arrangement of paintings at the annual Salon presentations, he co-organized the independent exhibitions of the Impressionists where they could enjoy a "great freedom for experimentation and a laboratory of [their] own," as one critic put it. Grouping all the works by each artist in intimately scaled rooms, walls painted with unorthodox colors to create effects that complemented the pictures, and extending evening visiting hours under gaslight, Degas and his colleagues created effects in line with the recent discoveries in optical physics. Like other Impressionist artists, Degas attached great importance to the picture frames whose colors and profiles he designed himself. As Monet later explained, Degas did this "to make the frame assist and complete the picture," thus enhancing its colors. Degas even stipulated that his pictures be kept in their original frames. When he happened to discover once that one of his works had been reframed with a conventional gilded molding, he repossessed it in a rage.

Since Degas's works were frequently exhibited together with paintings by Impressionist artists, critics often attached the same label to him as well. The term originated from a critic's derogatory remark about Monet's painting *Impression-Sunrise*, which was shown at the Salon des Indépendants in 1874. What Degas had in common with these artists was the pursuit

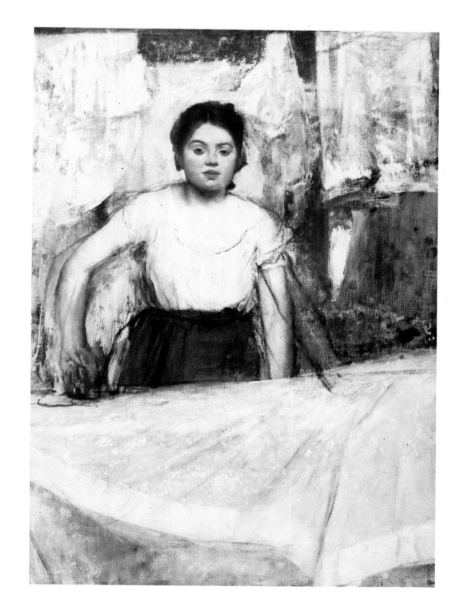

The Laundress
1869, c.; *Oil on canvas;*
36 x 29 in. (92.5 x 73.5 cm.).
Munich, Neue Pinakothek.
Common, everyday activities of working women—particularly laundresses—was one of Degas's favorite subjects during the 1870s. Degas's models never seem to pose. The viewer always has the impression of being a witness at a real event.

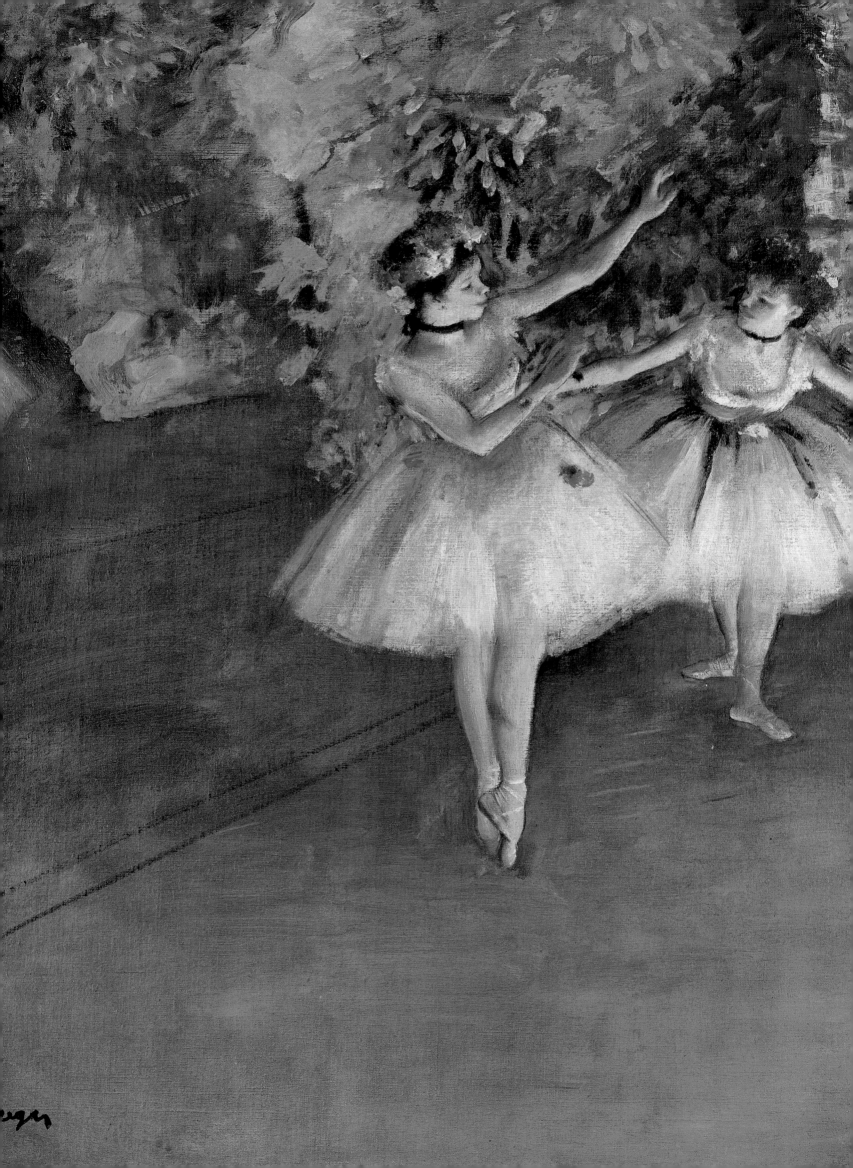

of visual "truth." At issue were precise observations based on the recent achievements in science, which the Impressionist painters claimed to express faithfully in their paintings. Degas realized that this label influenced the reading of his works while impeding critical appreciation of his own Realist ambitions. His emphasis on drawing and a higher degree of finish, as well as his preference for urban subject matters, distinguished his works from Monet's, for example—so much so that some critics actually dissociated Degas altogether from Impressionism's revolutionary techniques. Instead, they viewed him as the "honest" bourgeois posing as a radical. The factionalism among the Impressionist group, divided between such "colorists" as Monet and "draftsmen" such as Degas, led eventually to the alienation of key figures like Renoir, Sisley, and Monet from the movement, while at the same time Degas strengthened his own reputation and the advance of "the great cause of Realism."

Innovations

Degas's fascination with technical inventions is evident in his print making, but he also made an innovative use of traditional techniques like pastel and distemper (which is based on glue, not oil). Both are dry or fast-drying opaque mediums that allowed Degas to effectively make, and mask, changes to his compositions. Exploring their expressive potential for

Four Ballerinas Behind the Stage
detail; 1898, c.; Moscow, Pushkin Museum of Fine Arts.
The vigorous pastel strokes which model the body and tutu of the dancer illustrate Degas's working methods. By carefully placing layer upon layer of the pigments, he achieved tonal gradations of utmost delicacy.

Two Ballerinas on Stage
1874; *Oil on canvas;* 24 1/4 x 18 1/2 in. (61.5 x 46 cm.).
London, The Courtauld Institute Galleries.
Two single dancers are alone on the stage. Behind them are stage sets that suggest foliage. The tutu of a third ballerina in the rear is cut by the frame on the far left. Whether this scene is meant to be read as a performance or a rehearsal is not clear. The painting was acquired by an English collector just after its first showing in London in 1874.

Woman Ironing

1892-1895, c.; *Oil on canvas;*
31 1/2 x 24 in. (80 x 63.5 cm.).
Liverpool, Walker Art Gallery.
*Both scale and space are considerably
reduced compared to the version of an
ironing woman displayed in Washington,
DC, although both paintings share the
same-sized canvas. Here the figure is
sturdier, more independent, and there
are no distracting details. The energetic
freedom and brilliance of the emerald
green impasto of the fabric demands both
the viewer's and the woman's attention.*

Ironing Women (The Laundresses)

detail; 1884-1886, c.; Paris, Musée d'Orsay.
*This figure has become almost an icon
of a working-class woman of the turn
of the century. Holding a bottle of
wine in one hand, she is yawning in
boredom over her repetitive labor.*

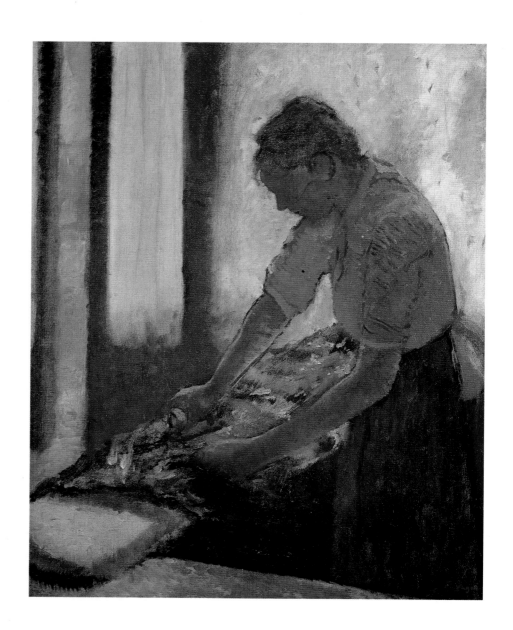

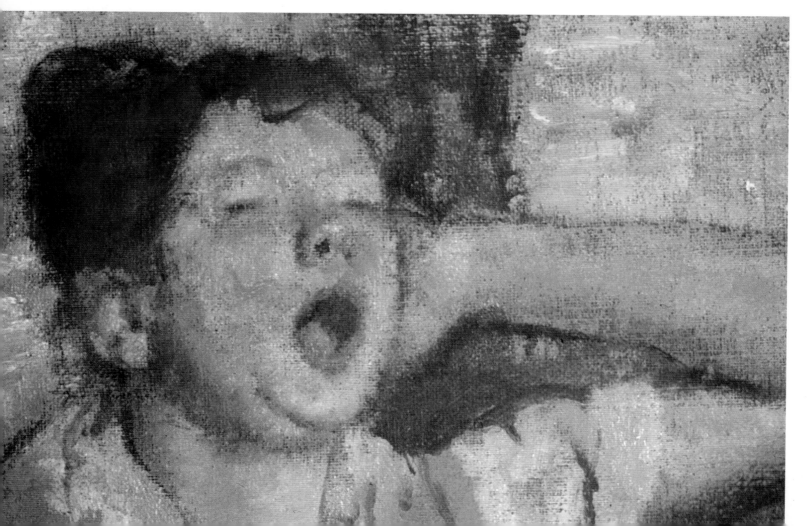

depicting the contemporary world of the opera and the café-concert, Degas found the fragility of these media perfectly appropriate for depicting the transient pleasures of the performing arts. The absence of a vital tradition allowed him to freely exploit the inherent flexibility of paper supports, adding or taking away pieces of paper while developing his compositions. He also used a stump or his fingers in order to create tonal areas, or he would apply the powdery pigments of the pastel sticks with brush and water to create fluid passages of colors.

His endeavors created a new vocabulary for Realism, similarly expressed in the contemporary literature of the de Goncourt brothers (Edmond-Louis-Antoine and Jules-Alfred) and Émile Zola. Critics remarked on the arbitrariness of odd viewpoints, cropped forms, and tilting floors in Degas's oeuvre. These elements were part of the Realism-Naturalism ideology. His compositions express, indeed, a spontaneity that belie their careful preparation. Edmond de Goncourt described Degas after a visit to a studio as "the one who has best been able, in transcribing modern life, to capture its soul."

Artistic Maturity

By the end of the 1880s, Degas had virtually fulfilled his wish "to be illustrious and unknown." He was worldly and influential, so constantly in contact with a large number of artists, that some of his colleagues became annoyed by his maneuvering. By the same token, as he was confident of his talent and secure of his position, Degas had withdrawn to a much more limited circle of close friends. He exhibited his works only in few selected public places, which called him to the attention of the influential art journals in Paris. He managed to produce an increasing number of finished works for the art market while carefully planning his sales strategy through a selected group of dealers. Of these, Durand-Ruel, whom Degas had met in the early 1870s, was the most influential.

Degas was conscious of commercial pressures and seems to have distinguished between a market-oriented production—his fabricated "articles" as he called them—and the rest of his art. Works of the first category are primarily characterized by their degree of finish, the latter ones distinctly more avant-garde. Several of these found their way to the gallery of Theo van Gogh (Vincent's brother).

While Degas withdrew more and more from his highly visible and active role within the artistic

The Pedicure
1873; *Essence on paper, mounted on canvas;*
24 x 18 1/8 in. (61 x 46 cm.). Paris, Musée d'Orsay.
This ordinary subject of a chiropodist treating a young girl—possibly Joe Balfour, René De Gas's stepdaughter—is rendered with great dignity and delicacy. The artist employed his special painting technique using an essence rather than oil, thus achieving softer and matter tones.

Fan: The Ballet

1879; *Watercolor and silver
and gold paint on silk;*
7 1/2 x 22 3/4 in.
(19.1 x 57.9 cm.).
New York, Metropolitan
Museum of Art,
Havemeyer Collection.
*Several dancers are clustered
in leisurely positions at the
center of an almost bare
stage. Degas painted twenty-
five fans in total, making
considerable effort as far as
the technique is concerned.
The present fan belonged
once to his painter friend
Mary Cassatt, whose
portrait Degas also painted.*

community in Paris, his influence on the younger generation became more pervasive. Although he never had any students, many artists, like Paul Gauguin, Georges Seurat, and Henri Toulouse-Lautrec, acknowledged the importance of Degas's works on their own. Such friends as the American painter Mary Cassatt and the sculptor Albert Bartholomé had always been directly encouraged by him.

The works of Degas's later years are somewhat difficult to assess. While much information for earlier periods can be gathered from his notebooks, he seems to have stopped keeping them from about 1886 onward. Beginning with the 1890s his works convey the spirit of an aging man, whose body, mind, and morale had deteriorated noticeably over the last twenty-seven years of his life. The wit and humor was replaced by a more serious tone, and his artistic output dropped slowly, caused by his increasing blindness. It has been noted that in these works Degas clearly indulged in the abstract elements of his art. Color became more intense, but line increased in vigor and expressive power. While space continued to be either theatrical or ambiguous, his figures, predominantly bathers, now show signs of aging, wearily dealing with the fragility of their bodies. Nonetheless, they still possess a strong and bold will, expressing that of the artist himself.

Often his late works have been interpreted merely as the result of a deteriorating, senile artist, who, stricken with increasing blindness, had become intolerant and anti-Semitic during the Dreyfus Affair and suffered from melancholy and loneliness. While all of the above is true, Degas was still capable of apparent contradictions, his mind demonstrating the flexibility to explore new paths. He experimented with the medium of photography, for example, and seems to have made use of it for some of his works. Stimulated by his sculptor friend Bartholomé, he produced numerous wax and clay models of dancers and horses. Degas valued wax for its mutability, and sometimes friends visiting his studio would happen upon a sculpture returned to the state of a ball of wax, as if the result had not been satisfactory. With the exception of *The Little Dancer Aged Fourteen*, he never exhibited any of them. It was not until after his death that many of them were cast in bronze—an action opposed by such intelligent observers as Cassatt.

After he was forced to leave his studio apartment in 1912 because of the demolition of the entire building, Degas seems to have stopped working altogether. Almost completely blind and deaf, he was often seen walking tirelessly through the streets of his beloved city, occasionally attending art auctions or exhibitions. His long white hair and beard, together with his infirmities, inspired some of his friends to compare him to the classical Greek poet Homer. Yet until the very end of his life, like a monument to independence, Degas remained true to himself.

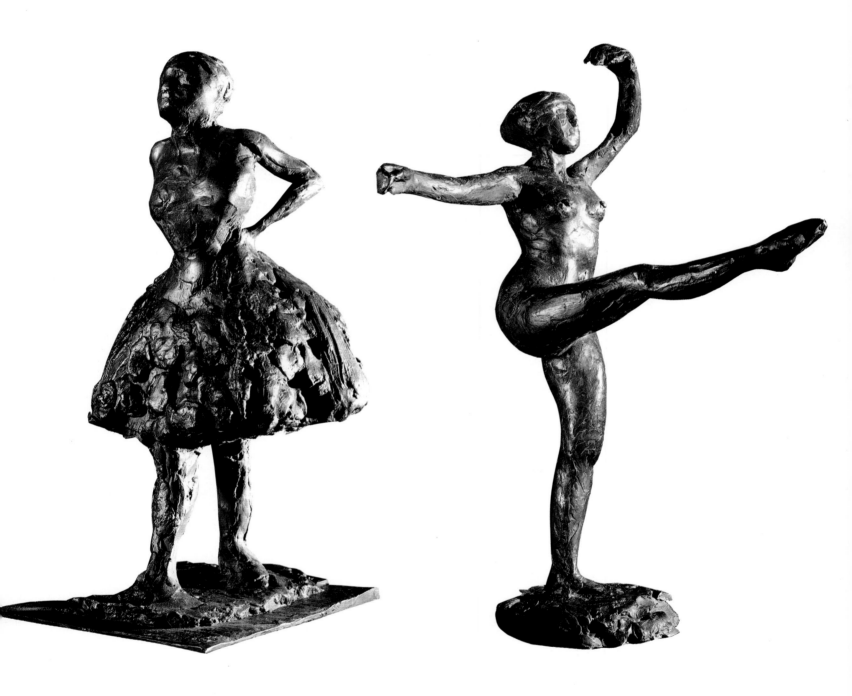

Dancer: Dressed and at Rest

1895, c.; *Bronze;* 16 7/8 in. (42.9 cm.) high; Paris, Musée d'Orsay.
*Occasionally, Degas modeled small wax sculptures of
figures he had already painted in previous works. Here
he studied the shape of a dancer's tutu, bouncing up at
the back, and the flickering effects of light. The rest
of the body does not show the same level of refinement.*

Spanish Dancer

1895-1910; *Bronze;* 17 5/8 in. (44 cm.) high;
Paris, Musée d'Orsay.
*The quintessential image of a dancer, this work
is perhaps Degas's best-known sculpture. The
movement of legs and arms is perfectly balanced.*

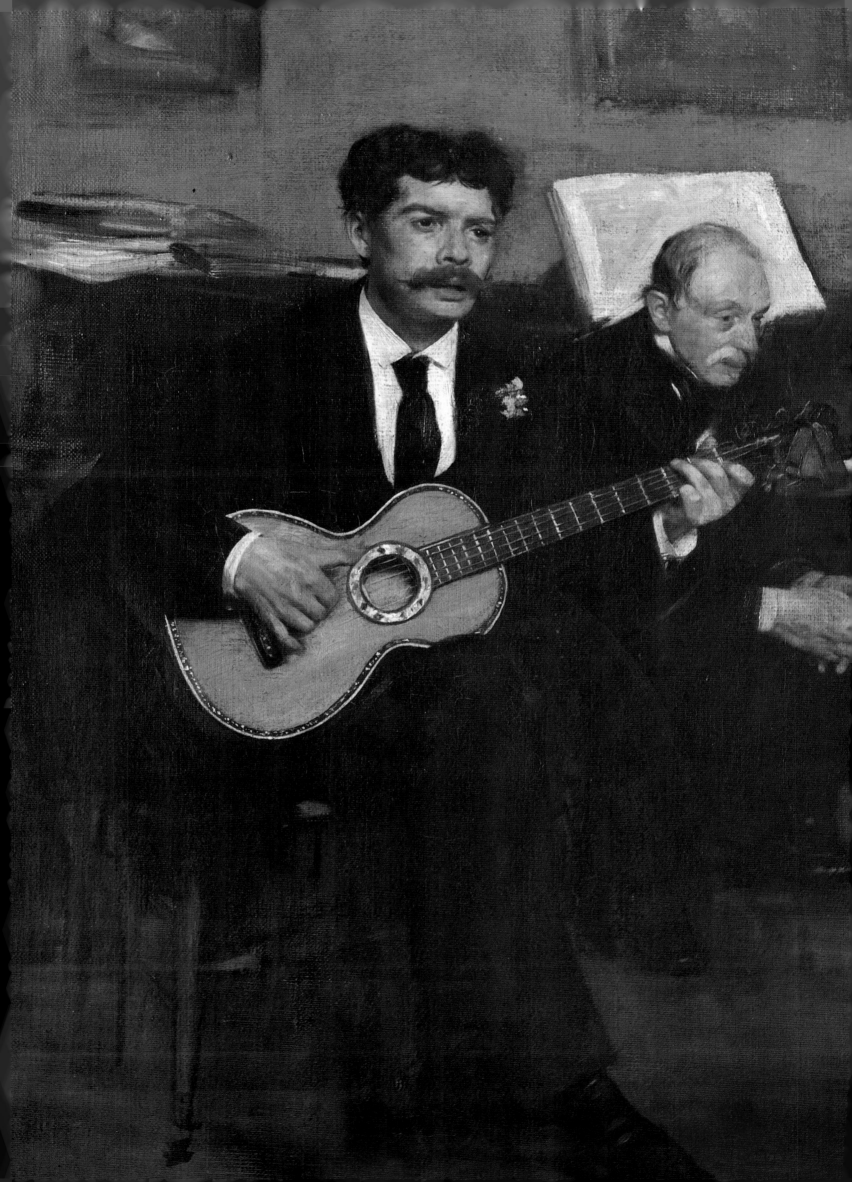

CHAPTER 1
FAMILY AND FRIENDS

The portraits of Degas reveal a dichotomy. These are clearly intended to be renderings of a person's features in the traditional sense of a portrait; others are more complex and include narrative elements of genre scenes. Even in such cases, they were still painted with the intention of representing a person's likeness. In a notebook entry of 1859 to 1860, the artist wrote about future projects: "I must do something with [Marquis de] Vauvenargue's face, which is close to my heart. And not forget to do René [the artist's brother] full-length with his hat, as well as a portrait of a lady with her hat, putting on her gloves while she is getting ready to go out."

Favorite Models
Until his return from Italy, Degas's models were—aside from himself in various self-portraits—mostly members of his extensive family, including his brothers and sisters, aunts and uncles. He did not paint them all with the same frequency, preferring some, such as his Aunt Laura in Florence and his brother René, for merely pictorial reasons. His sister Thérèse, for example, had the cool and distant semblance of a woman who could have stepped out of one of Ingres's paintings, while her husband and first cousin, Edmondo Morbilli, possessed the looks of an Italian nobleman of the sixteenth century. Not all of Degas's women can be considered pretty, but they often have what he himself called "that saving touch of ugliness." The artist Berthe Morisot remarked about the portrait of the dancer Mme. Gaujelin, exhibited at the Salon of 1869: "M. Degas has a very pretty

Lorenzo Pagans and Auguste De Gas (The Guitar Player)
1871-1872, c.; *Oil on canvas; 21 2/4 x 15 3/4 in. (54 x 40 cm.).*
Paris, Musée d'Orsay.
The artist had a special reverence for this painting, which represents the musician Pagans and his own father, Auguste. The Spanish-born Pagans devoted himself mostly to the popular melodies of his country and performed at several of the musical evenings held by Auguste in his apartment. The senior Degas was a dedicated music lover and was said to sit drinking in the music just as his son painted him.

little portrait of a very ugly woman in black." Indeed, the sitter was not flattered at all and rejected the painting, which she had commissioned from the artist.

Among family members, Degas never had a chance to paint his mother, who died in 1847, and he painted his father once, in 1870 (see Chapter 4). Auguste encouraged his son to pursue seriously portrait painting as a possible source of income. Degas excelled eventually in this genre not because his models were of extraordinary beauty, but rather because he imbued them with a strong character and expression of their own. He achieved this by frequently exaggerating the sitters' features, as with The *Collector of Prints* and the portrait of his grandfather Hilaire De Gas, whose old age is made clearly visible in his wrinkled skin and the bags under his eyes.

Figure and Space
One of Degas's primary concerns during his early years was to master the relationship of the figure to its surrounding space. In his *Self-portrait* of 1855, an early work executed before his trip to Italy, he used a dark background in the manner of the great Spanish painters Francisco José de Goya and Diego Rodríguez de Silva Velázquez. Only twenty years old in the painting, he bears a charcoal holder in his right hand instead of a paintbrush—as if he wanted to stress his inclination as a draftsman following Ingres's dictum that any good artist must incessantly draw lines. But drawing with charcoal was also part of the training at the École des Beaux-Arts, where Degas had studied briefly. However, he does not seem to have used this medium in the 1850s.

The uncertainty and aloofness of his expression were to be repeated in other self-portraits, like the one in which he is lifting his hat, painted about seven or eight years later. The dark background has opened up a little to the right, where a break in the wall reveals something like a sky, comparable to backgrounds one might find in portraits by Venetian masters such as Titian. These references to old masters notwithstanding, it is the casualness of his gesture as well as the unpretentious, simple dress of a gentleman that makes this painting so modern. As in the earlier work, Degas did not represent himself as an artist, rather as a citizen of a certain distinction, who only happens to be an artist.

A peculiar contrast between a self-conscious, older

anced by a modern, almost abstract view of a cityscape in grays, blacks, blues, and pinks seen through the large studio window behind the two men. It is as if Degas intended to distinguish between the old and the new, the traditional and the modern characters of the sitters.

Group Portraits

As previously noted, from the beginning of his career, Degas demonstrated a particular interest in and affection for his family, especially for his father's relatives in Italy. Auguste De Gas, who was born in Naples and had several brothers and sisters there, had recommended that his son stay with his relations during his trip to Italy. The efforts of Edgar's artistic aspirations and his family bonds were soon galvanized and culminated in his first monumental masterpiece, the group portrait of *The Bellelli Family*.

Auguste's sister Laura was married to the baron Gennaro Bellelli, with whom she had two daughters, Giulia and Giovanna. Edgar stayed with his aunt and uncle in Florence, where the family was living in exile from Naples for political reasons. They did not like their temporary environment, which Laura called a "detestable country," remarking that her husband hated to live in "rented rooms." Furthermore, the relationship between the parents was troubled, and his aunt complained about Gennaro's "immensely disagreeable and dishonest" character.

Degas seemed to have had a special fondness for his aunt. She was certainly his favorite among his father's sisters, although her health was fragile and she was apparently slightly unbalanced. In letters she wrote to Edgar in Paris after his return there, she referred frequently to the madness she thought was stalking her, believing she would end up in a hospital for the insane. She wrote, "Living with Gennaro...who has no serious occupation, shall soon lead me to the grave." The atmosphere in the family must at times have been suffocating, possibly relieved by the presence of Giulia and Giovanna.

Degas was capable of imbuing this group portrait with an eerie sentiment of a domestic drama by merely presenting the members of the family. Dressed in a somber black gown and with a stern, yet somewhat distracted, look on her face, Aunt Laura is the dominating figure. Her absentminded air does not undermine her towering position in the picture, however. Gennaro is sitting in an armchair near the fireplace with his back to the viewer and apparently disconnected from what is happening around him. In essence, the two are avoiding one other. Little Giovanna is gazing at the painter and viewer, her hands folded over her white apron. By all accounts she was a rather undisciplined child, which makes her gesture seem somewhat hypocritical. On the other hand, her slightly younger sister, Giulia, demonstrates a more

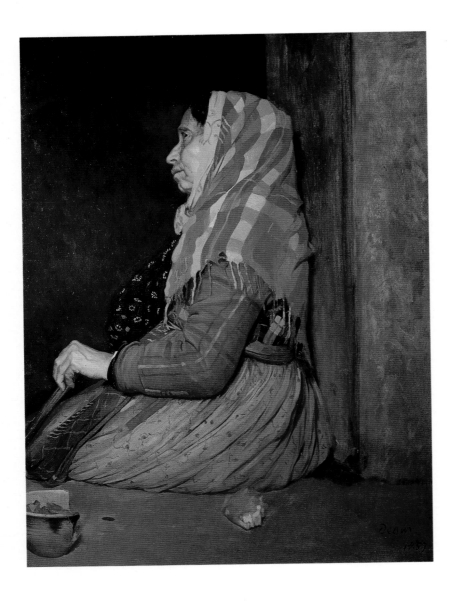

Roman Beggar Woman
1857; *Oil on canvas*; 39 1/2 x 29 5/8 in. (100.3 x 75.2 cm.).
Birmingham, Birmingham City Museum of Art Gallery.
Although part of the tradition of "popular life in Italy," as promoted by the French Academy in Rome, Degas did not indulge in the usual depiction of misery, nor did he offer a bourgeois sentimentality in this monumental, isolated figure of a poor Italian woman.

colleague and a thoughtful, hesitant younger artist is evident in the double portrait of Degas and his friend Evariste de Valernes. Originally Degas intended to show himself also with a top hat and his hand lowered on his lap, but he must have felt dissatisfied with the repetitious character of such a solution. The two figures are inscribed in a circle with Valernes's heart at the center. This deliberate classical element is carefully counterbal-

outgoing and impatient character by placing her hands coquettishly on her hips. She is the only link between her parents, who are separated by a table. A drawing on the wall near Laura's head depicts her father (and Edgar's grandfather), Hilaire De Gas, who was living in Naples at the time. The drawing, which is depicted as having been executed in red chalk, is framed with a mat to give it the appearance of an old master drawing. An open door to the left and the reflections in the large mirror above the mantelpiece extend the room—though it could not compare with the grandeur of the sitters' palaces in Naples. With the Unification of Italy in 1860, the family was able to return to its native city.

Degas must have painted this enormous canvas after his return to Paris in 1859 in his new and spacious studio. He certainly could not have worked on such a scale in his relatives' apartment in Florence. Various studies and a pastel drawing indicating the arrangement of the figures served as a guide to accomplish this enormous task. Although he apparently labored over this project for several years, Degas does not seem to have regarded it with the same interest he displayed for his history paintings like *Semiramis* or *Young Spartans Exercising*. After it's completion he probably kept the painting rolled up in a corner of his studio. It was virtually unknown when it reappeared at the studio sale in 1918 after his death, causing a great sensation. The painting was immediately purchased by the Louvre.

During the Franco-Prussian War (1870-1871), Degas, like many other citizens, volunteered for the National Guard. He was posted to defend a fortification north of the Bois de Vincennes on the outskirts of Paris under the command of his friend Henri Rouart, whose portrait he painted a few years later. Eager to serve his country, he complained that he had not yet heard a cannon going off. "He is looking for an opportunity to hear that sound because he wants to know whether he can endure the detonation," Mme. Morisot wrote. In January of 1871, the war ended with the capitulation of Paris and a humiliating peace. The war offered Degas the chance to be in touch with a wide variety of people. At the Bastion 12, where he was serving, Degas came to know Jean-Baptiste Jeantaud, Édouard Laine, and a gentleman by the name of Linet, all of whom he painted in a group portrait in March 1871. Sitting with folded arms at the table on the left is Jeantaud, an engineer who in 1881 distinguished himself in building the first electric automobile. Except for his surname, almost nothing is known of Linet, the man at the center represented in a relaxed position with his top hat on. The third man at the right, who is seen reading a newspaper, is Édouard Laine, an industrialist and friend of Rouart's. Degas chose to depict his comrades in an elegant and relaxed atmosphere, rather than in the military milieu. The setting appears to be a bourgeois club or a restaurant, where the friends might have gathered for a meal. Attention is paid to their faces, while other details are clearly neglected. The palette of black, brown, and garnet, accentuated by the white of the tablecloth, sleeves, and collars, was Degas's favorite at the time.

After a trip to London in October the same year, Degas expressed his desire to visit his brother's family

Portrait of Joséphine Gaujelin
1867; *Oil on canvas;* 24 1/8 x 18 in. (61.2 x 45.7 cm.).
Boston, Isabella Stewart Gardner Museum.
Joséphine Gaujelin, a ballerina who had commissioned the portrait, rejected the work, noting that it did not do her justice. Dressed in black, which contrasts with the livelier crimson and yellow around her, she looks straight out of the painting with melancholy eyes and a pensive expression on her face.

and other relatives in New Orleans in America. Degas's mother, Célestine Musson, was born there. In 1863 her sister Odile Musson had arrived in Paris with her two daughters, Estelle and Désirée, fleeing the Civil War. Probably around that time René had developed an affection for Estelle, whose husband had been killed during the war, leaving her with a baby. Encouraged by Edgar, René moved to America, leaving their father's business. Eventually, René married Estelle, and some time later Achille De Gas followed his brother to New Orleans, joining the affairs of the family business.

René's visit to Paris during the summer of 1872 inspired Edgar to return with him to America. The following October, the brothers left together headed for New Orleans via New York. In a letter dated November 4, shortly after his arrival there, Degas wrote to his friend Dihau in Paris: "All day long I am among these dear folk, painting and drawing, making portraits of the family." And later: "Family portraits must be done to suit the taste of the family, in impossible lighting, with many interruptions, and with models who are very affectionate but a little too bold—they take you less seriously because you are their nephew or cousin." One of the portraits produced during this period is *Woman with a Vase of Flowers*. The model is most likely Désirée Musson, the painter's cousin. It is hard to believe that Degas should have dreaded to work on this portrait since the vividness of the colors and the fresh and vital brushstrokes belie his state of mind. Only the difficulty of lighting becomes somewhat apparent in the dark and heavy shadows.

Although he was longing to return soon to Paris, Degas extended his stay in New Orleans until March the following year, mainly because he was working on his second large, ambitious group portrait after *The Bellelli Family*. About three months after his arrival he had begun to work on *Interior of an Office in New Orleans*, also known under the somewhat

Monsieur and Madame Édouard Manet
1868-1869; *Oil on canvas*; 25 5/8 x 28 in. (65 x 71 cm.).
Kitakyushu, Japan, Municipal Museum of Art.
Dega's close but somewhat ambiguous relationship with the "leader" of the Impressionists, Manet, is documented in the present painting. Manet, apparently not satisfied with the rendering of his wife, Suzanne, playing the piano, is said to have slashed the right half of the painting. Degas took it back to his studio, yet never managed to restore the figure of Mme. Manet.

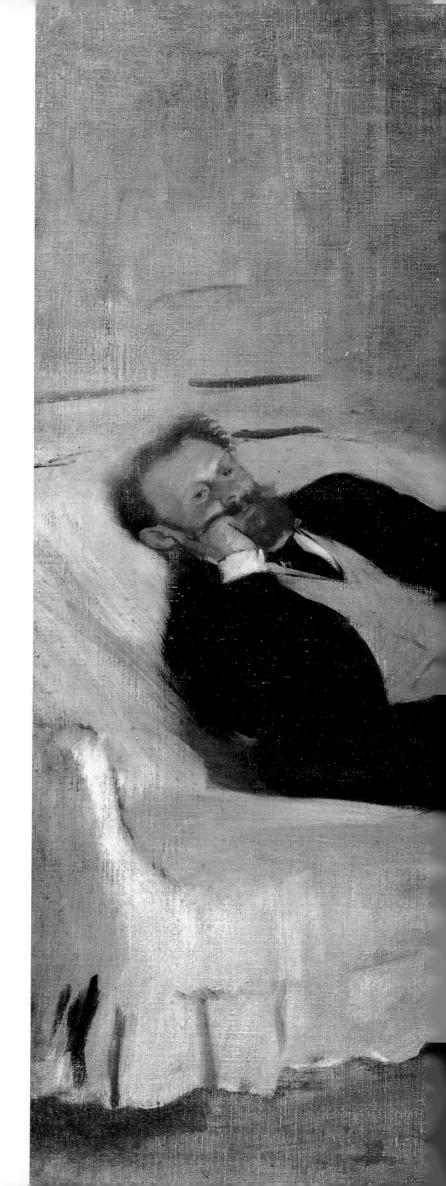

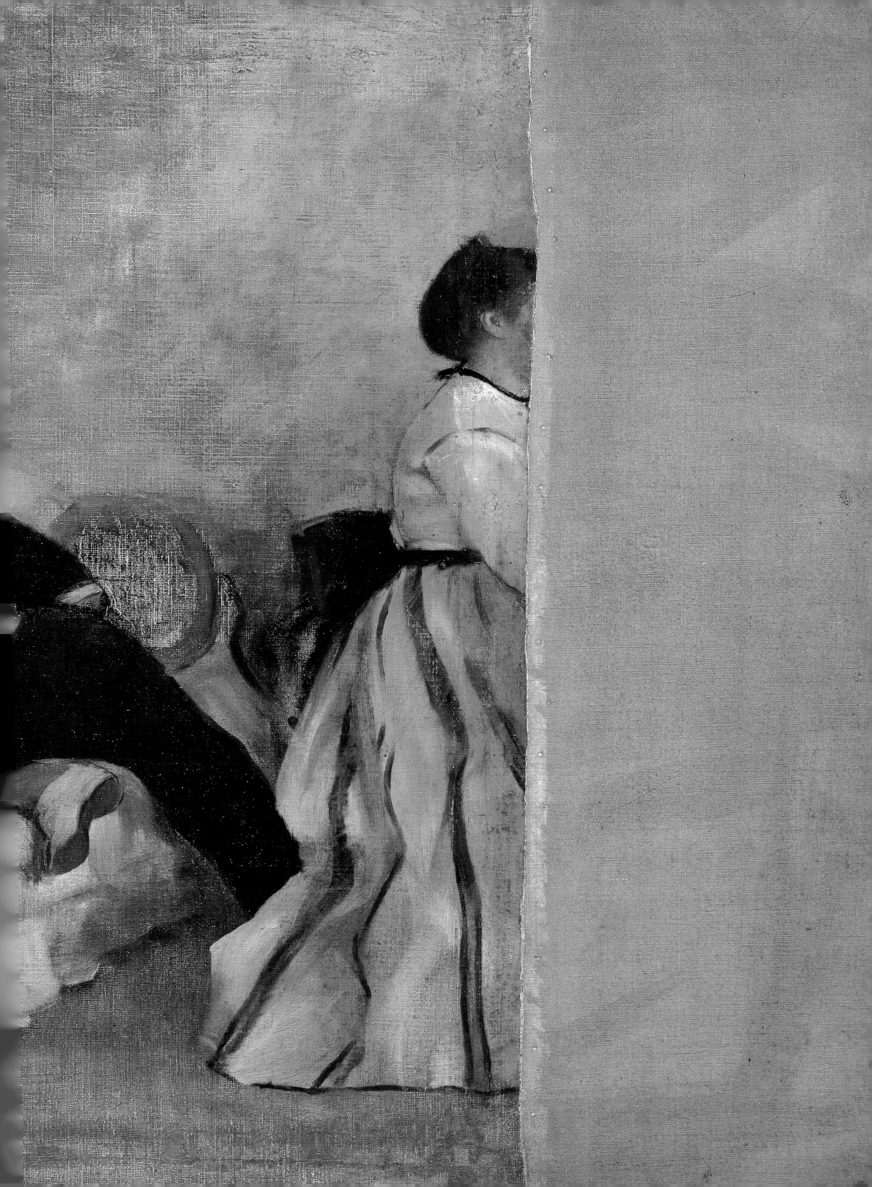

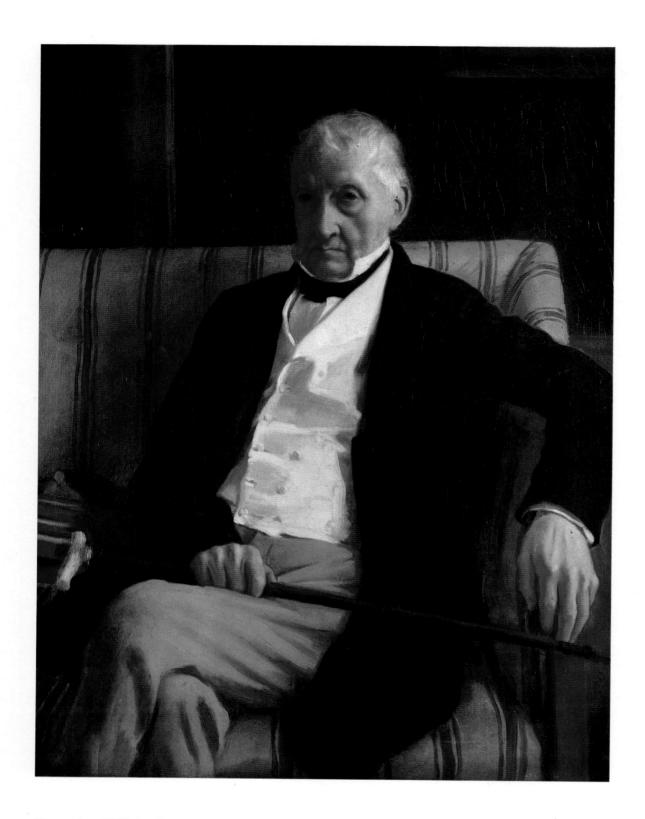

Portrait of Hilaire De Gas

1857; *Oil on canvas;* 20 7/8 x 16 1/8 in. (53 x 41 cm.).
Paris, Musée D'Orsay.
Hilaire De Gas was the artist's grandfather and lived near Naples. Edgar painted this solemn portrait during his stay in Italy, when the sitter was eighty-seven years old. The warm light and the dignity accorded the older man reveal the grandson's affection and admiration, which is also attested to by family correspondence.

Edmondo and Thérèse Morbilli
detail; 1865, c.; 1931 Purchase Fund.
Courtesy Boston Museum of Fine Arts.
Degas's sister Thérèse was a preferred model for his portraits of family members. The pale oval shape of her face is reminiscent of works by the artist Ingres, whom Degas admired, particularly during his early years.

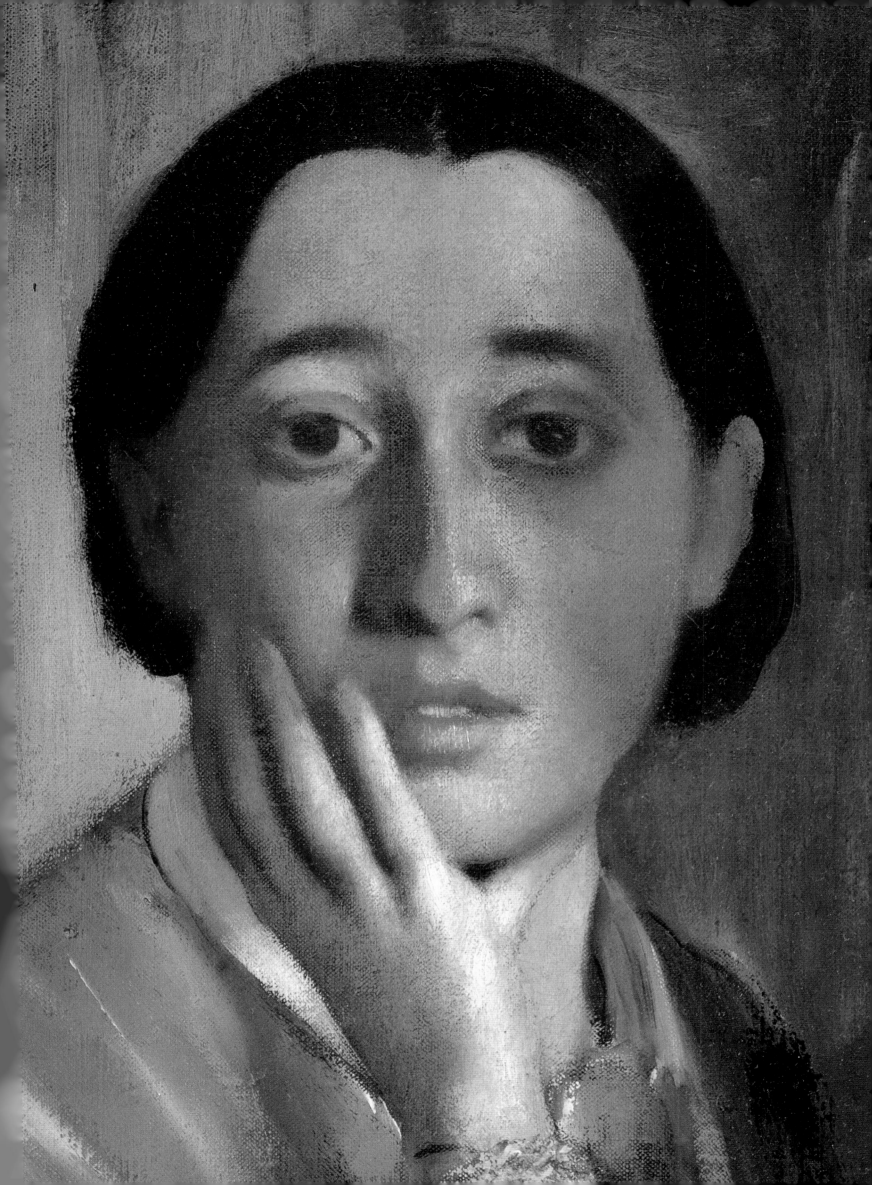

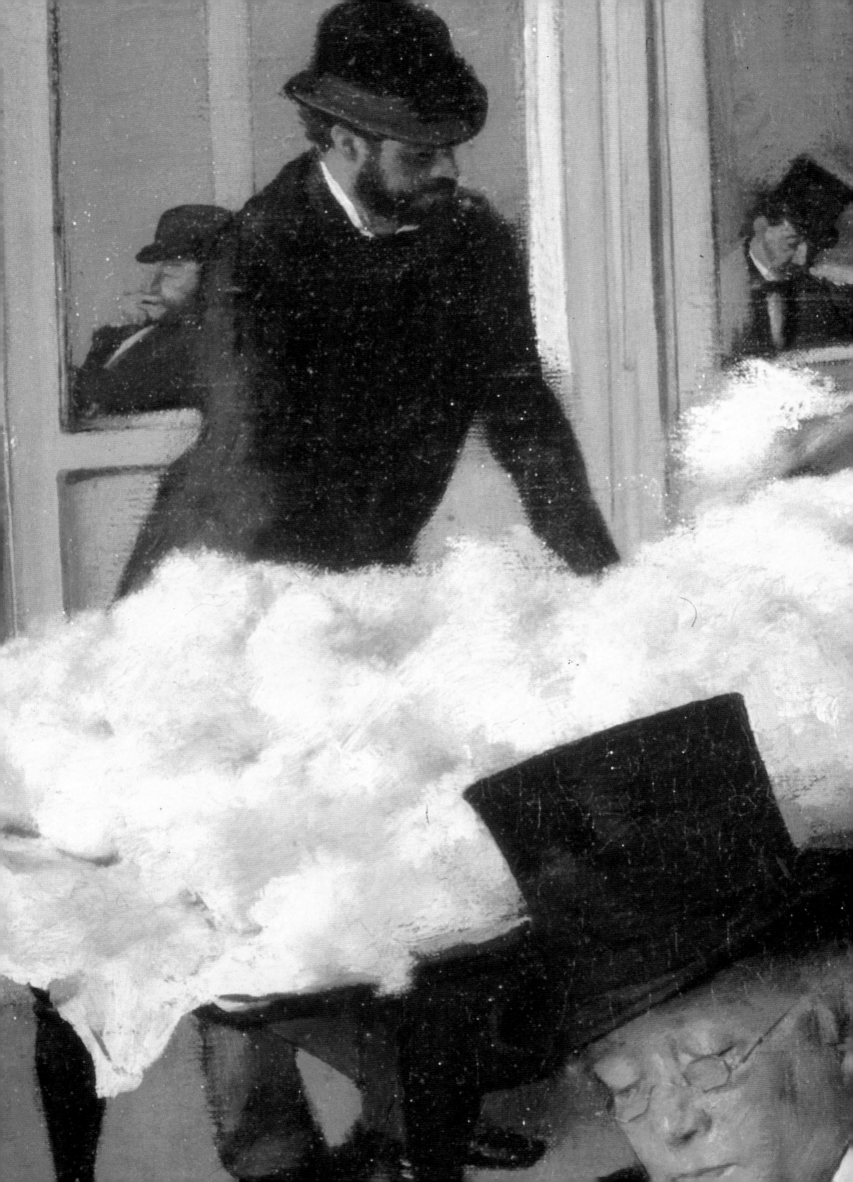

misleading title *The Cotton Market at New Orleans*. At first glance the painting might be taken just for an interior scene where some figures check the quality of the cotton displayed for sale. Others are involved in accounting or bookkeeping, while still others are gazing somewhat distractedly at the events in the room. Degas himself provided a brief description of this painting in a letter to his English painter friend James Tissot in London: "In it there are about fifteen individuals more or less occupied with a table covered with the precious material, and two men, one half leaning and the other half sitting on it, the buyer and the broker, are discussing the pattern."

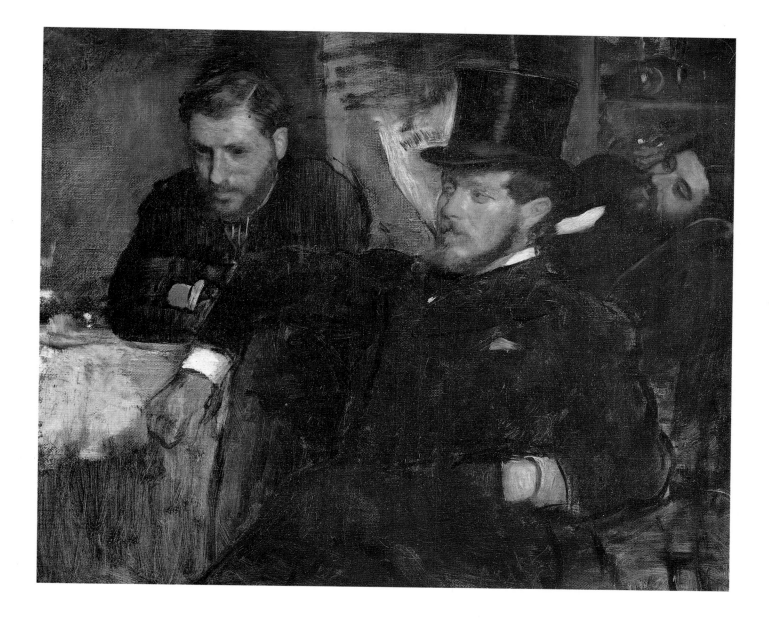

Interior of an Office in New Orleans
detail; 1873; Pau, Musée des Beaux-Arts.
Cotton was an omnipresent phenomenon in Degas's own experience in New Orleans, but it was particularly its white, fluffy quality which formed a pictorial challenge for the artist.

Jeantaud, Linet, and Laine
1871; *Oil on canvas;* 15 x 18 1/8 in. (38 x 46 cm.).
Paris, Musée d'Orsay.
Degas and the three sitters were volunteers for the National Guard, active in the defense of Paris during the Franco-Prussian war of 1870-1871. Concentrating on the facial expressions of his friends, Degas deliberately neglected the details of the setting, most likely a restaurant.

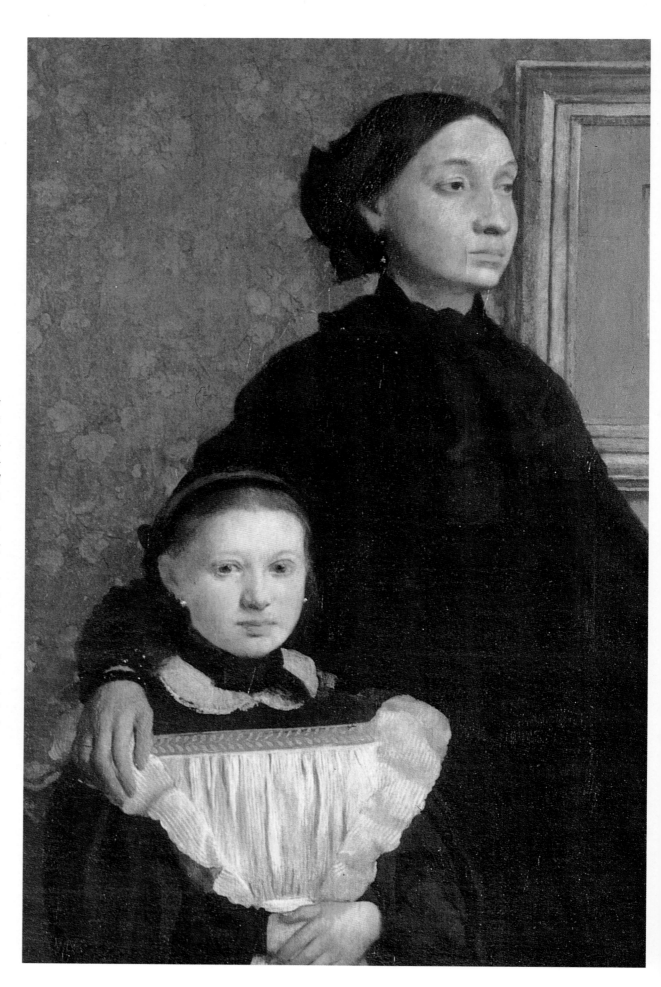

The Bellelli Family
detail; 1858-1867;
Paris, Musée d'Orsay.
*Although his Aunt
Laura in Florence was
slightly unbalanced and
neurotic, Degas had a
special fondness for her.
She appears to have
been the dominating
figure in the family.
The motionless face
expresses her role
eloquently. Degas's
younger cousin
Giovanna was known
to be an undisciplined
child. Nevertheless,
she is represented as
a well-behaved girl
with her hands folded
over her white apron.*

The circumstances that triggered the idea for this work are not known, but the omnipresence of cotton obviously captured the painter's imagination, remarking that in New Orleans, "One lives for cotton and from cotton." He also must have wished to escape the limitations of painting individual members of the family. Perhaps he even wanted to demonstrate to them what his artistic mind was able to create. The painting is indeed more than an elaborate interior scene—it is actually a sublime group portrait. In the foreground, touching a sample of cotton, is Michel Musson, Degas's maternal uncle. Behind him are his two sons-in-law, René DeGas, the painter' brother, reading the *Daily Times-Picayune*, and the broker William Bell, sitting on the edge of the table. In the left corner of the room, standing with his legs crossed, is Achille De Gas, Edgar's other brother, and to the right studying the thick register is John Livaudais, the company's cashier. Sitting behind René, on a high stool and dressed in a light brown jacket, is James Prestige, Musson's business partner. Each figure seems to be cast in his typical attitude, thus clearly displaying an almost embarrassing indifference toward the two Degas brothers, who, with a hint of Parisian nonchalance and dandyism, are completely inactive amid their hardworking American partners.

The room, depicted in a clearly constructed perspective, is seen obliquely from a high vantage point, permitting a full view of a tranquil and prosperous American work place. The black suits contrast with the whites of the fluffy cotton, the shirts, and the newspaper, while the pale green walls, the beige ceiling, and the pinkish tone of the wooden floor provide a unifying coloristic framework. The admirable still-life on the right with the paper basket, the counter covered with papers and registers, and a small framed seascape painting on the wall animate the scene. When he returned to France, Degas left the painting behind in New Orleans so that it could dry properly without having the surface ruined during its transportation.

The critics' response to the work was mixed after the painting was first seen in Paris. Some noted that it was uncharacteristic for the artist thus far, and even Zola, usually a staunch supporter of the cause of Impressionism, lamented that Degas had spoiled the painting by adding the final touches (the writer felt his best pictures were sketches). "[Degas's] artistic insights are excellent, but I am afraid that his brush will never be creative," he critiqued. Others, however, praised the painting for its realism and its frankly modern depiction of ordinary life.

Degas had originally intended for this painting to be displayed with an art dealer in Manchester, the center of the English spinning industry, "for if a spinner ever wished to find his painter, he really ought to hit on me," he noted. Despite these expectations, the painting ended up in a French museum—in fact it was his first work to enter a public collection. After its exhibition in Pau in the south of France in 1878, the work was purchased by the curator of the Pau museum, where it is still housed today. Very flattered and satisfied to see his work in a public institution, Degas was willing to part with it for the modest sum of two thousand francs.

Degas achieved different, more spontaneous results than other painters in his portraits, which at times hardly look like portraits at all. By binding his sitters into the surrounding space, by supplying them with attributes of

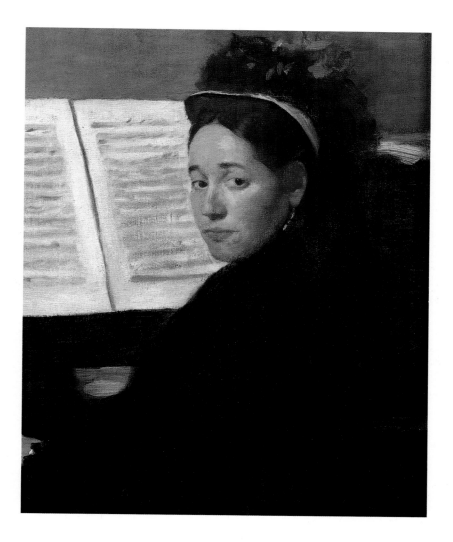

Marie Dihau at the Piano
1869-1872, c.; *Oil on canvas;* 15 5/8 x 12 7/8 in. (39 x 32 cm.).
Paris, Musée D'Orsay.
The sitter was the sister of the bassoonist of the
opera in Paris, Désiré Dihau, whom Degas portrayed
in The Orchestra of the Opéra. *Marie Dihau was a*
distinguished pianist and singer and lived mostly in
Lisle, but she visited her brother in Paris frequently.
Degas went with his father to several of her concerts.

their character or profession, and by subtle yet acute interpretations of their personalities, Degas enlarged considerably the possibilities of a genre that other artists treated in much more conventional terms. For example, in his renderings of *Hortense Valpinçon* and *Woman with a Vase of Flowers*, the artist placed his models amid a still-life setting. The young girl is leaning over a table decorated with a colorful embroidered cloth while eating an apple. One expects her to run away impatiently at any moment. The woman's portrait, on the other hand, reveals the sitter's tranquil, contemplative mood, her

hand thoughtfully raised to her chin. The sumptuous bouquet of autumn flowers underscores this calmness; in fact, the laces of her bonnet relate beautifully to the petals of the asters.

Sometimes it is also the unusual perspective, the close viewpoint, or the cutoff shapes of figures or objects, as in *Henri Rouart in Front of His Factory*, that make his portraits as well as his other paintings look so modern. And it was precisely these characteristics that bothered some of Degas's critics, not foreseeing how seminal his works would be in the future.

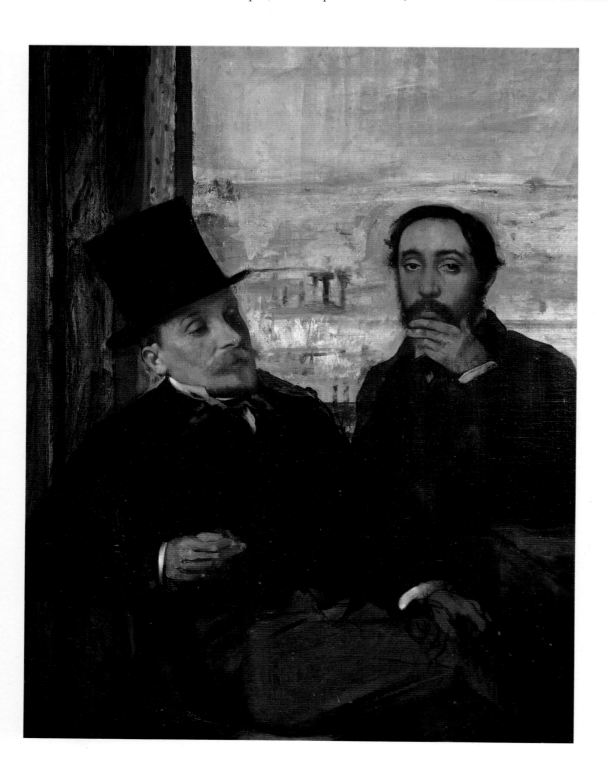

The Artist and His Friend Evariste de Valernes
1865, c.; *Oil on canvas;*
45 3/8 x 35 in. (116 x 89 cm.).
Paris, Musée d'Orsay.
The artist's last self-portrait shows him in company of his painter friend de Valernes, who was about twenty years his senior. A rather unsuccessful artist and on the brink of poverty, Degas seemed to enjoy the company of this affable gentleman.

Self-portrait: Degas Lifting His Hat
1863, c.; *Oil on canvas;*
36 3/8 x 26 1/8 in.
(92.5 x 66.5 cm.).
Lisbon, Calouste
Gulbenkian Museum.
As with his earliest self-portrait, Degas depicted himself not as a painter but as a young gentleman. This unfinished painting reveals his intimate knowledge of the tradition of the Venetian Renaissance, in particular that of Titian, but the manner with which he is about to raise his hat is a modern, casual gesture.

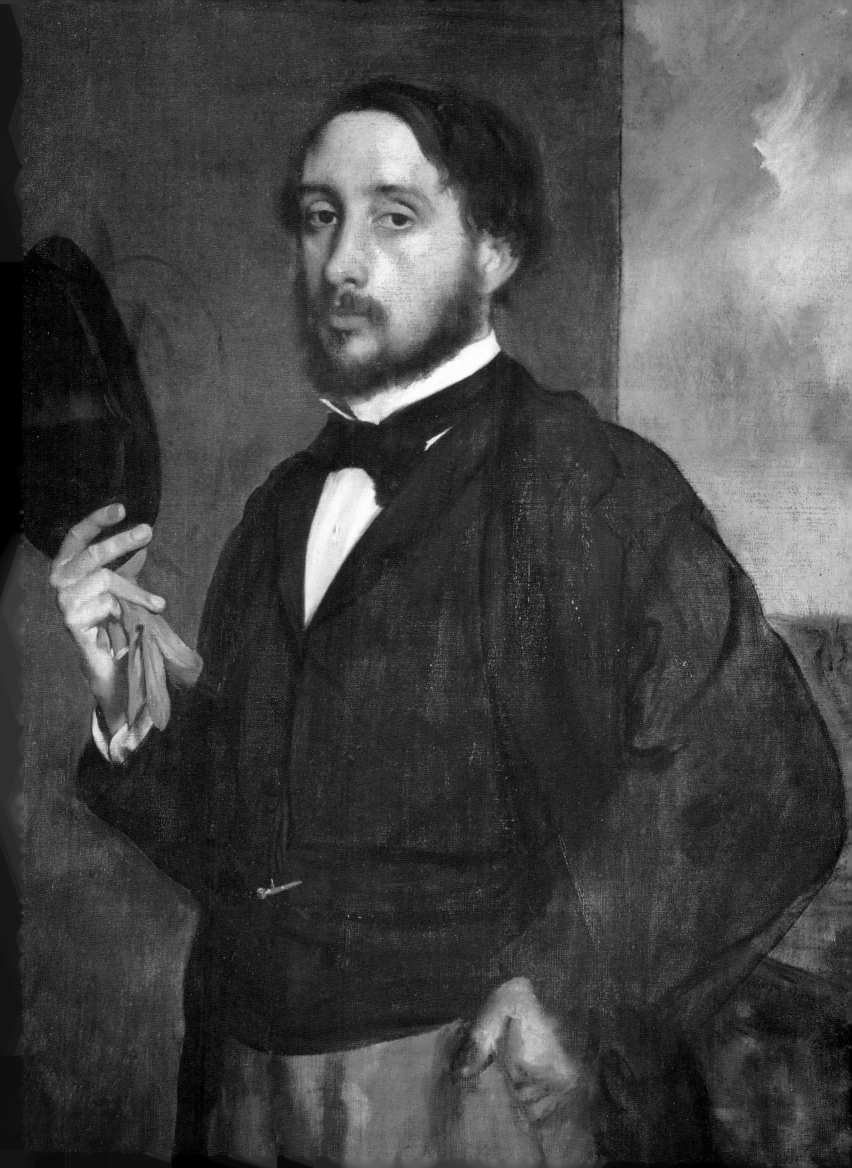

Portrait of Léon Bonnat

1862; *Oil on canvas;* 16 7/8 x 14 1/8 in. (43 x 36 cm.). Bayonne, Musée Bonnat.

Degas visited regularly the painter Léon Bonnat during his stay in Rome, where his painter friend spent two years between 1858 and 1860 thanks to a scholarship of his native town, Bayonne. Degas delivered this canvas to the sitter long after their relations had become more distant and their friendship had dissolved through a mutual lack of understanding.

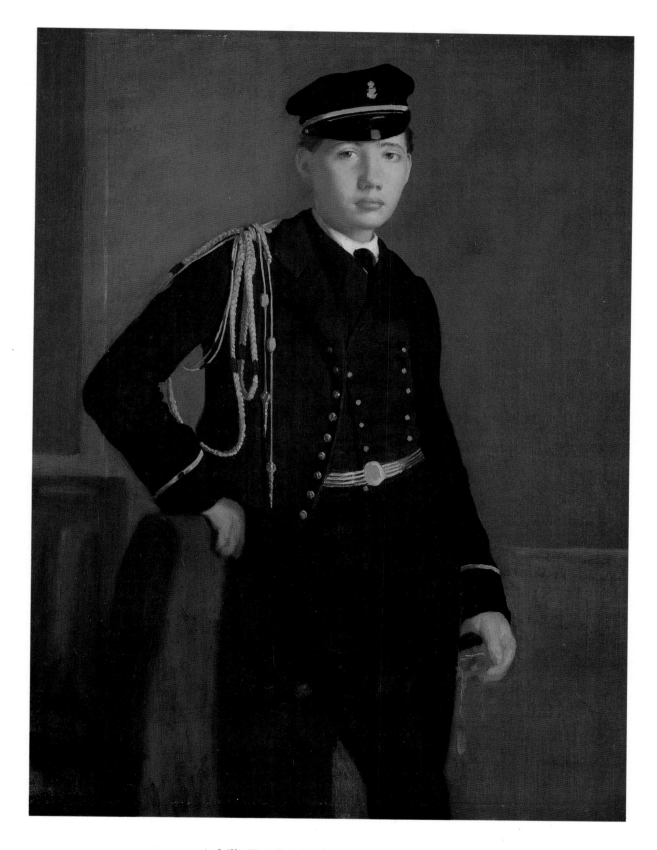

Achille De Gas in the Uniform of a Cadet
1859-1857; *Oil on canvas*; 25 3/8 x 20 1/8 in. (64.5 x 51 cm.).
© 1993 Washington, DC, National Gallery of Art, Chester Dale Collection.
*The artist's younger brother was painted in this striking midshipman's uniform when he was
a student at the Naval Academy. Of an unruly and impulsive nature, he resigned from the navy
and founded together with his brother René the firm of De Gas Brothers in New Orleans.*

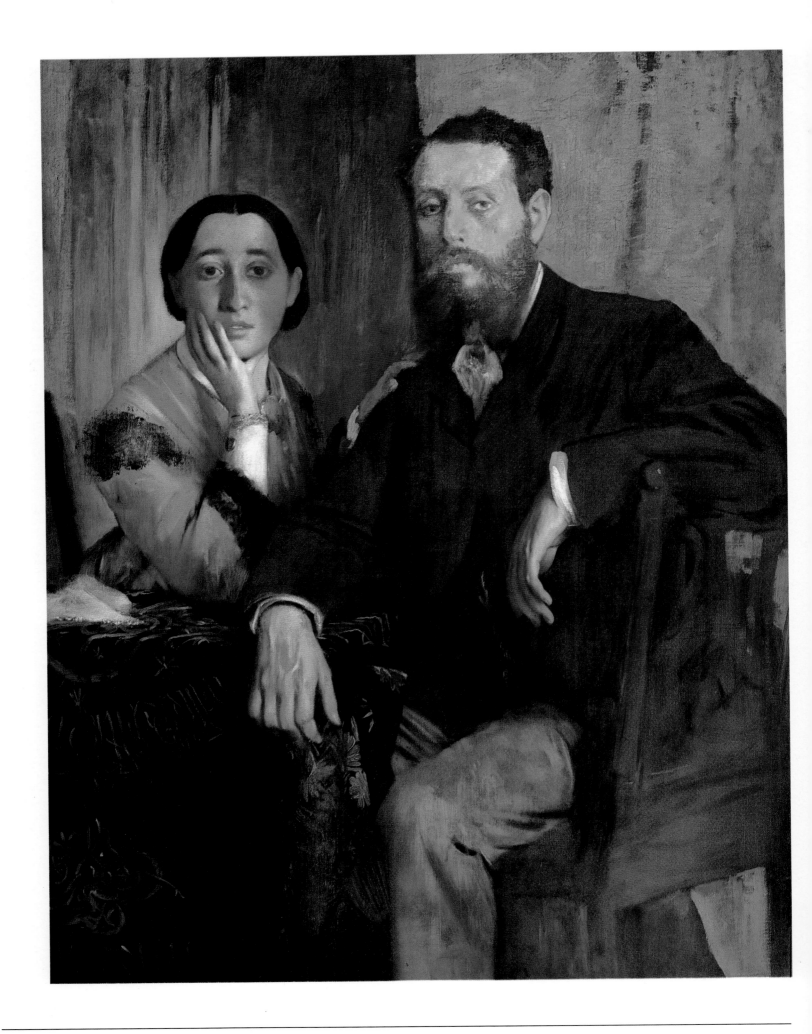

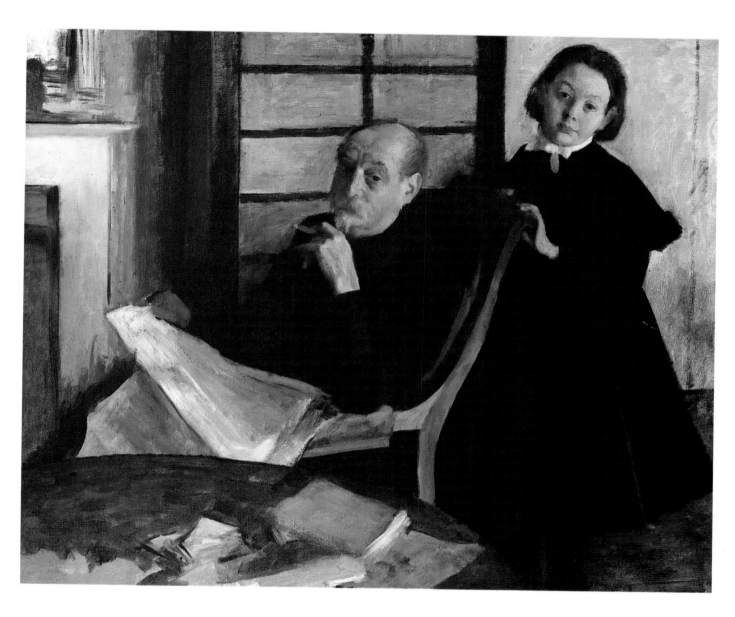

Henri De Gas and his Niece Lucie De Gas
1876: Oil on canvas; 39 1/4 x 47 1/4 in. (99.8 x 119.9 cm.).
Photograph © 1993, The Art Institute of Chicago.
All Rights Reserved.
Degas painted this portrait of his niece and his uncle in Naples in 1876. It was at this time that the girl, who had already been orphaned twice, had been placed into the custody of her uncle. The painting records one of the few peaceful moments in an otherwise stormy period of the girl's life.

Edmondo and Thérèse Morbilli
1865, c.; *Oil on canvas;* 45 7/8 x 34 3/4 in. (116.3 x 88.3 cm.).
Gift of Robert Treat Payne, II,
Courtesy Museum of Fine Arts, Boston.
The artist's sister Thérèse De Gas married Edmondo Morbilli, her first cousin from Naples, in 1863 with papal dispensation necessary because of their blood relations. Both of an unambitious character, they led a quiet and uneventful life. Attracted by their expressive features, however, the artist painted the couple several times.

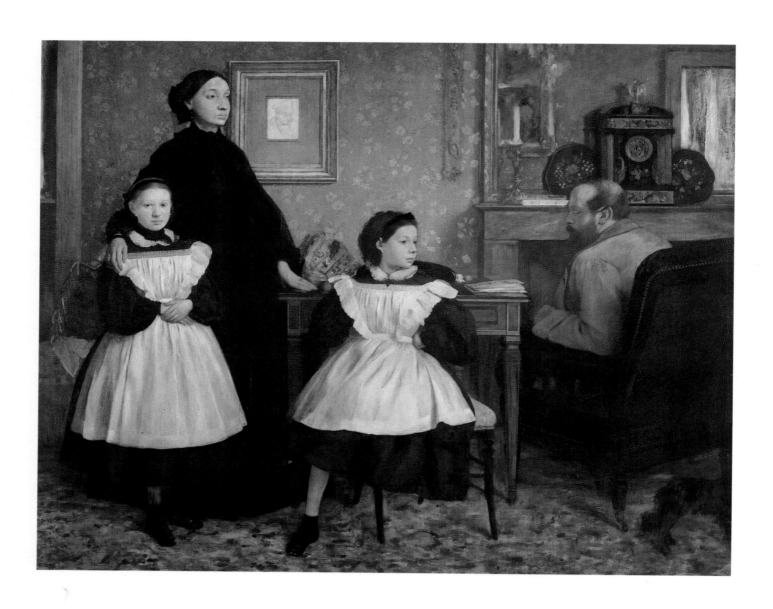

The Bellelli Family
1858-1867; *Oil on canvas;*
78 3/4 x 98 3/8 in. (200 x 253 cm.).
Paris, Musée d'Orsay.
*During his study period in Florence, Degas stayed
with the family of his uncle Gennaro Bellelli, who was
temporarily exiled from Naples. The lack of communica-
tion among the sitters reflects the tense relationships
between the family members. The painting, which was
preceded by years of preparatory studies and sketches,
was found in Degas's studio at the time of his death.*

The Collector Of Prints
1866; *Oil on canvas;* 20 7/8 x 15 3/4 in. (53 x 40 cm.).
New York, Metropolitan Museum of Art.
*This portrait of an enthusiastic, avid collector, bending over
a portfolio of drawings or prints, seems to represent the type
of connoisseur Degas was soon to become himself. The sitter's
sharp features, his piercing eyes and prominent nose, make him
one of those curious fanatics as described by writers like Balzac.*

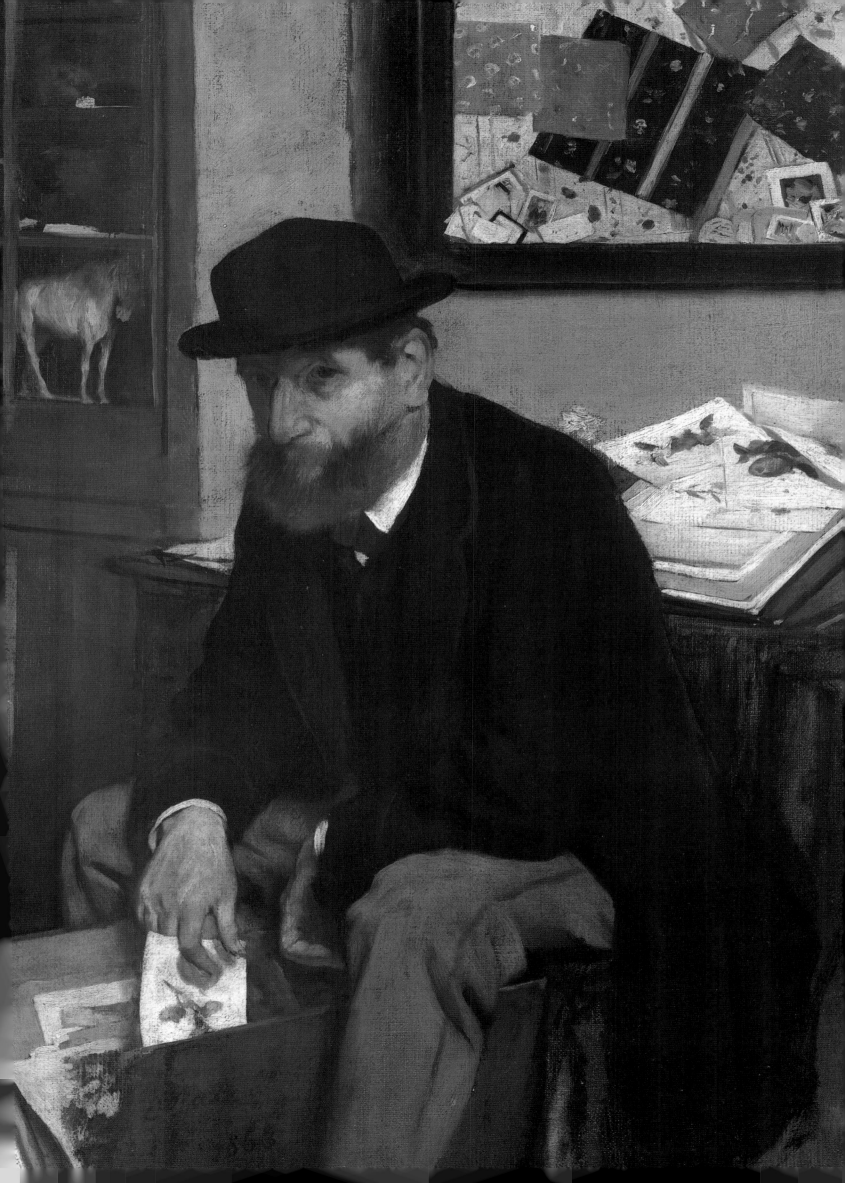

Hortense Valpinçon
1871; *Oil on canvas;*
29 7/8 x 43 5/8 in. (76 x 100.8 cm.).
Minneapolis, The Institute of Arts.
This little girl leaning over a
table with a piece of apple in her
right hand was the only daughter
of one of Degas's old schoolmates.
The still-life of a sewing basket
and an unfinished piece of embroi-
dery refers to the girl's mother,
who had made also the black
cloth with colorful floral motifs.

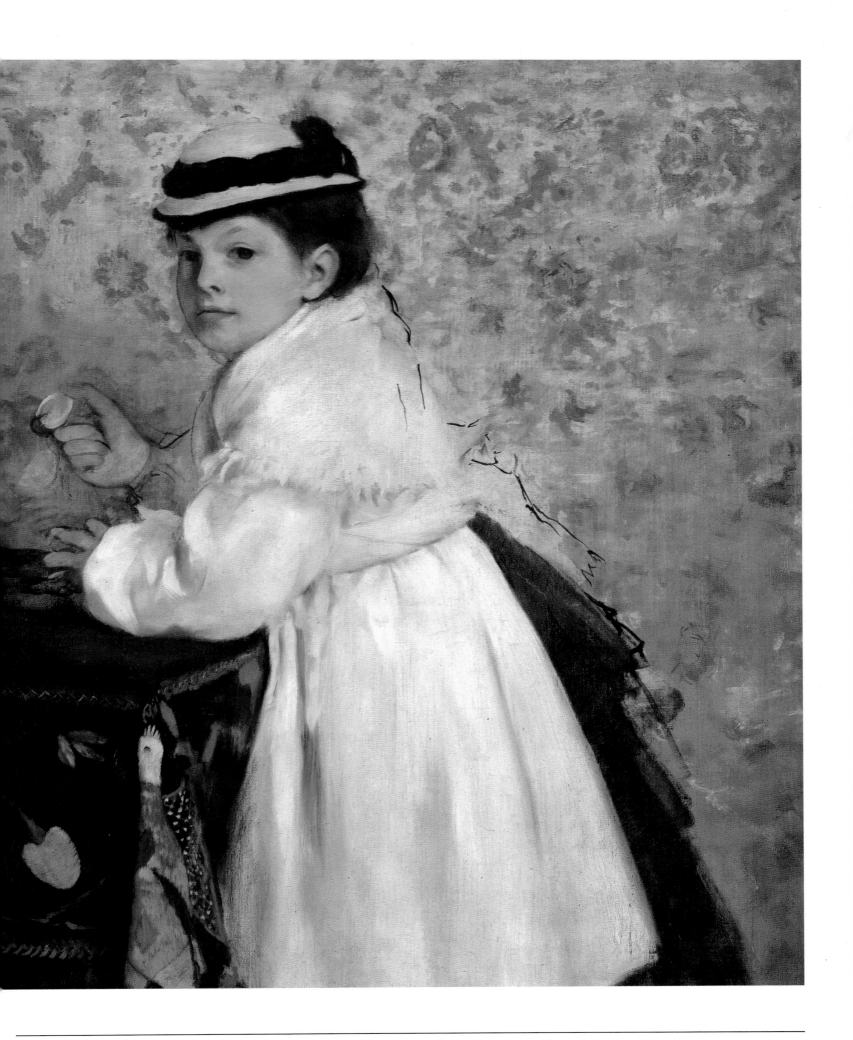

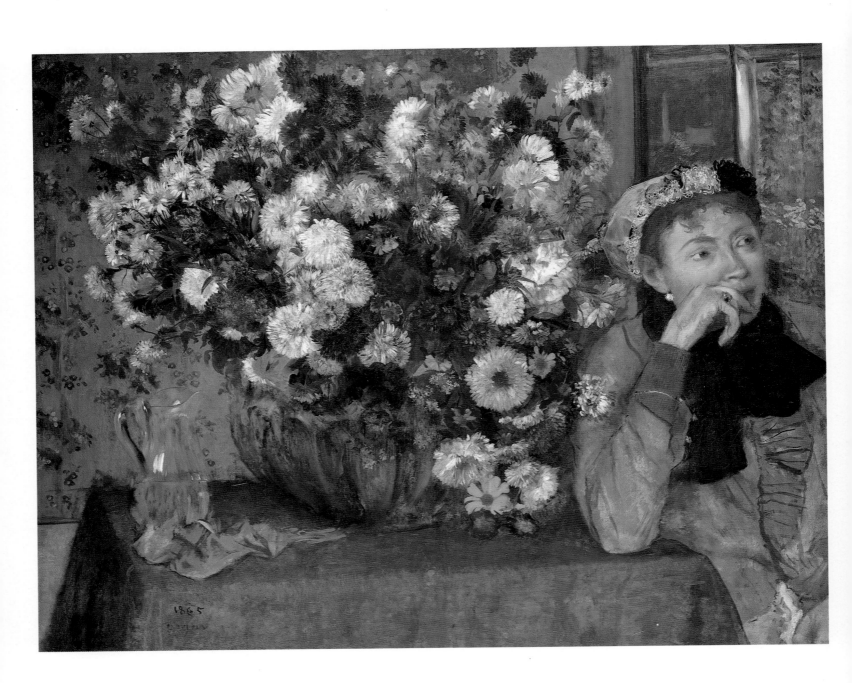

Woman With a Vase of Flowers

1865; *Oil on canvas; 29 x 36 1/2 in. (73.7 x 92.7 cm.).*
New York, Metropolitan Museum of Art.
Possibly representing the wife of his friend Paul Valpinçon, this portrait combined with an exquisite arrangement of freshly cut autumn flowers (asters, dahlias, and the like) is an extraordinary symphony of brown, purple, and white. The casualness with which the sitter poses on the right belies the carefully balanced composition of this painting.

Woman With Chinese Vase

1872; *Oil on canvas; 25 5/8 x 13 3/8 in. (65 x 34 cm.).*
Paris, Musée d'Orsay.
Painted shortly after the artist's arrival in New Orleans, this woman might represent Desirée Musson, the older sister of René De Gas's wife, Estelle. The exotic flower serves to accentuate the face, lit by a harsh light coming from the right, while one whole side has been cast in a shadow. A calm, pensive expression contrasts with the rather rough treatment of the surface.

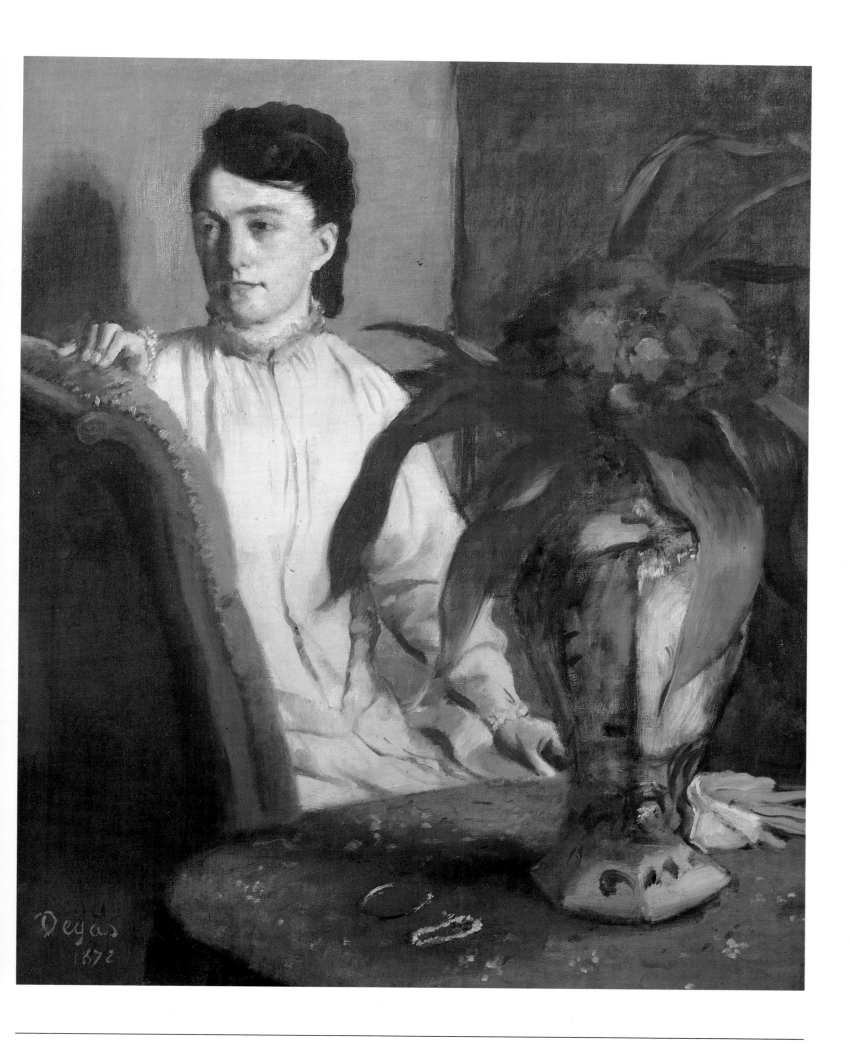

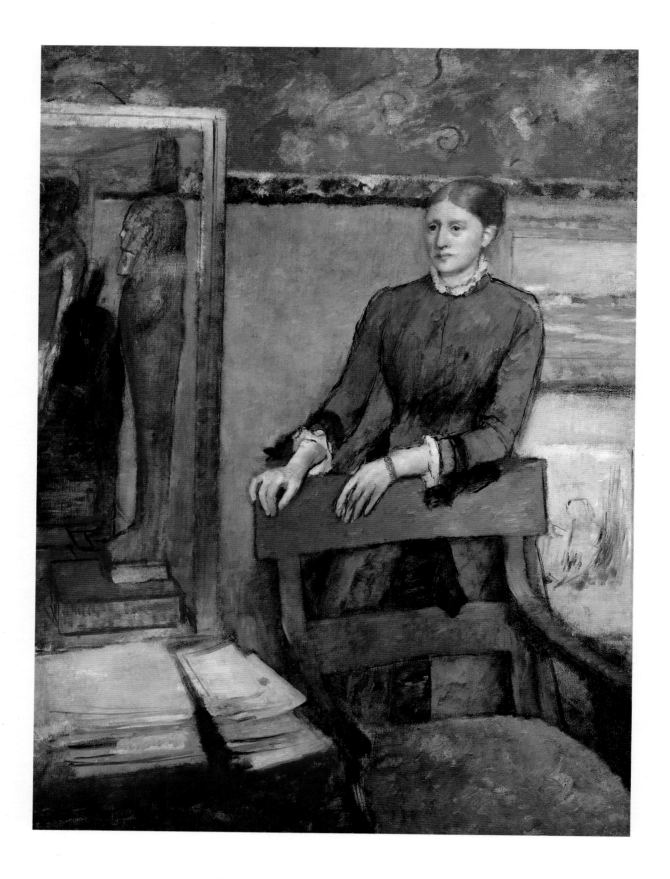

Hélène Rouart in her Father's Study
1886; *Oil on canvas;* 63 3/8 x 47 1/4 in. (161 x 120 cm.). London, National Gallery.
The daughter of one of Degas's high school friends, the painter Henri Rouart, is shown here in her father's studio in the Rue de Lisbonne in Paris. For years Degas was a regular dinner guest at the Rouarts, whom he once referred to as his only family "in France."

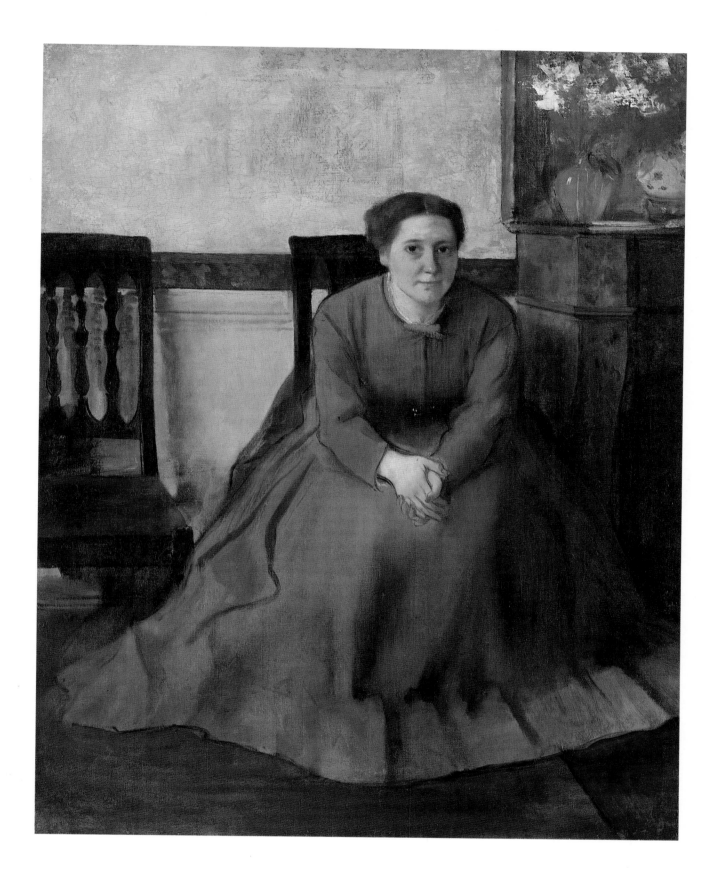

Portrait of Victoria Dubourg
1868-1869, c.; *Oil on canvas*; 32 x 25 1/2 in. (81.3 x 64.8 cm.). Toledo, The Toledo Museum of Art.
Victoria Dubourg was a still-life painter of a certain distinction. Degas focused on her intelligent face and
the folded hands on her knees, hinting thus to her profession as an artist. The empty chair to the left has
been interpreted as an allusion to her fiancé and later husband, the prominent painter Henri Fantin-Latour.

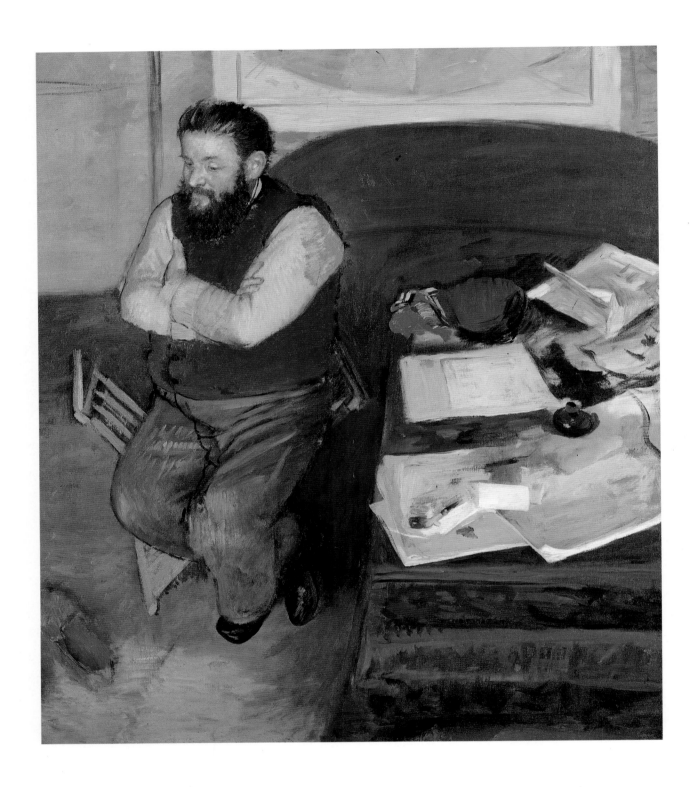

Diego Martelli
1879; *Oil on canvas*; 43 1/2 x 39 3/4 in. (110 x 100 cm.).
Edinburgh, National Gallery of Scotland.
A writer and art critic from Florence, Martelli
was a principal advocate of the Italian Impressionist
movement, called the Macchiaioli. During one of his
extended visits to Paris, he became friendly with
Degas, who depicted him from an unusually high angle.
This resulted in a sharp foreshortening of the scene.

Mary Cassatt
1884, c.; *Oil on canvas*; 28 1/2 x 23 1/8 in. (71.5 x 58.7 cm.).
Washington, DC,
National Portrait Gallery, Smithsonian Institution.
The American painter Cassatt presumably received this
portrait as a gift from Degas, who in turn acquired one
of her paintings. Many years later Cassatt expressed
her dislike of this portrait, perhaps because it shows her
holding tarot cards in the manner of a fortune teller.

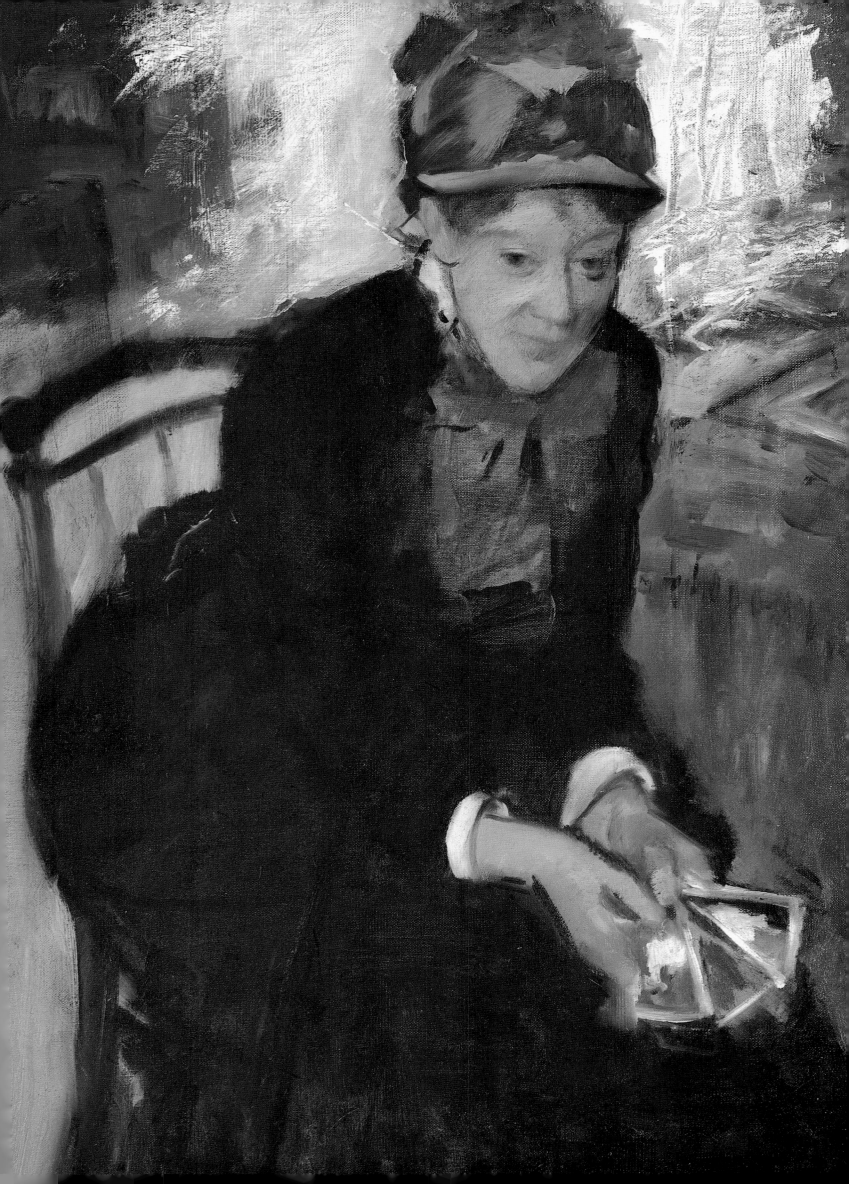

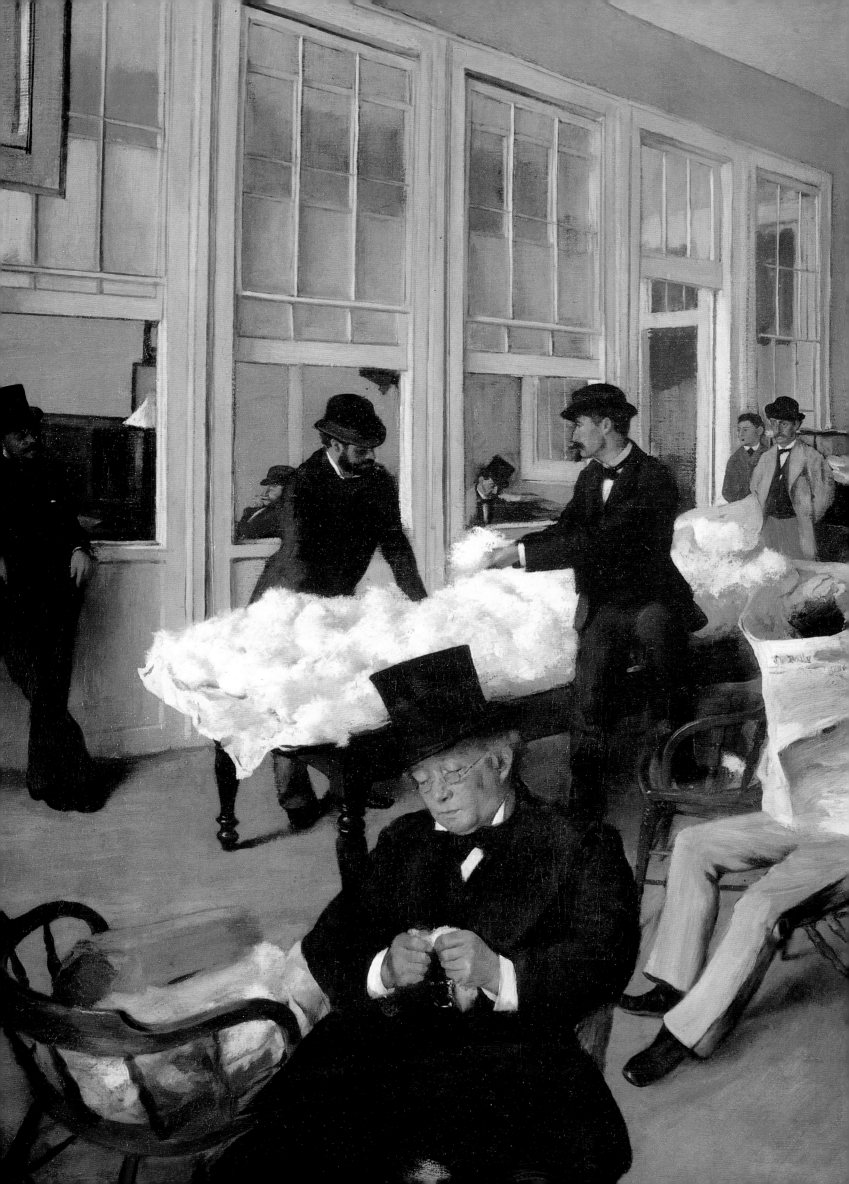

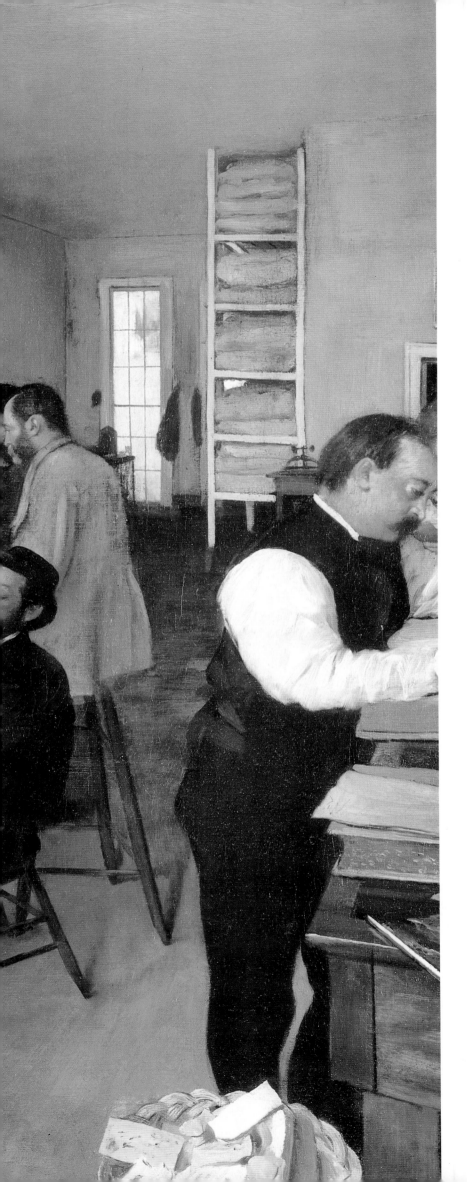

Interior of an Office in New Orleans
1873; *Oil on canvas;* 28 3/4 x 36 1/4 in. (73 x 92 cm.).
Pau, France, Musée des Beaux-Arts.
Edgar Degas's brothers, Achille and
René, had founded a cotton business
in New Orleans. Edgar painted this
work on a visit there, and its realism
and classic influences differentiate it from
most other works by the artist. It was
his first painting to enter a museum.

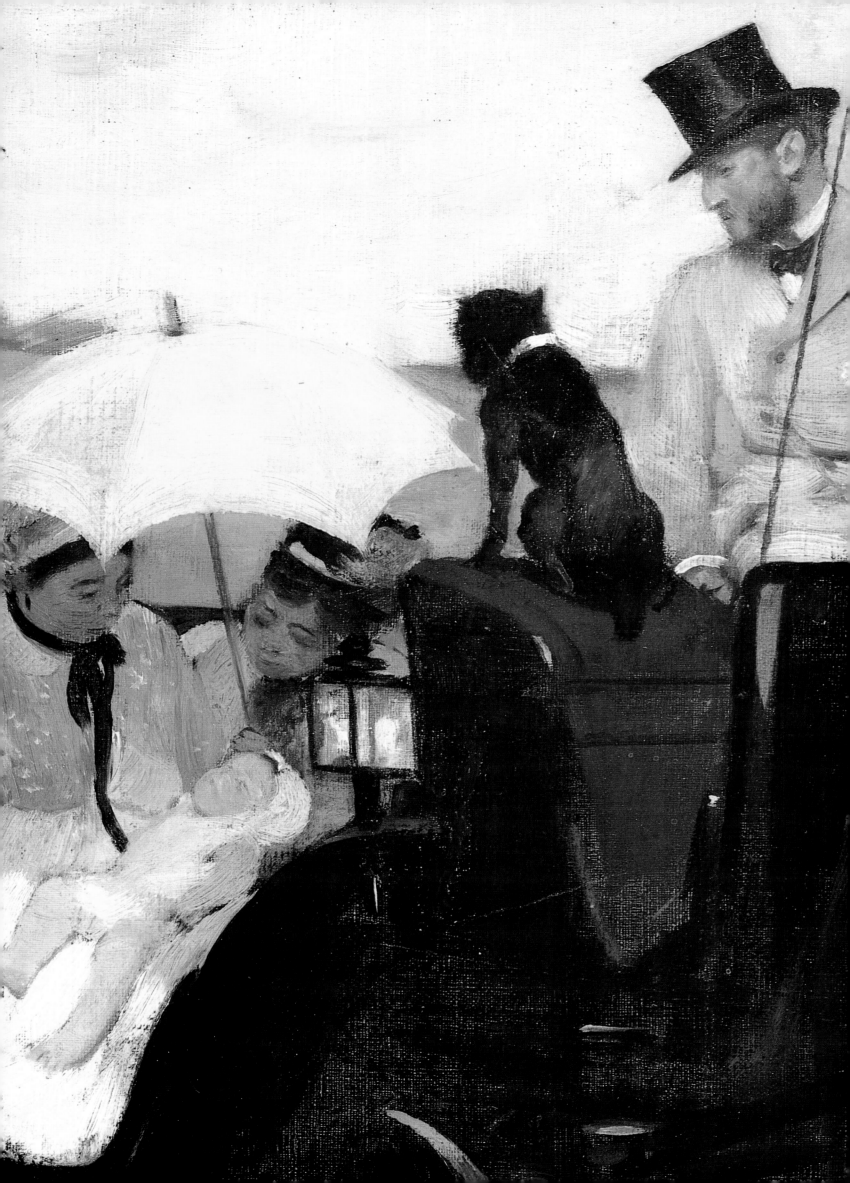

CHAPTER 2

THE OUTER WORLD

The outside world fascinated Degas just as much as the intimate circle of his family and friends. He dedicated the same attention and care to the depiction of events and places in the city and the countryside. Among these works, four major themes emerge: Horse-racing scenes, working women, history, and life in Paris.

Horse Racing

Contrary to the general belief, Degas demonstrated interest in horses very early in his career, when he was still in Italy. Notebook entries from the 1850s and 1860s show that he was not neglecting contemporary life and that racecourse scenes were already emerging as subject matter. During his stay in Rome he watched the traditional Roman horse races on the Via del Corso, which had fascinated Théodore Géricault. In fact, the artist made quick sketches of these horses while they were running frenziedly down the narrow street without horsemen. Upon his return to France, scenes of horses and jockeys appeared more frequently in his work. This was mainly due to visits to his friends the Valpinçons in Normandy, who had a summer estate at Ménil-Hubert, near a national stud farm and the Argentan racecourse. An exquisite little painting, *At the Races in the Countryside* is a memory of one of these excursions in the company of his friends. It was then that Degas, who was very much a city person, discovered the countryside and recorded his enthusiasm for it in letters to friends. The landscape reminded him of "England precisely. Pastures, small and large, enclosed by hedgerows; damp footpaths, ponds green and umber."

Degas was clearly influenced by English genre painting, in which horses proliferate. Yet Géricault's works, which he had copied in the Louvre after his return from Italy, were also influential. Curiously, his friend from those days, Moreau, also gave him a strong impetus in this direction. Although Moreau was actually a master of romantic mythological paintings, Degas listened to his older friend and turned his attention to a contemporary subject that he would not cease to explore for the rest of his life.

The blending of influences and interests gave rise to the first series of racecourse scenes, dating from about 1860 to 1862. *The Gentlemen's Race: Before the Start* is one of them, although it was considerably reworked by the artist about twenty years later, thereby changing its

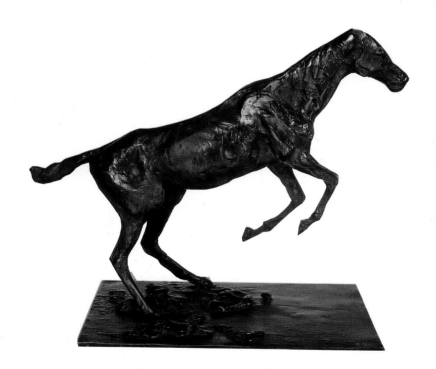

**Horse Balking,
erroneously called Horse Clearing an Obstacle**
1888-1890; *Bronze*; 12 1/8 in. (31 cm.) high. London, The Tate Gallery.
Degas had long been interested in horses and racecourse scenes. Stimulated by the example of his friend the animal sculptor Joseph Cuvelier and by photographs of horses by Eadweard Muybridge, Degas began to make small sculptures of horses in motion. These objects have a rather painterly quality with a richly textured surface.

Carriage at the Races
detail; 1869; Courtesy, Museum of Fine Arts, Boston.
The Valpinçon family were some of Degas's closest friends. When he visited them on their country estate in Normandy during the summer of 1869, he painted this family idyll centered around the newborn son Henri.

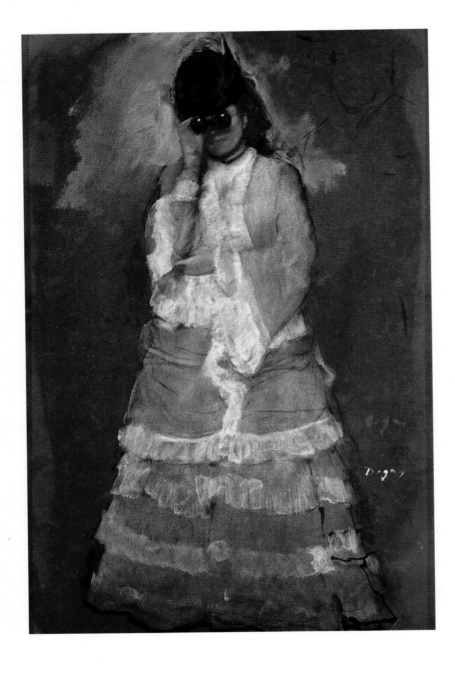

Woman With Field Glasses
1875-1876, c.; *Oil on cardboard;* 18 7/8 x 12 5/8 in. (48 x 32 cm.).
Dresden, Staatliche Kunstsammlungen, Neue Meister.
In this ironic image, the common relationship
between the viewer and the subject viewed is reversed.
Probably related to scenes of racetracks, this figure
was actually never included in any painting—possibly
because of its haunting quality. Degas gave this
work to his friend and fellow painter James Tissot.

character and style. The painter's hesitations and rework-ings account for a certain fuzziness in the horsemen and the originally flat landscape, which resembled that of English paintings, now includes hills and smokestacks of suburban factories. The lively colors of the jockeys' jackets and caps were largely imaginary, but they form a lively contrast to the leaden sky. In *Racehorses Before the Stands* Degas avoided almost completely any movement of the horses with the exception of one galloping in the dis-tance in an awkward anatomical position. Instead, he depicted a quiet moment before the race. The long shad-ows of an afternoon sun, the opaque quality of the paint—Degas used his special essence rather than oil—and an immobile crowd watching from the tribunes all contribute to the tranquil character of this work. There is nothing of the turbulence and excitement usually attributed to such a location, particularly as described by Zola in a famous passage of his novel *Nana*, in which he described a race-track as a "whirlwind of the most lively colors."

Years later, in 1897, Degas confided to a journalist friend that at the time of his early horse paintings his understanding of the mechanics of a horse's movements was very limited: "I knew infinitely less than any non-commissioned officer, who, because of his years of meticulous practice, could imagine from a distance the way a certain horse would jump and respond." However, Degas's incessant studies eventually provided him with the necessary knowledge. Reluctant to spend precious hours on the Champs-Elysée studying the mounted horsemen or the elegant carriages pass by, he began to model little wax sculptures of horses instead (as he would eventually also do with dancers). His unorthodox approach and handling of this material testifies to Degas's lifelong interest in experiments and technical progress. His sculptor friend Bartholomé was possibly a crucial stimulus. Degas also knew the achievements of the photographer Eadweard Muybridge, who had ana-lyzed photographically a galloping horse by stop-action photography. But it was not until after the publication of Muybridge's *Animal Locomotion* in 1887 that one finds clear evidence of Degas's interest in this technology.

After his return from New Orleans in 1873, Degas neglected the subject of horses for some time, but resumed it again more forcefully in the 1880s, when he probably perceived this genre as being more marketable. Once he had arrived at a successful composition, he would paint groups of closely related variations. He sold a number of them to dealers, in particular to Durand-Ruel, but also to Theo van Gogh, who purchased a work for his gallery at Boussod et Valadon.

The Racecourse, Amateur Jockeys, begun in 1876, but completed in 1887, was a work commissioned by the singer Jean-Baptiste Faure. In his typical fashion, Degas procrastinated with finishing the painting. Only Faure's

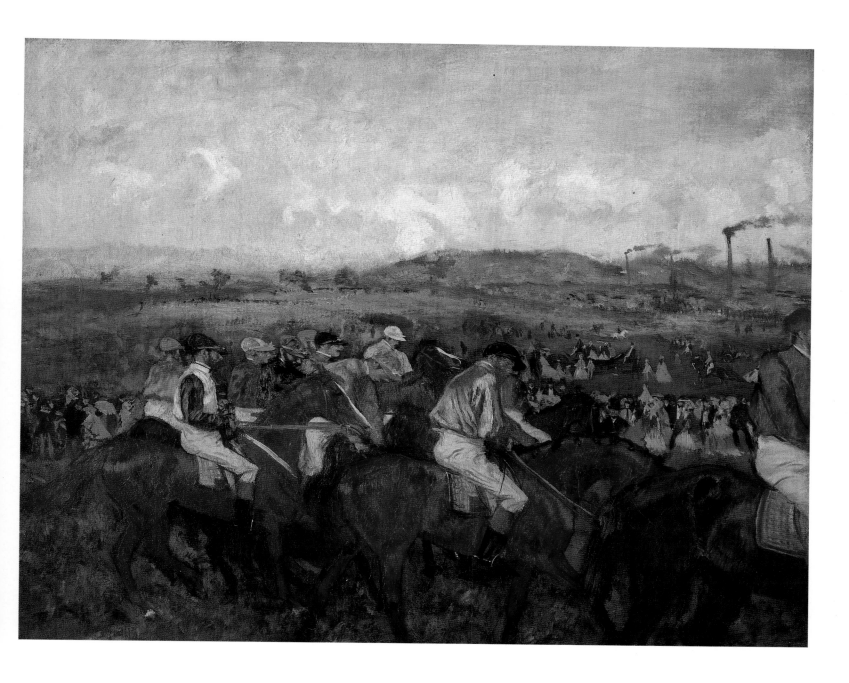

threat to seek legal recourse convinced Degas to surrender the work in 1887 after having reworked it extensively. X-radiographs show that originally a railing parallel to the picture plane ran across the foreground, with two figures leaning or standing in front of it. One of them may have been a woman with field glasses like the one of that same title displayed today in Dresden. The carriage on the right in the painting was introduced only after the railing and the other two figures had been eliminated. A witty element is the speeding jockey on the left, whose movement echoes that of the train in the distance puffing its white smoke. As it stands, the composition is among the most monumental and successful racecourse scenes by Degas. It represents perfectly Degas's understanding of rural diversions of urban citizens. The work also expresses an optimism for the coexistence of nature and technological progress of the machine age.

Perhaps the latest work on the subject of horses is *Fallen Jockey*, from around 1896 to 1898. Based on an earlier composition, Degas created a highly abstract scene of a riderless horse galloping across a meadow, while

The Gentlemen's Race: Before the Start

1862, reworked c.1882; *Oil on canvas;* 18 7/8 x 24 in. (48 x 61 cm.). Paris, Musée d'Orsay.

When Degas began to paint racecourse scenes, English painters and landscapes as well as English writers played a key role in the definition of this subject matter. In a friezelike arrangement jockeys are seen on their horses in the foreground; a crowd is scattered in the background; and smoke-stacks of a factory appear in the distance.

Leaving the Paddock

1866-1868, c.;

Pencil and watercolor on paper;
4 1/8 x 6 3/8 in. (10 x 16 cm.).
Boston, Isabella Stewart
Gardner Museum.
*Jockeys with their horses
are leaving the paddocks,
preparing for a race. The
one at the center is accompa-
nied by an attendant, while
several bystanders take little
notice of them. They are
awaiting the actual race
itself. This study might
have been planned for a
larger scheme, possibly an
oil painting, although
Degas never seemed to have
pursued this motif again.*

the jockey, apparently dead, lies flat with outstretched limbs on the grass underneath. Degas shows only the aftermath of the deadly jump, yet the event is no less clearly understood. The spare, epigrammatic treatment of the figures and the space strengthens the persuasive power of this painting.

Women at Work

Though not as celebrated a subject as the racetrack, Degas's thematic treatment of working-class women, in particular of laundresses and milliners, is just as compelling. All these scenes take place in interiors, although they are sometimes reduced to abstractions of bare walls. In the context of these works, the nature of Degas's relationship with women has regularly been discussed, frequently assuming that he had a misogynistic viewpoint. However, it should become clear by taking a closer look at his works that Degas cannot have intended to humiliate his subjects. They rather express dignity and self-esteem. In this respect, Manet's comment that Degas treated his models like "little beasts" cannot be upheld by evidence derived from his pictures.

The best-known painting of the milliner series is the one on display at the Metropolitan Museum of Art in New York, titled *At the Milliner's*. A woman is trying on a hat before a mirror, which cuts obliquely across the milliner's figure, thus concealing her almost completely. This extraordinary slicing of the composition serves to focus the attention on the young lady, who has come to the shop to find a new hat for herself. The contrast between the rather elegant and probably expensive hat and the customer's incomplete toilette—"hastily done in order to run to the milliner's," as a contemporary critic wrote—is noteworthy. The baggy brown jacket of her street dress, which is wrinkled at the skirt, is loosely topped with a simple cape. This has led some to speculate that she is a prostitute or kept woman. Another explanation for this discrepancy may lie with the identity of the model, the artist Berthe Morisot, who was known to have had a passion

for extravagant hats. Years later she admitted that she posed for Degas "once in a while when he finds the movement difficult, and the model cannot seem to get his idea." Whatever Degas's intentions might have been, he created in this figure the image of an independent-minded, energetic woman, fully assured of herself.

The most complex and elaborate version of depictions of millinery shops is the pastel in the Thyssen-Bornemisza Museum, also called *At the Milliner's*. Various materials and accessories are displayed in a lush arrangement on the table in the foreground. Behind it a woman, accompanied by a lady friend, is trying on a hat with a remarkably charming gesture and a questioning smile. The second woman is seen only from the back, and the outlines of her shoulders, arms, and hat alone describe her presence. This time no milliner is present, but the young woman seems again to be of a lower class. The detailed materiality of the hats bring to mind a humorous proposal Degas made to a retailer that he publish an edition of Zola's novel *Au Bonheur des Dames* with genuine samples of goods pasted in as illustrations—an eloquent example of Degas's sense of "reality," which was shared by the great novelist.

The largest and probably the last treatment of the milliner theme is the painting called *The Millinery Shop*, displayed at the Art Institute in Chicago. Here the composition has been noticeably simplified. The space has been enlarged and the number of objects reduced. A young woman is sitting at a table covered with several hat stands, her elbow placed carefully on the edge. Degas had originally intended to show in her a customer examining a new hat, but he changed his mind, switching the woman's identity from client to milliner. The bouquet of hats demands equal attention from the viewer. The one on the stand closest to the woman, topped with a garland of flowers, is floating like a crown or halo above her head. The large green ribbon echoes the position of her gloved arm.

All three paintings were executed in a relatively short span of time, between 1882 and 1886, which is the reason for their exceptional cohesiveness in the artist's oeuvre. They all contain some element of humor. Morisot reported that Degas once expressed his "liveliest admiration for the

Scene of War in the Middle Ages, erroneously called The Misfortunes of the City of Orleans
1863-1865, c.; *Essence on paper mounted on canvas; 31 7/8 x 57 7/8 in. (81 x 147 cm.). Paris, Musée d'Orsay. This work clearly is an allegory, in the tradition of enigmatic Renaissance paintings. Although the figures are dressed in a medieval style, the painting is probably related to Civil War atrocities in New Orleans, where northern soldiers, after capturing the city in 1862, treated the women with indisputable cruelty.*

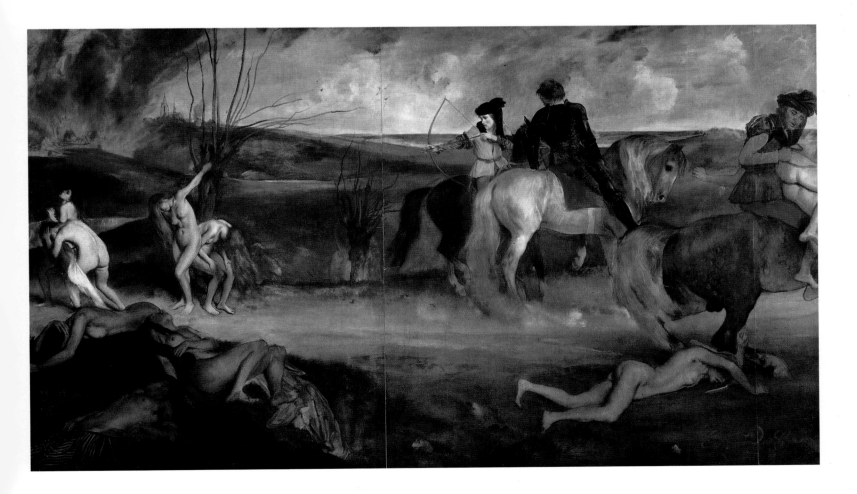

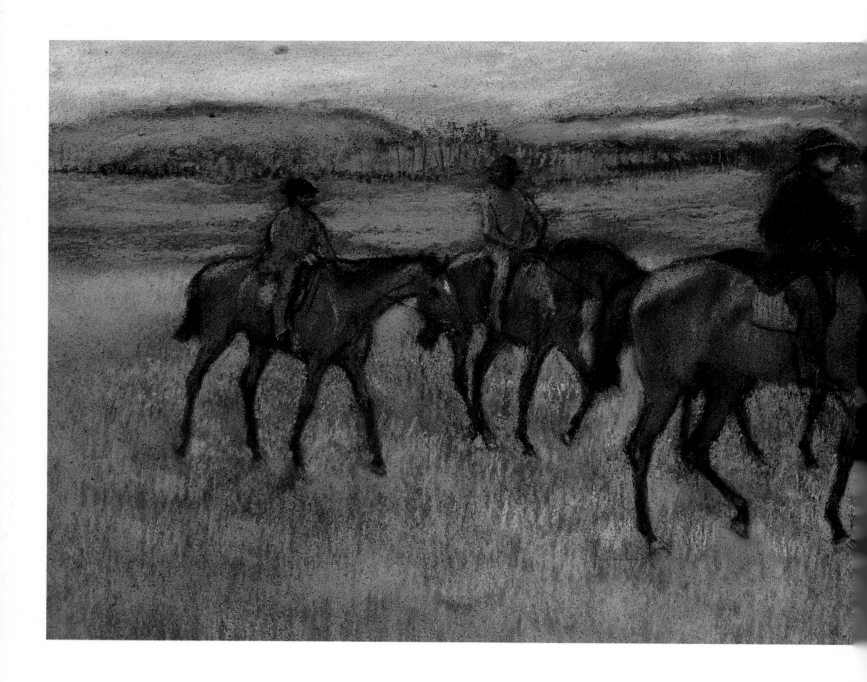

intensely human quality of young shop girls." By that he may have meant the elemental character of their very existence, which he so poignantly featured in his works.

Degas imbued the same kind of respect in his paintings of laundresses, although occasionally paired with an obtrusive intimacy. The most famous and striking example of this group is *Ironing Women*. Caught at a moment of total obliviousness to possible onlookers, the laundress on the left is seen in an audacious, even embarrassing gesture of yawning, which tellingly epitomizes the joyless boredom of her activity. The remarkable novelty of this motif is paralleled in the unique technical handling of the painting. Degas worked on an unprimed canvas (even more unusual is its particularly coarse weave), doubtlessly seeking to obtain the same richly textured surface structure as that found in his pastels. To that end he applied the paint

very dry, dragging it across the rough fabric, thereby achieving a chalky effect, which has lost nothing of its vibrancy since the work has never been varnished. The textures of the various fabrics, such as the scratchy yellow shawl around the woman's neck or the linen shirt that the other laundress is ironing— a gesture that was turned two decades later into an icon of misery by Picasso—are made palpable to the eyes. Even the glazed surface of the terra-cotta bowl on the table is distinguished by a subtle reflection of light. The proximity of the figures to the foreground is characteristic of other works from the mid-1880s, such as the milliners.

A more serene interpretation of the same subject is the painting entitled *Woman Ironing*, in the collection of the National Gallery of Art in Washington, D.C. A brightly lit room with large windows is filled with laundry hanging

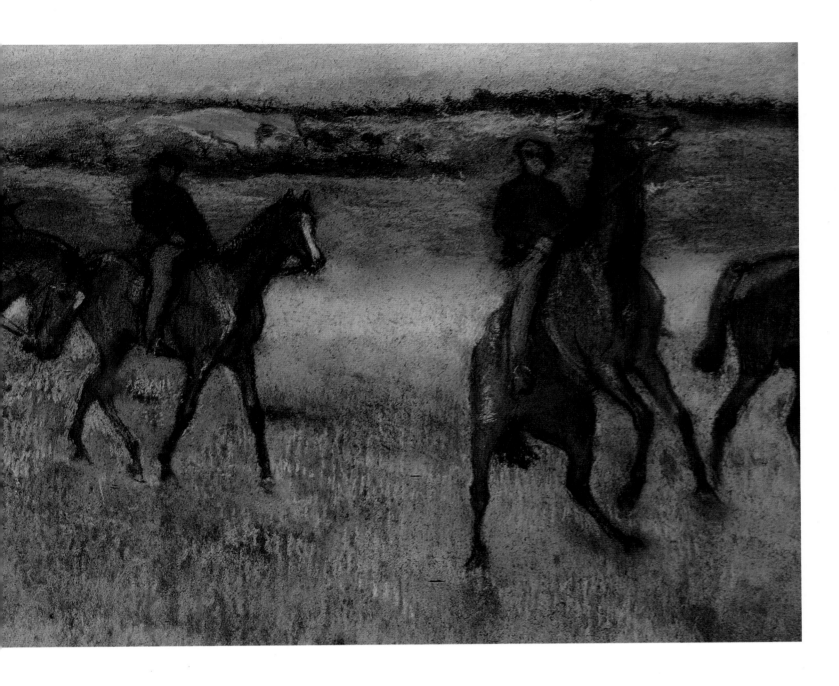

from the ceiling to dry. Degas obviously enjoyed the play of light filtered through a translucent cloth, achieving an effect of transparency. A freshly pressed white dress shirt has been neatly placed on the table next to the starched handcuffs, while another shirt is being ironed for the same customer. The healthy, naturalistic tone of the woman's flesh and the colorful dotted blouse make her look more prosperous than her two counterparts in the work discussed previously. Degas gave her an individualistic expression and even an earring as adornment. The reason for this change of atmosphere might be that Degas painted this canvas for his patron Faure in exchange for an earlier work by him depicting the same subject.

Another example of the same theme, also entitled *Woman Ironing* (this one displayed in Liverpool at the Walker Art Gallery), was painted about a decade later. This time Degas chose a much closer viewpoint for a canvas of the same size. The result has a somewhat claustrophobic feeling. The room has only a narrow opening or window on the left, and the figure is squeezed in between an ironing board and the picture

Exercising Racehorses
1880; *Pastel on paper;*
14 3/8 x 34 3/8 in. (36 x 86 cm.).
Moscow, Pushkin Museum of Fine Arts.
A group of jockeys is taking horses out for exercise. The outdoor scene is relaxed and includes long distance views. Degas had been particularly interested in horses since the 1860s.

frame. Her face is virtually abstract. Harsh, broken lines of black paint outline her arms and back. The overall impression is less ingratiating than in the previous work, but her presence is not without an aura of charm and warmth.

History Paintings

The small group of paintings with historic subjects has never found the same popularity as Degas's other works. They were and sometimes still are perceived as failures or inadequate solutions to an old-fashioned genre. Degas himself certainly did not think that way. He labored over these works extensively, making numerous studies and oil sketches, and he showed his fondness for them even long after he had abandoned this subject. He never disowned any of his youthful works. Yet, it is also true that none of these paintings are considered finished, apparently because the artist himself did not seem to have known exactly where he wanted to go.

From the seventeenth century onward, history painting had been regarded as the noblest form of art, and the academic training of young artists had been focused around this genre. But by Degas's time, history painting was in a deep crisis and even pronounced dead by some. Arduous exhumations of the past by such artists as Gérôme and other neo-Greeks—with their attempts to reconstruct a "true" history—had led to a stifling and artificial atmosphere that made any innovative reform impossible. The thorny issue of history painting was a complex one, although it is hard to imagine its importance today.

Degas, however, saw a challenge in this crisis. He did believe that history painting was dead and searched instead for ways to modernize the field. For him salvation had to be sought in a different and resolutely contemporary truth. He wanted to imbue history painting with new color, subjects, and modes of execution. As Degas's friend the writer Edmond Duranty wrote, "the

At the Milliner's
detail; 1882; Madrid, Thyssen-Bornemisza Museum.
This detail exemplifies Degas's mastery in rendering the qualities of materials with a seemingly unlimited variety of textures and colors. The use of pastel rather than oil allowed for a constant reworking.

flame of contemporary life" could illuminate the ancient past. In *Semiramis Building Babylon*, the artist achieved a fresh solution to a historical subject. Semiramis, accompanied by various warriors and attendants, is standing on a terrace, surveying the construction of Babylon, the city she has founded on the river Euphrates. Degas drew his information primarily from descriptions by classical writers, but he also took certain details from Assyrian works, which had recently been purchased by the Louvre. His notebook entries reveal the diversity of his sources, including Egyptian and Persian wall paintings as well as works by early Italian Renaissance artists, then called "Primitives." The city view in the distance, for example, is inspired by Italian landscape paintings of the fourteenth and fifteenth centuries.

Degas opted for simplicity, bareness, and rigor, rejecting the tinsel and decoration of Moreau, who at times would overload his images with unlimited jewelry. Learning from the example of the old masters and translating antiquity carefully into a contemporary idiom, Degas had found another reality, "truer" than the laborious reconstructions of his predecessors. Interestingly, this painting is also an implicit criticism of contemporary town planning. Degas's Babylon, with its borrowings of Italian architecture, stood in direct opposition to the sweeping modernization plans of Baron Haussmann in Paris, where entire historic quarters were demolished to make room for large boulevards and modern tenement blocks.

Around the same time, Degas also painted *Young Spartans*, another ambitious canvas concerning a classical subject. The choice of this unusual topic might have resulted from the artist's frequent reading of classical authors. The athletic world of ancient Sparta, where both young men and women would exercise to prepare for possible wars with enemies, was indeed unique in history. Degas decided to abandon specific references to classical Greece, avoiding any archaeological detail. The faces of his boys and girls have been recognized as commonplace faces of the children in the streets of Paris. The triangular composition, the bare setting, and the muted palette were considered a new and decidedly modern approach to a historical subject.

More an allegory than a history painting is *Scene of War in the Middle Ages*, a work whose meaning has been difficult to decipher. The violence against women committed by invading soldiers in New Orleans during the Civil War would seem to be the source of inspiration for this scene. Degas transplanted the accounts of atrocities into the Middle Ages—with all its attendant barbarism—although the costumes of the riders are not historically correct. The work was executed rather quickly, without the usual hesitations. Later, Degas showed less fondness for this painting than for his other history scenes.

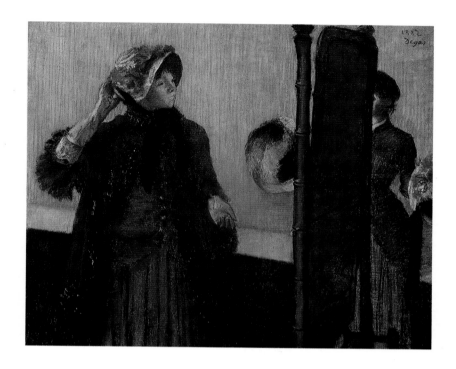

At the Milliner's
1882; *Pastel on paper*; 29 3/4 x 33 3/4 in. (75.6 x 85.7 cm.).
New York, Metropolitan Museum of Art.
Lost in a moment of reverie, a woman tries on a hat that she has apparently long coveted in a shop window. The mirror partially conceals the milliner from view.

Capturing Paris

Even when Degas looked back into history, he never forgot about the present and the city in which he lived. Street scenes, coffee houses, public spaces, even people's homes were subjects he frequently treated with great psychological insight. In *The Absinthe Drinker* he depicted the touching scene of a simply dressed woman in a café, who is sitting in front of her absinthe-filled glass. The man to the right smoking a pipe is looking out of the picture, without paying any attention to his companion at his side. The sad expression on their faces, the bleakness of the café interior, and the lack of any distraction make this a compelling image of the misery of the lower classes, who hope to find some relief from their daily burden in a glass of alcohol. The "slap-dash" manner and the "very disgusting novelty of the subject" was criticized at the painting's first public presentation in London.

An even greater uproar was caused by *Women on the Terrace of a Café in the Evening* when it was shown at the third Impressionist exhibition in Paris in April 1877. Degas had dared to depict prostitutes chatting on a

boulevard café, a subject which, though certainly not uncommon to encounter in the streets of the city, shocked many visitors of the show because of its frank portrayal of the subject and its acute observations of human behavior.

Another slice of life comes with the painting *At the Stock Exchange*. Degas was fairly well connected and had numerous contacts to wealthy business people. One of them was the financier Ernest May, who collected works by Manet and the Impressionists as well as those of Degas. In this work, the bespectacled May is portrayed at the center reading a document. Although the painting is unfinished, it provides a clue to the lifestyle of a Parisian businessman and the chaotic, noisy environment of the stock trade at the time.

Degas also displays his talent for sharp observation of human behavior in *Interior, or The Rape*, created from 1868 to 1869. The painting has long been admired for its masterly execution and superb treatment of light, but even more so for its unprecedented presentation of human tragedy. Insufficiently veiled by the charm of a proper bourgeois bedroom, a dramatic, even enigmatic,

situation is in progress. The man, his back to the door, is staring with indifference into the void. A young woman is seated with her back to the intruder in a pose of abandonment. Two objects in the room take on considerable significance, the bed and the table with the lampshade. Clothes are strewn about and the gaping box on the table shows its interior in disarray.

The title's words, *The Rape*, are surely an afterthought, and Degas himself called his work an interior. The subject is probably based on a scene in the novel *Thérèse Raquin*, by Émile Zola, in which two lovers, now married after having murdered the woman's first husband, meet a year later for their wedding night. But the painting should not be read as a mere illustration from the book. In fact it is deliberately an ambiguous canvas, filled with meaning. Certainly, Degas intended to show a woman, who having lost her virginity—masterfully expressed in the symbol of the open box with its pink lining—is left alone with her emotional turmoil. The "intruder," a young bourgeois gentleman, demonstrates total indifference to her conflict. Here, Degas has exposed the cruel and bitter aspects of a human relationship.

At the Stock Exchange
1878-1879, c.; *Oil on canvas;*
39 3/8 x 32 1/4 in. (100 x 82 cm.).
Paris, Musée d'Orsay.
Commissioned by the successful financier Ernest May, the painting shows him at the Paris stock exchange, reading a document handed to him by an usher or a secretary. Though seemingly chaotic, this scene is actually grounded by architectural elements in the distance.

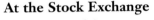

Interior, or The Rape
detail; 1868-1869; Philadelphia, Museum of Art,
The Henry P. McIlhenny Collection,
in Memory of Francis P. McIlhenny.
The still-life sewing box under the lamp, which sheds a soft light on the table and the room, is painted with utmost accuracy for the quality and texture of the materials involved. Rarely would Degas achieve similar effects later in his career.

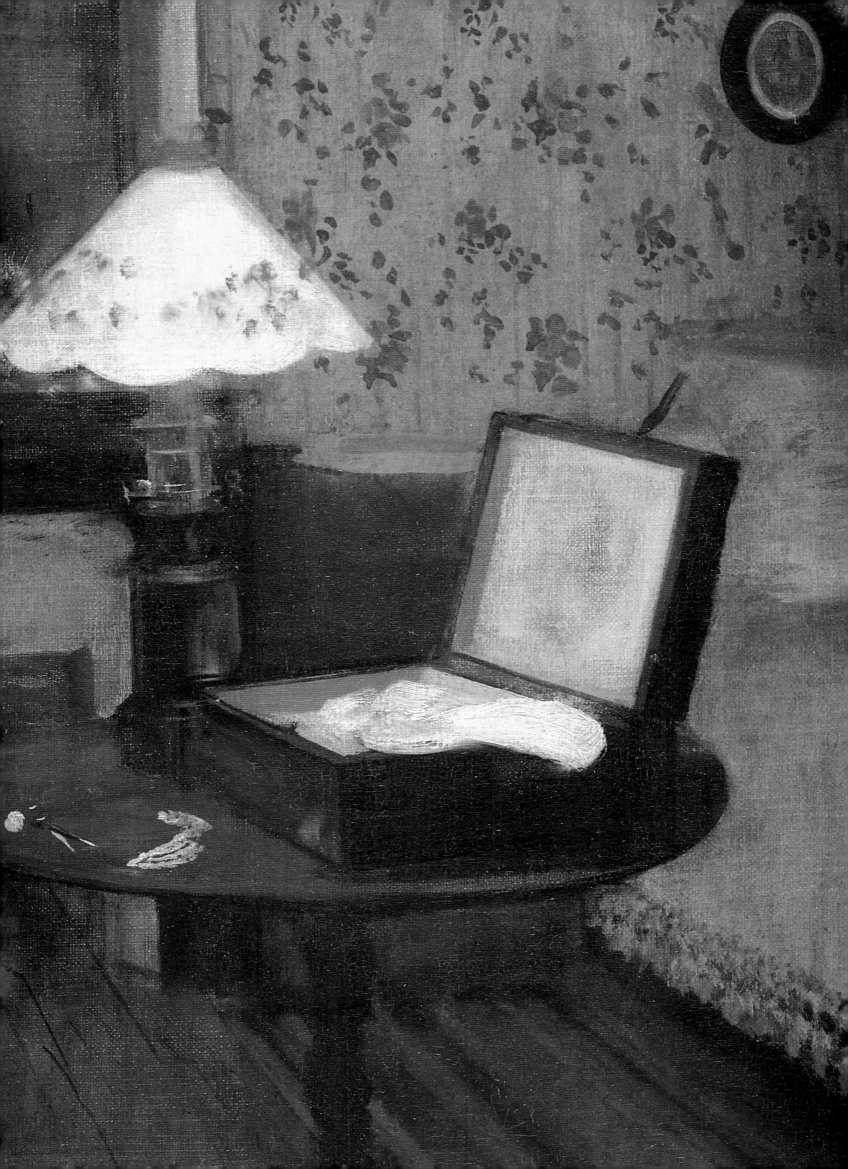

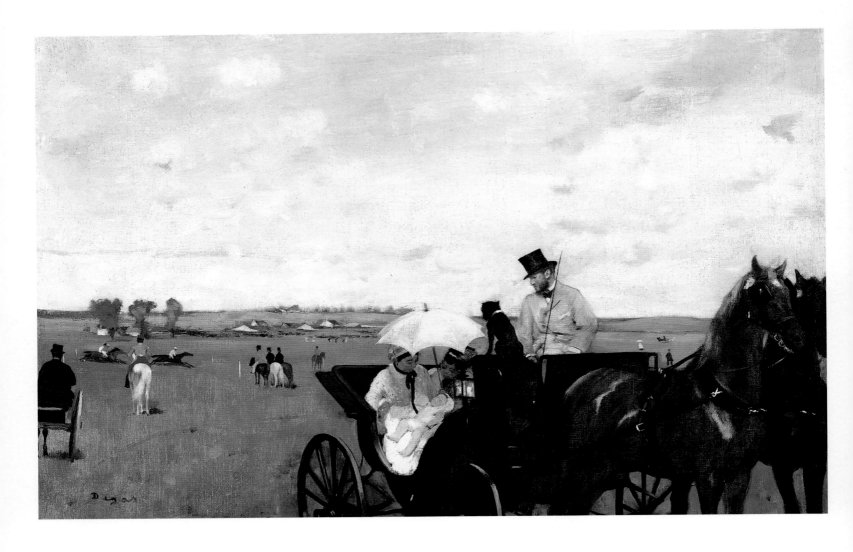

Carriage at the Races

1869; *Oil on canvas;* 14 3/8 x 22 in. (36.5 x 55.9 cm.).
1931 Purchase Fund. Courtesy, Museum of Fine Arts, Boston.
*The family in the carriage is that of Degas's friends, the
Valpinçons. During the artist's visit to their country estate
in Normandy, they all went to the horse races at Argentan—
a flat, melancholy plain nearby. The attention is focused on
the baby, Henri, resting under an umbrella on his mother's lap.*

Racehorses Before the Stands

1866-1868; *Essence on paper mounted on canvas;*
18 1/8 x 24 in. (46 x 61 cm.). Paris, Musée d'Orsay.
*Its great popularity notwithstanding, the painting's history
remains largely a mystery. Neither can the location be
clearly identified. The long shadows cast by the horses
and their jockeys seem to indicate a late spring or summer
afternoon. The calmness of this scene reveals nothing of
the excitement usually associated with this type of location.*

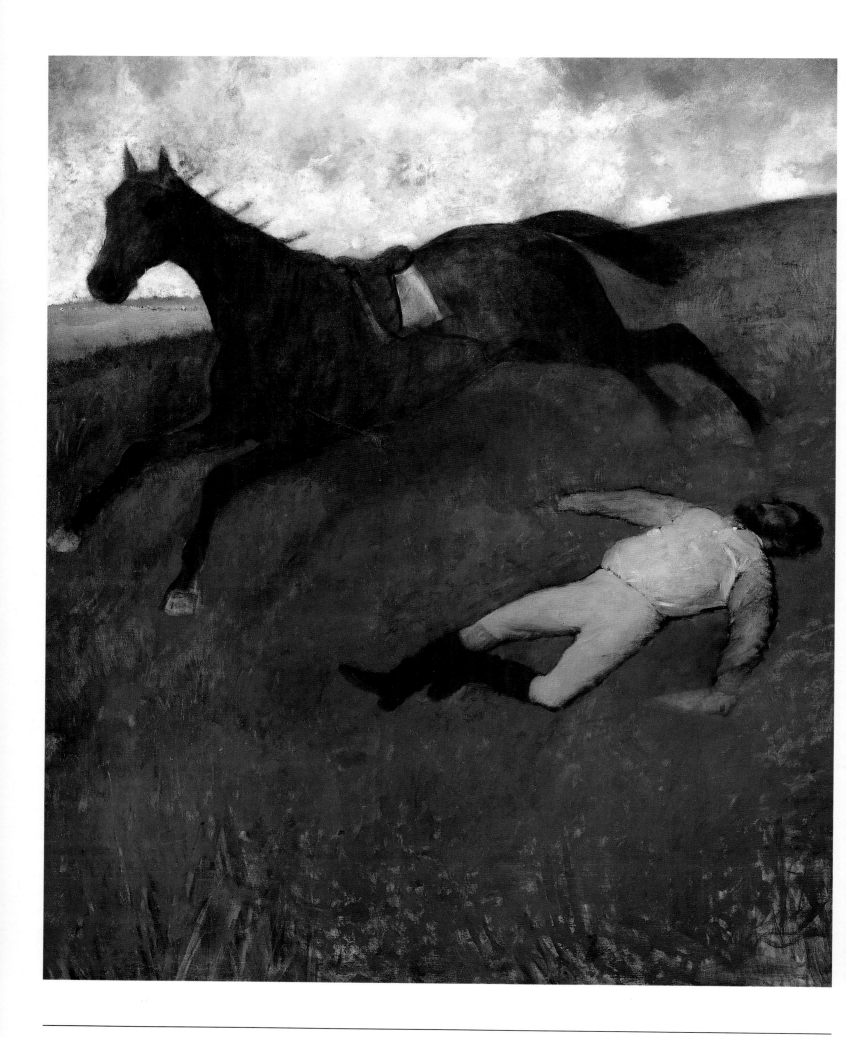

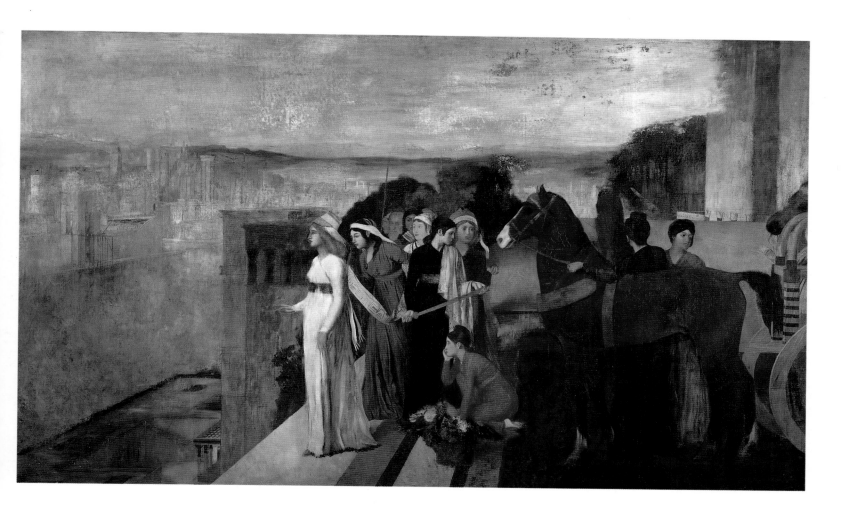

Semiramis Building Babylon
1860-1862, c.; *Oil on canvas*; 59 x 101 5/8 in. (150 x 258 cm.).
Paris, Musée d'Orsay.
Degas's history paintings are few, but the artist always showed
great fondness for them. Semiramis, accompanied by attendants,
ministers, and warriors, is standing on a terrace looking over
the construction of Babylon, the city she founded along the
Euphrates River. The figures and other details were inspired by
Assyrian reliefs, which had recently been acquired by the Louvre.

The Fallen Jockey
1896-1898; *Oil on canvas*; 71 1/4 x 59 1/2 in. (181 x 151 cm.).
Basel, Oeffentliche Kunstsammlung, Kunstmuseum.
A frightened runaway horse bursts through the picture,
which has been enlarged to almost heroic proportions.
The forthright treatment of this apparently fatal
horse-riding accident is a scene from "real" life.
The abbreviated, almost abstract landscape is defined
only by the declining line of a hill and the cloudy sky.

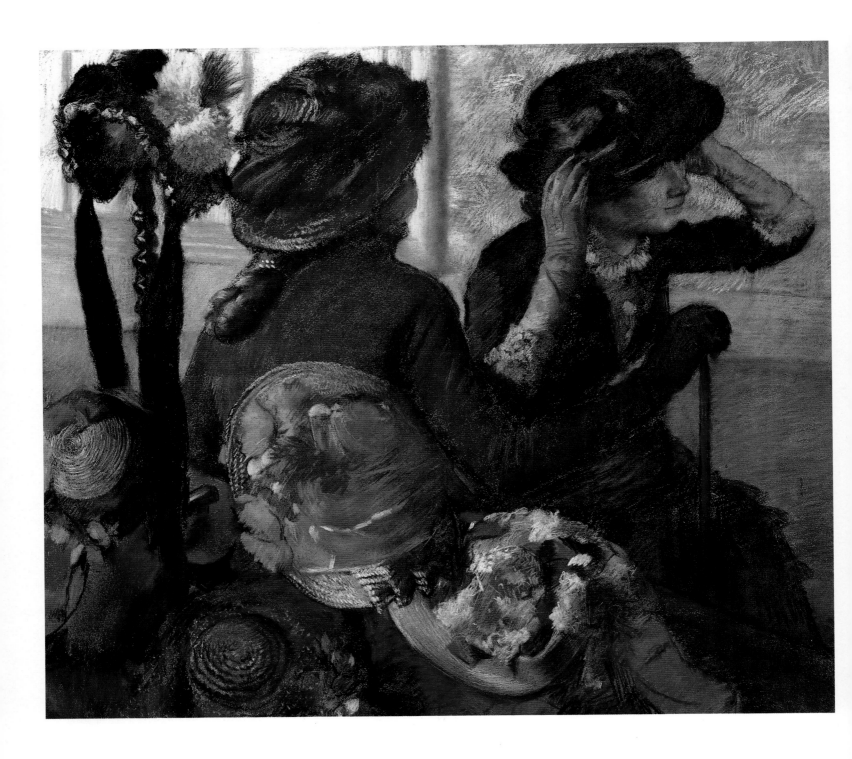

At the Milliner's
1882; *Pastel on paper;* 29 7/8 x 33 3/8 in. (75.9 x 84.8 cm.).
Madrid, Thyssen-Bornemisza Museum.
*This is the most splendid of Degas's milliner pictures and the first
to be shown in public, in London. With unsurpassed brilliance, Degas
painted the forefront with various hues to convey the textures and
brilliance of silk, feather, satin, and straw. The structural hinge of the
composition is the strong diagonal of the table, but the depth of space
is made more suggestive by the gilt-framed mirror on the back wall.*

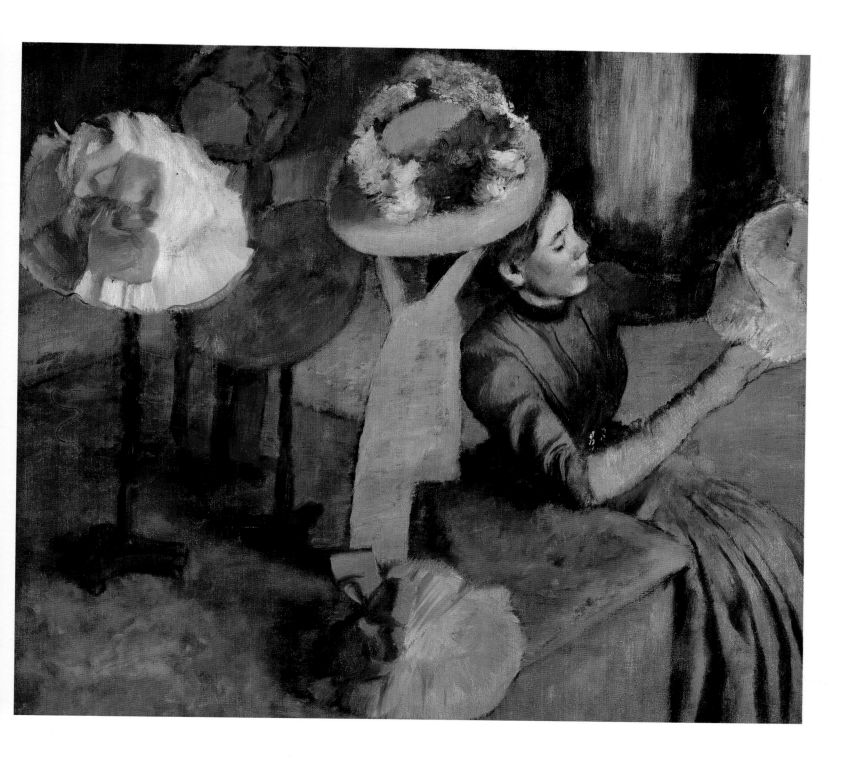

The Millinery Shop

1882-1886, c.; *Oil on canvas*; 39 1/8 x 43 1/2 in. (100 x 110.7 cm.).
Photograph © 1993, The Art Institute of Chicago. All Rights Reserved.
*It is likely that the young woman in this millinery shop
is actually a salesperson rather than a client looking to
buy a hat. The composition develops around the woman's
elbow, which is set on the corner of the table, where several
other hats are on display. The artist chose an elevated
vantage point, from which he looked down onto the scene.*

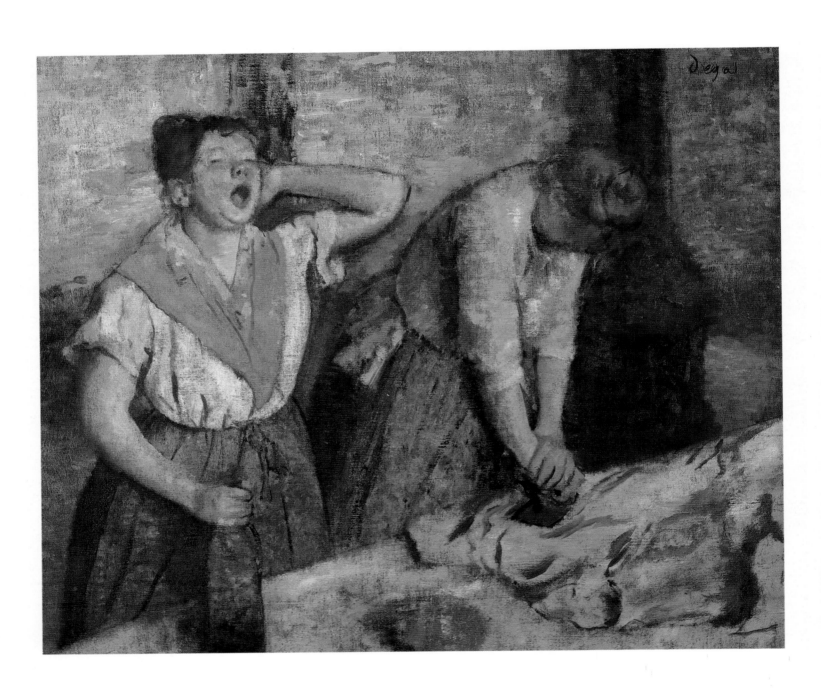

Ironing Women (The Laundresses)

1884-1886, c.; *Oil on canvas;* 30 x 31 7/8 in. (76 x 81 cm.).
Paris, Musée d'Orsay.
The gesture of the laundress yawning over her dull and
joyless work while holding a bottle of wine in one hand
is a striking feature of this well-known painting. Executed
on an unprimed canvas, a unique case for the artist, the
chalky surface looks as though it were done in pastel.

Woman Ironing

begun c. 1876, completed c. 1887;
Oil on canvas; 32 x 26 in. (81.3 x 66 cm.).
Washington, DC, National Gallery of Art.
Collection of Mr. and Mrs. Paul Mellon, © 1993.
A laundress is working at a table ironing men's shirts.
Her figure is outlined in profile against the light entering
the room through the windows. Additional light reflects
from the white worktable and the laundry. The woman
wears a blue dotted blouse and a mauve apron. More
colored clothes are hanging from the ceiling to dry.

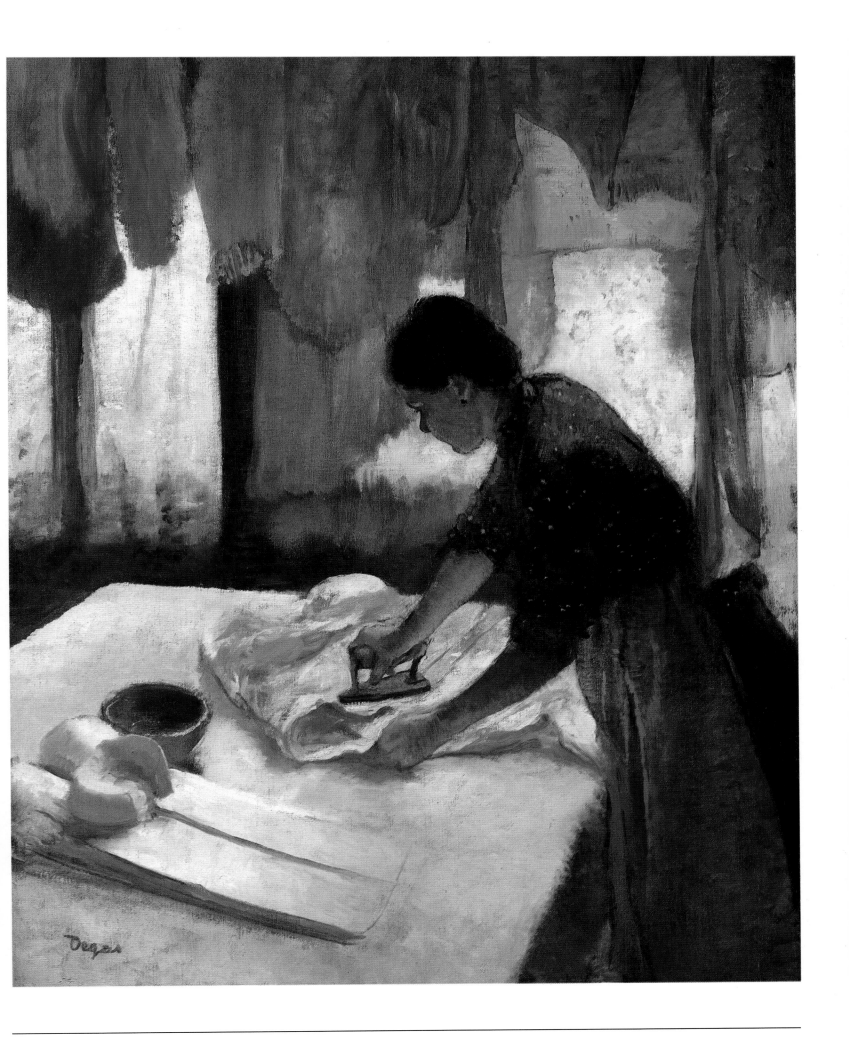

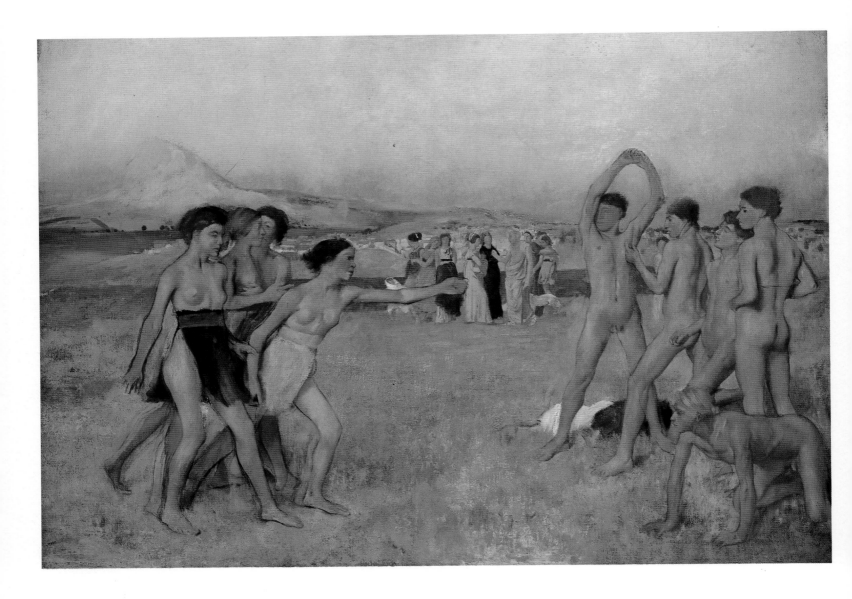

Spartan Girls Provoking Young Men
1860-1862, reworked until 1880; *Oil on canvas;*
42 7/8 x 61 in. (109 x 155 cm.).
London, National Gallery.
*Degas, who was very fond of this history painting, never sold this work
and in his later years displayed it prominently in his house. The scene of
young Spartan girls challenging the boys to combat is probably the result of
the artist's excellent knowledge of classical writers. Spartans were known
for their emphasis on physical exercise and equal treatment of the sexes.*

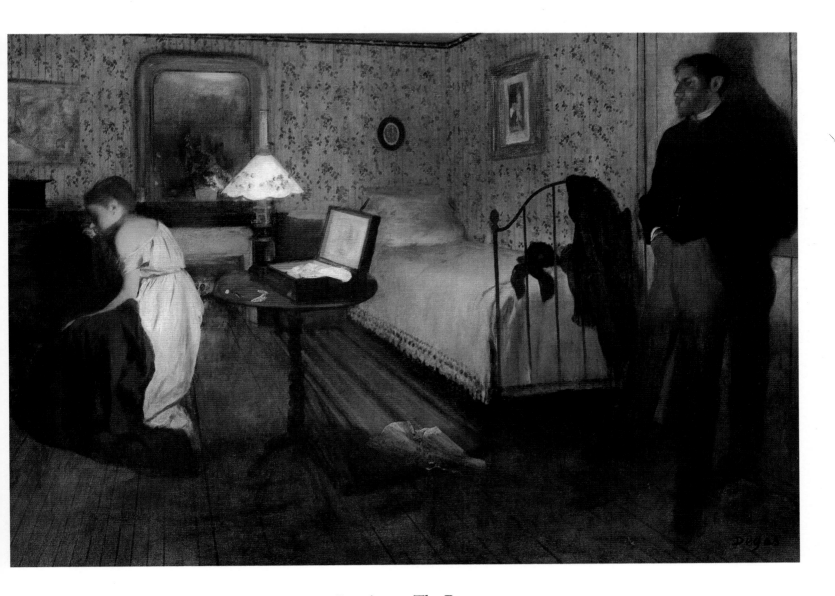

Interior, or The Rape

1868-1869, c.; *Oil on canvas*; 31 7/8 x 45 5/8 in. (81 x 116 cm.).

Philadelphia, Museum of Art.

The Henry P. McIlhenny Collection in Memory of Francis P. McIlhenny.

This is the most baffling and ambiguous picture by Degas. The second part of its title, The Rape, *appears to be of a later date, since the artist himself called it simply a genre scene. Perhaps based on a novel by Zola, the painting is an expressive symbol of lost virginity, the open sewing box with its pink lining being the most outspoken attribute. The light effect with only the lamp at the center is a masterly accomplishment.*

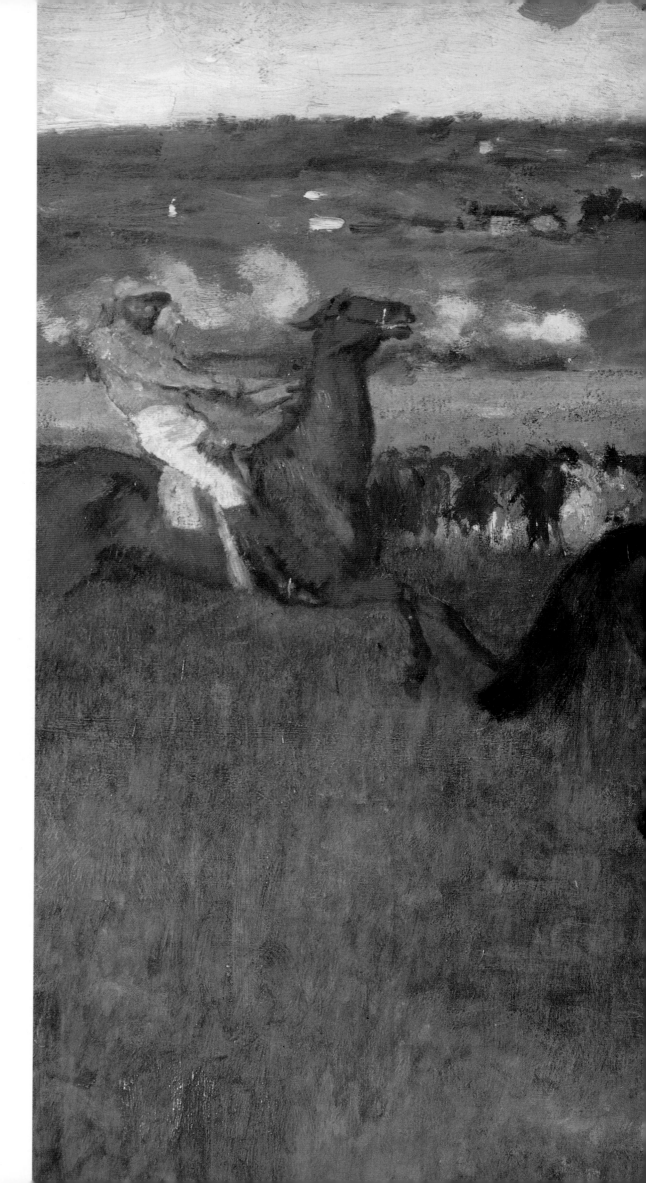

**The Race Track,
Amateur Jockeys
Near a Carriage**
1876-1887; *Oil on canvas;*
26 x 31 7/8 in. (66 x 81 cm.).
Paris, Musée d'Orsay.
*This is one of Degas's
most monumental and
original scenes of horses
and jockeys at races. A
crowd of spectators in the
distance form a human
wall, waiting for the
race to start. A couple of
onlookers on the extreme
right are clearly city
people who are spending
a day in the country.*

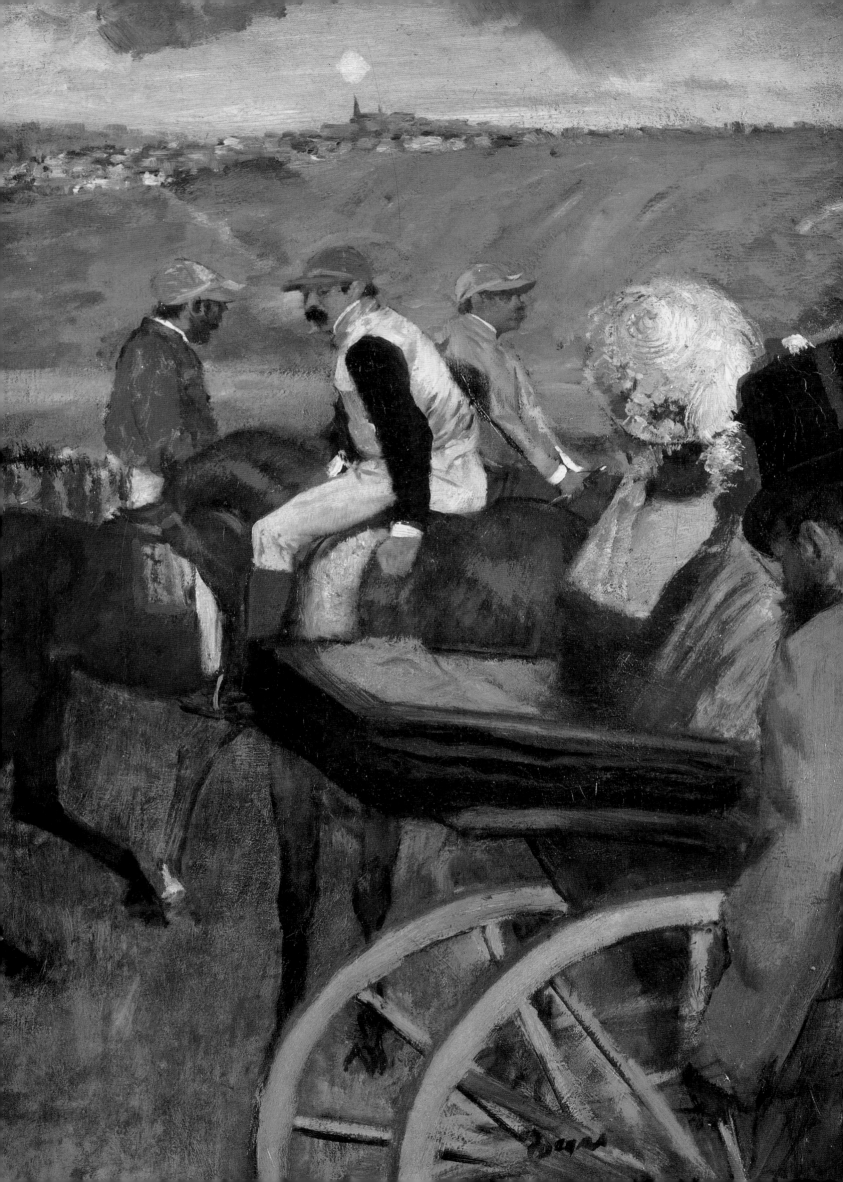

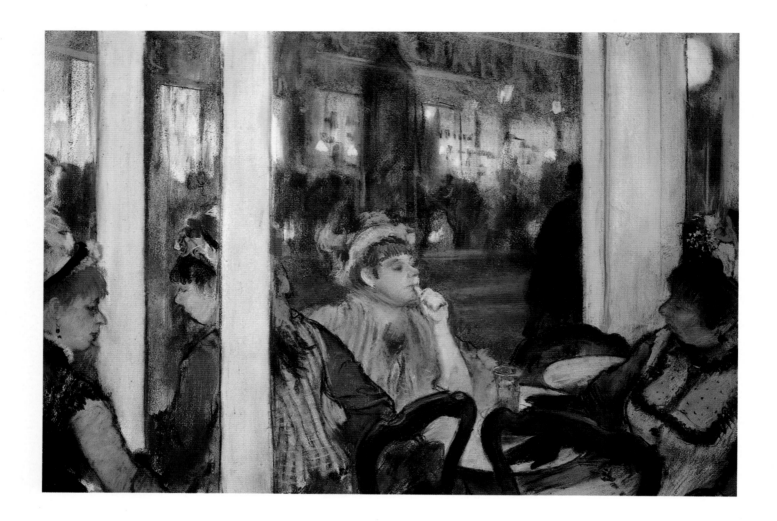

Women on the Terrace of a Café in the Evening
1877; *Pastel over monotype on paper;* 16 1/8 x 23 5/8 in. (41 x 60 cm.).
Paris, Musée d'Orsay.
Degas offers an astute observation of human behavior as
observed on the streets of Paris. The subject, several prostitutes
chatting in a boulevard café, caused a sensation when the
painting was exhibited at the third Impressionist exhibition
in 1877. Some saw in Degas nothing but a relentless
criticism of the bourgeois and accused him of cynicism.

The Absinthe Drinker
1875-1876; *Oil on canvas;*
36 1/4 x 26 3/4 in. (92 x 68 cm.).
Paris, Musée d'Orsay.
The artist's notebook indicates the names of the
models, Hélène Andrée and the artist-etcher
Marcellin Desboutin, one of Degas's friends. The
image conveys the misery and depression of people
addicted to this cheap liqueur. It was rejected by a
critic as a "very disgusting novelty of the subject" at
its first exhibition, in Brighton, England, in 1876.

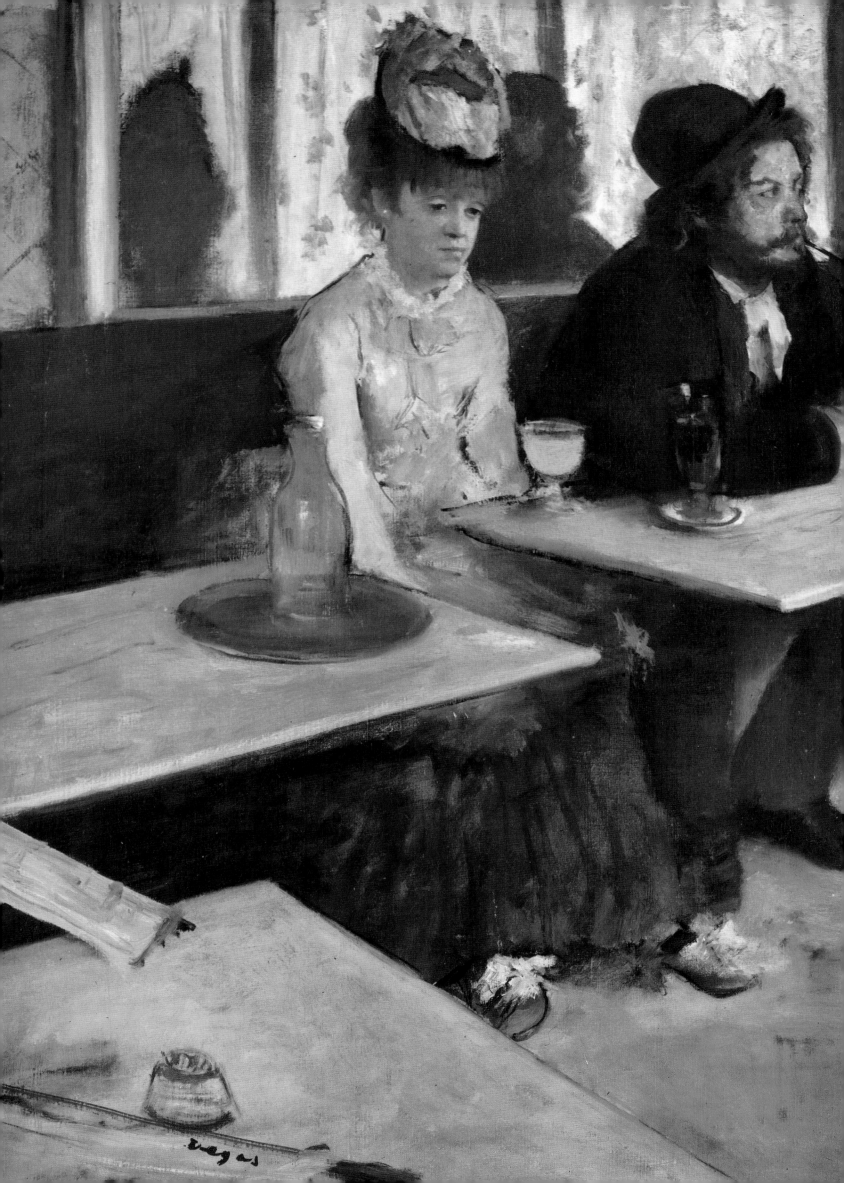

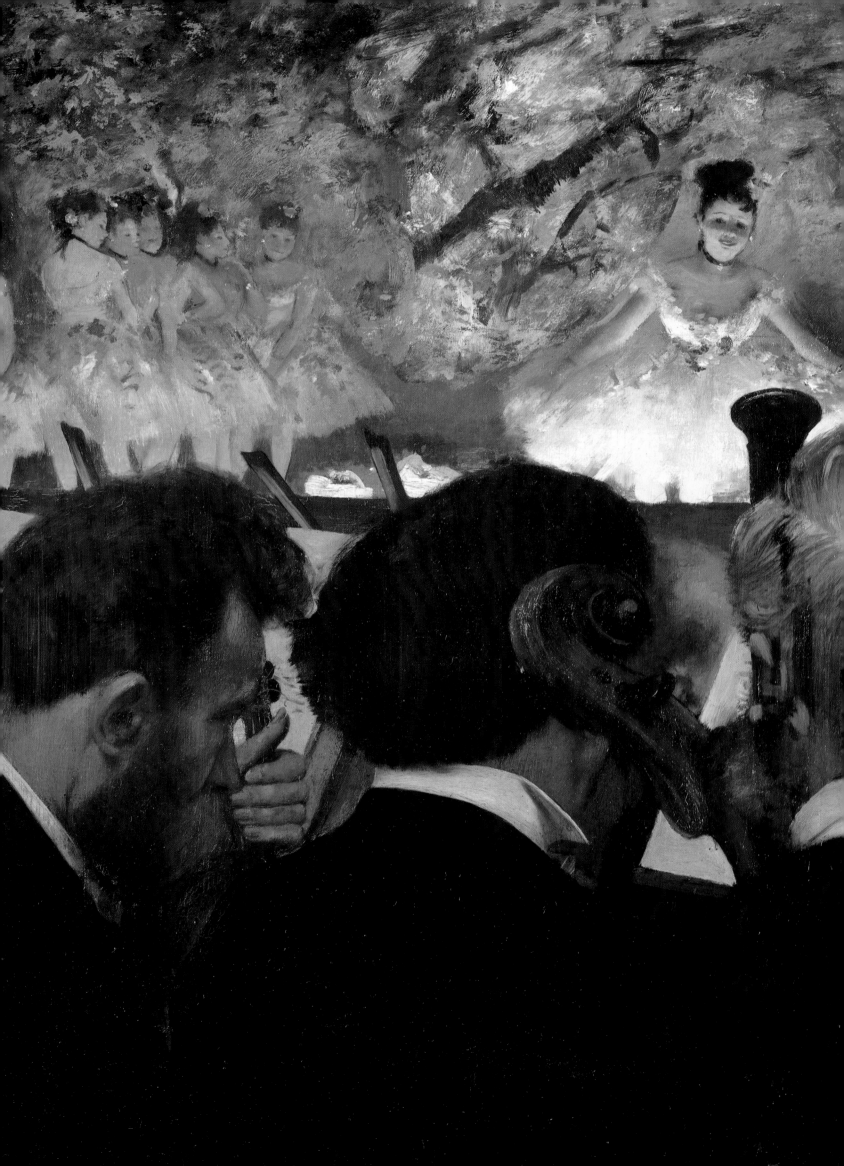

CHAPTER 3

THEATER AND DANCE

The world of theater and dance halls, ballet, and music formed an essential part of Degas's life and oeuvre. His father, Auguste, held regular musical soirées on Monday evenings in his apartment, which were attended by musicians and friends of the family alike, among them Manet. In his 1870 portrait of the Spanish tenor Lorenzo Pagans, Degas included the likeness of his father—the only portrait of him he ever painted—sitting behind the young musician, attentively listening to the music. By that time Auguste was already an old man with a bald head and gray mustache. The music sheets placed on the piano behind him frame his head like a halo. Degas held this painting in high esteem and kept it for the rest of his life over his bed.

Orchestral Themes

His most successful and also his first painting in a series of a group of musicians was *The Orchestra of the Opéra*, finished around 1870. Although the work was created for the bassoonist Dihau—who is prominently shown in the center playing his instrument—Degas inserted him in a complex arrangement of portraits, both of other musicians of the Opéra as well as of friends of the artist. Every feature has been individualized and attracts some attention on its own. Yet this work cannot be considered a group portrait like Fantin-Latour's various homages. This is a painting of an individual within a group. In order to single out Dihau, Degas had to rearrange the usual order of the instruments in the orchestra pit. The dark colors of the musicians in their black tuxedos, highlighted by their white shirts, contrast with the bright stage light behind them, where several

ballerinas in their pink and blue tutus are performing. The dancers' heads are cut off by the picture frame, which has led some to believe that this motif was a later insertion. This seems unlikely though, since Degas must have felt the need to balance his composition coloristically. The painting remained with the sister of its first owner, Marie Dihau, whom Degas painted separately in a small canvas, until her death in 1935.

With a comparable work, *Orchestra Musicians*, Degas created this time not a portrait but a genre scene. The figures are not individualized, in fact they are only seen from behind, and the dancers have the commonplace

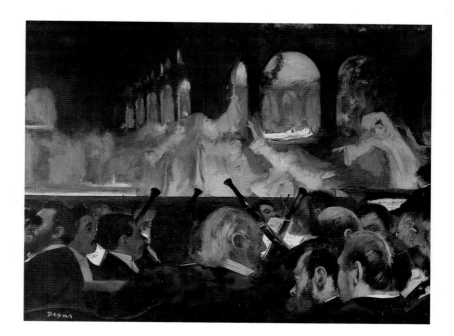

Orchestra Musicians

1870-1871, c., reworked 1874-1876; *Oil on canvas;*
27 1/8 x 19 1/4 in. (69 x 49 cm.).
Frankfurt, a.M., Staedelsches Kunstinstitut.
Like the artist, the viewer is seated in the front row.
As a result the painting lacks a traditional panoramic
perspective. The juxtaposition of the two worlds of dance
and music is underscored by the difference in painting
technique: dark colors and smoothly applied paint for the
musicians, light hues and rapid brushstrokes for the dancers.

Ballet From 'Robert le Diable'

1876; *Oil on canvas;* 29 3/4 x 32 in. (75 x 81 cm.).
London, Victoria and Albert Museum.
The famous baritone Jean-Baptiste Faure, a major patron
of Degas during his earlier years, commissioned this work
together with several others. It depicts a ballet scene from
the opera Robert le Diable *(Robert the Devil) by Giacomo*
Meyerbeer, a friend and patron of Faure's, in which demonic
nuns perform a ghostly dance. Contrasting light effects and
swiping brushstrokes interpret perfectly this farcical subject.

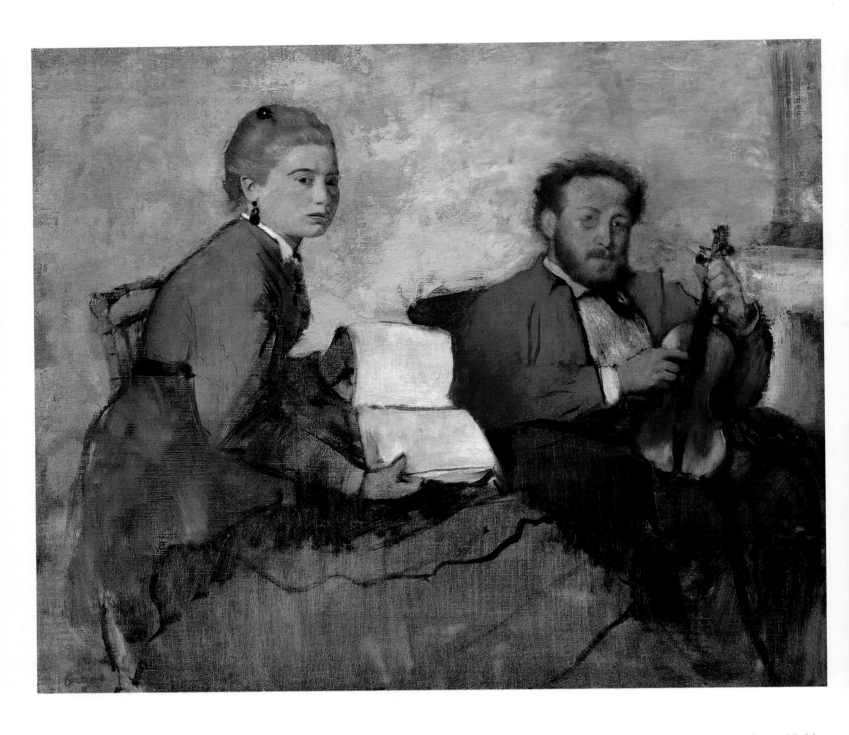

Violinist and Young Woman Holding the Music

1870-1872, c.; *Oil on canvas;*
18 1/4 x 22 in. (46.4 x 55.9 cm.).
Detroit, Michigan, Institute of Arts.
This unfinished portrait depicts two anonymous musicians caught during a break at their rehearsal. The elegantly dressed woman with jet-black earrings is holding a score while looking up as if disturbed in her reading. She is probably either a pianist or a singer. Her companion, wearing a casual red jacket, is holding his violin on his knees. Degas himself had attempted to learn this instrument some ten years earlier.

features of the young ballerinas as Degas would later paint them. Unlike in the previous work, here the worlds of dance and music share the painterly space evenly. Yet, this was only achieved after Degas reworked the painting several years later, adding a piece of canvas on the top so that the dancers were no longer cut off at their waists. Degas chose the moment where the prima ballerina is taking her bows while the supporting cast is relaxing in front of the flats to the left. The bassoonist, framed by a cellist to the left and a double bass to his right, is certainly again Dihau, this time, however, located in the correct position in the orchestra. Their eyes on the score again, the musicians are prepared to start playing again. The narrow angle and limited perspective of the viewpoint make this painting a novelty in its kind. The different light effects of the two groups are achieved by a distinctive handling of paint and the brushwork, smooth and precise for the musicians, quicker and more

vibrant for the dancers, a feature Degas would explore more fully in his later paintings.

Another painting of a ballet scene with an orchestra is related to a specific musical event. *The Ballet from 'Robert le Diable'* is based on a highly successful opera by Giacomo Meyerbeer. The ghostly scene of demonic nuns dancing was highly popular and Degas himself attended many performances, sitting in the first rows of the orchestra and sketching. He was fascinated and intrigued by the chiaroscuro effects of the lighting, the strangeness of the subject, and the contrast between the musicians with the audience in the darkness and the performance on the stage. By that time, however, the opera was already forty years old, and true opera lovers criticized the music as old-fashioned. The man with binoculars on the extreme left looking out of the painting seems to represent one of these critics, who no longer could enjoy this scene, in which the ballet dancers were encased in the shapeless habits of nuns. But it was just

this that pleased Degas: to show the faded charm of music known only too well, a production trotted out year after year, the lack of interest on the part of the spectators contrasted with the incomparable scenic effects.

Café-Concerts

A different kind of theatrical and musical entertainment was offered by the fashionable café-concerts, which combined the attractions of pub and concert hall. These establishments emerged in Paris in the 1830s and became quickly a common feature of Parisian life, reaching their peak of popularity in the 1870s. They offered a varied program, generally divided into three parts, with singers and comics appearing in the opening numbers. The audience was free to move around and drinks were served during the performances. Events from daily life and politics were wittily commented upon by up-to-date performers, making the café-concerts a kind of social commentary put to music. Certainly, Degas was not to

Harlequin and Colombina

1886, c.; *Pastel on paper;*
16 1/8 x 16 1/8 in.
(41 x 41 cm.).
Vienna, Kunsthistorisches
Museum.
This scene can be linked to a specific ballet, Les Jumeaux de Bergame *(The Twin Brothers from Bergamo), a farce in the tradition of the Italian commedia dell'arte, which seems to have intrigued the artist. Here, Harlequin, with a stick behind his back, appears as an aggressive suitor to his beloved Colombina.*

miss this particular aspect of modern life and seems to have begun rather suddenly to include this subject into his oeuvre.

The Café des Ambassadeurs was one of the favorite places of its kind. As an outdoor café-concert on the Champs-Elysée, it attracted large audiences and numerous prostitutes later in the evening. There Degas saw the famous singer Thérèsa, who was about forty years old and perhaps the most successful character in her genre. The artist portrayed her while performing *The Song of the Dog*, a popular parody. Her stout body encased in a yellow dress, she is standing above the audience on the stage near the footlights. The expressive face seen in profile is covered with heavy makeup, while the pawlike gestures of her gloved arms accompany her singing. Degas was a great admirer of her voice, calling it "the most natural, the most delicate, and the most vibrantly tender" instrument he could imagine. The background of glowing gas lights under the trees has been treated with the same keen observation. A mustachioed old man has fallen asleep in the front row, a waiter farther in the back is taking an order, and a couple is departing in the middle of the performance.

In another pastel, called *Concert at the Café des Ambassadeurs*, Degas chose a different vantage point, this time looking from the audience toward the stage. The singer's outstretched arm seems to invite the viewer to share the performance. Stage lights lined up behind her intensify the illusion of depth. The protruding scroll of a double bass serves as a continuation of the column and holds the singer visually on the stage. This motif is almost a reminder of the earlier orchestra scenes. The striking red color of the performer's dress and the extraordinary effects of light provide this scene with liveliness and immediacy. Interestingly, Toulouse-Lautrec would later explore this genre in the following two decades, immortalizing the same café and its singers in his own fashion.

Degas was also interested in another, related form of popular contemporary entertainment, the circus. In January 1879 he repeatedly visited the Cirque Fernando, which was located in Montmartre and considered to be the most attractive establishment of its kind in the city. The sketches made during performances there resulted in *Miss Lala at the Cirque Fernando*. The acrobat Lala is being pulled up to the roof of the circus tent by a rope held between her teeth. The ceiling is inclined completely to one side and conveys the exact sensation of the eye that follows her movement. This pastel is a highly finished preparatory study for a painting, which differs only slightly from the present sheet.

Degas acknowledged having been influenced in his "new perception" by contemporary literature, in particular by the novels of such realists as Zola and the de Goncourt brothers. He also adopted the still fairly new technique of photography for his compositions, the results conveying a sense of spontaneity despite their

The Song of the Dog
detail; 1876-1877, c.; Private Collection.
The head of the famous café-house singer Thérèsa with its somewhat exaggerated shape appears to be based on contemporary illustrations of monkeys in publications on Darwinistic theories. However, Degas never lost touch with his deeply rooted sense of humanity.

Concert at the Café des Ambassadeurs
1875-1877; *Pastel over monotype;*
14 1/2 x 10 5/8 in. (37 x 27 cm.).
Lyon, Musée des Beaux-Arts.
The Café des Ambassadeurs was a popular club that served as a meeting place for artists and writers. Unusual light effects and bright colors characterize this work. Illusion of depth is created by stage lights lined up behind the performer whose outstretched arm draws the viewer in.

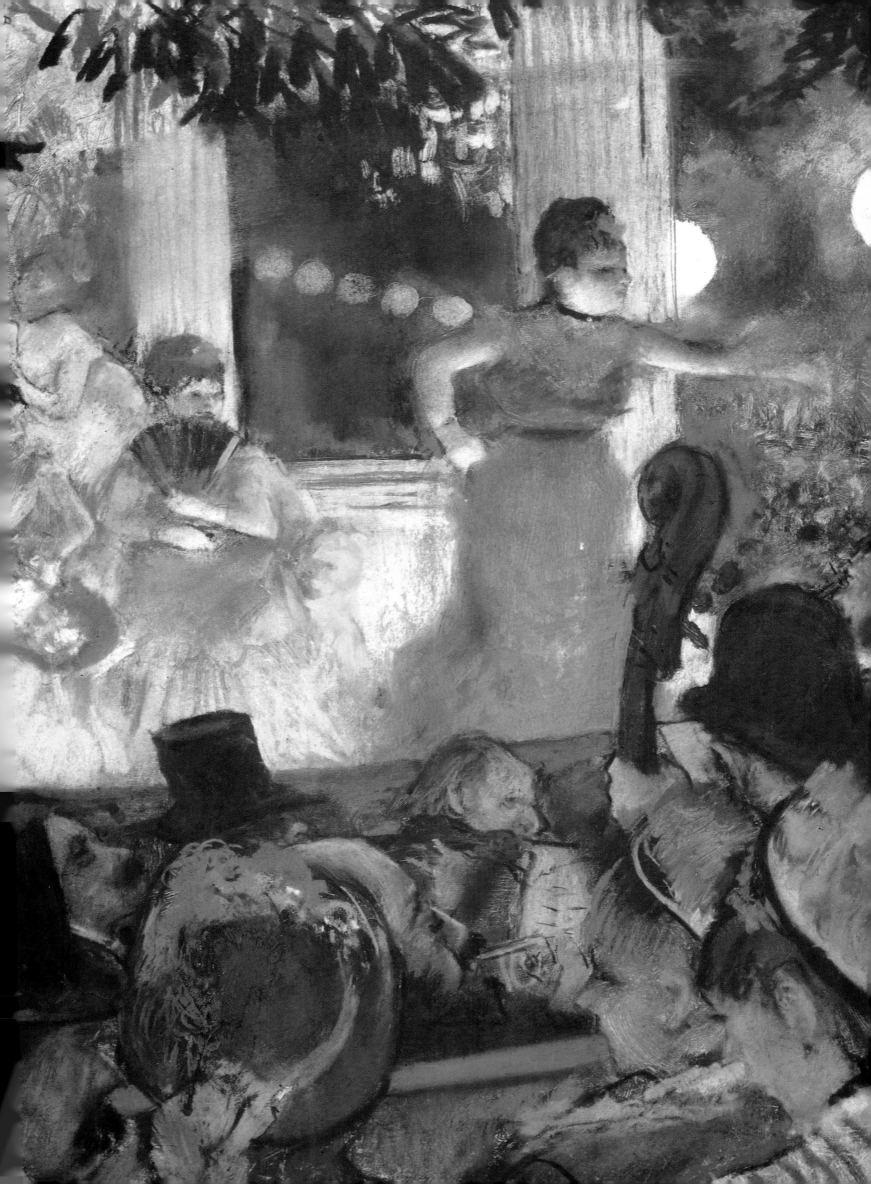

Café-House Singer (Green Singer)

detail; 1884, c.; New York, Metropolitan Museum of Art.
Looking closely at this image of a café-house singer, one can clearly see the pastel strokes and the layers of pigments on the surface of the paper. This technique facilitated reworking of the paintings and to model the shapes of the objects with a higher degree of physical reality.

laborious execution. Degas distinguished himself from his Impressionist fellow artists by his process of synthesis and constant research for what was a seemingly casual view of contemporary life. In his notebooks, which are of immense importance for the understanding of the artist's development, he confirmed his desire for the appearance of immediacy through careful study, resisting the temptation to "draw or paint immediately." At first Degas's new beauty of Realism was rejected by critics as a "murdering brush," which dissected reality into something ugly and repulsive. From the mid-1870s onward, however, his treatment of the human figure began to be recognized as a keen analysis and telling synthesis of the human physiognomy in the tradition of Daumier. Nowhere else but in his series of ballet dancers did Degas manage to epitomize more poignantly his virtually scientific, analytical approach.

At the Ballet

From the early 1870s Degas began to focus more and more on the theme of ballet dancers. He had already included some of them marginally in his orchestra paintings. Scenes of rehearsals or rather moments of relaxation during class were to become his favorite subject for a number of years. Rarely would he depict actual performances. Equally small in number are works showing individual dancers; the artist preferred to study the interaction of figures in space. The general reception of the dance paintings has been quite favorable from the beginning. After a visit to the third Impressionist exhibition in 1877, where Degas showed his *L'Étoile*, among other dance scenes, the young critic Georges Rivière expressed his enthusiasm: "After having seen these pastels, you will never have to go the Opéra again." By 1880, however, Degas had exhausted the receptiveness of the public, which showed signs of tiring of the artist's obsessive use of dance subjects as his principal form of expression.

Ballets were performed at the Opéra, but he drew most of his studies in his studio, since it was not until some fifteen years after his first ballet painting that Degas was finally permitted to visit the backstage. Before then, Degas invited some of the dancers to his home, where they posed for him in the quiet atmosphere of his studio. The paintings too were done there, whereby he often used drawings of the same model in different poses for different figures.

In the two earliest paintings, *The Foyer (Dance Class)* and *Dance Rehearsal at the Opéra of the Rue le Peletier*, dating from 1871 and 1872, respectively, a large space is left free at the center, thus giving a single dancer the opportunity to demonstrate a solo part under the supervision of the instructor. In *The Foyer (Dance Class)* the graceful pose of *en pointe arrière* is taken by Joséphine Gaujelin, whom Degas painted also in a rather somber portrait. Awaiting the sign of the ballet master, who has taken up his pocket violin, she is the only dancer out of nine who is actually performing. Her companions are either stretching their legs at the barre or adjusting their costumes; others are seen chatting. *Dance Rehearsal at the Opéra of the Rue le Peletier* differs from the *Dance Class* most obviously in its higher finish. Most likely spurred by the quick sale of the first painting, Degas was encouraged to complete this second one, which he situated in the old rooms of the Opéra. The poses of the dancers are comparable to the previous work, but the soft, golden light, the marble-surfaced columns, and the presence of the famous ballet master Louis Mérante give this second work a greater solemnity.

Shortly after his return from New Orleans in 1873, Degas began to paint the well-known *Dance Class*, now in the collection of the Metropolitan Museum of Art in New York. There is also a second, slightly different version by the same name exhibited in Paris at the Musée d'Orsay. The first version is more polished, the colors more saturated, in particular the green of the walls. Degas's concern for details, bold contrasts, and brilliant light effects bring this painting closer to his earliest ballet scenes and to *Interior of an Office in New Orleans*. The center of the composition is psychologically as well as technically dominated by a young girl dancing an arabesque for the ballet master, the same Perrot at the right. The overall arrangement of the figure groups is

Miss Lala at the Cirque Fernando

1879; *Pastel on paper;* 24 x 18 3/4 in. (61 x 47.6 cm.).
London, The Tate Gallery.
A female acrobat is holding a rope between her teeth while being pulled up to the roof of a circus tent. Degas witnessed such a scene during a visit to the popular Cirque Fernando in the Montmartre district, where the acrobat Lala, a black or mulatto woman, performed acts of strength. The composition focuses on the compact, swirling body.

more eccentric and includes even spectators lined up against the wall on the far back, probably mothers accompanying their daughters to class.

The version exhibited in Paris shows the same rehearsal room of the Opéra, but this time the interior is more crowded with dancers. At the center of the dance floor stands the aging ballet master Jules Perrot, resting on a stick. The dancers are taking a break from their rehearsal and appear in disarray. The gray-haired Perrot is talking to the young ballerina with a green sash, who is singled out by the large door frame behind her. The light and almost translucent application of the paint is so

confident as to make the effort required to produce the work almost unnoticeable.

From about 1875 on, Degas shifted to the opaque media of pastel, gouache, and distemper, possibly stimulated by exhibitions of pastels by Jean-François Millet, as well as by the works of his friend Giuseppe de Nittis. The great advantage of these media is that they allow the artist to work more quickly and spontaneously without having to wait for the oil to dry. And because of their opaque quality, changes to the compositions can be masked effectively. For Degas, this meant that he could complete small-scale works more quickly and they could

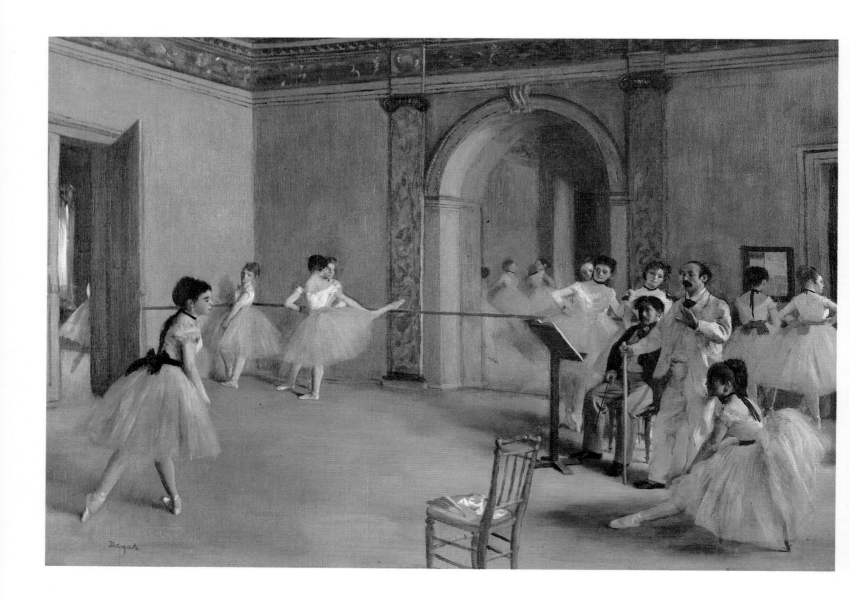

Dance Rehearsal at the Opéra of the Rue "Le Peletier"
1872; *Oil on canvas; 12 5/8 x 18 1/8 in. (32 x 46 cm.). Paris, Musée d'Orsay.*
The scene has a distinct "Parisian" look, as it is taking place in the rehearsal room of the old Opéra on the Rue le Peletier. The dancers are about to move to the center of the room after having completed their exercises at the barre. The standing dancer on the left is about to do a reverse arabesque and awaits the sign from the ballet master. The chair in the foreground fills the void of the space seen obliquely across the room.

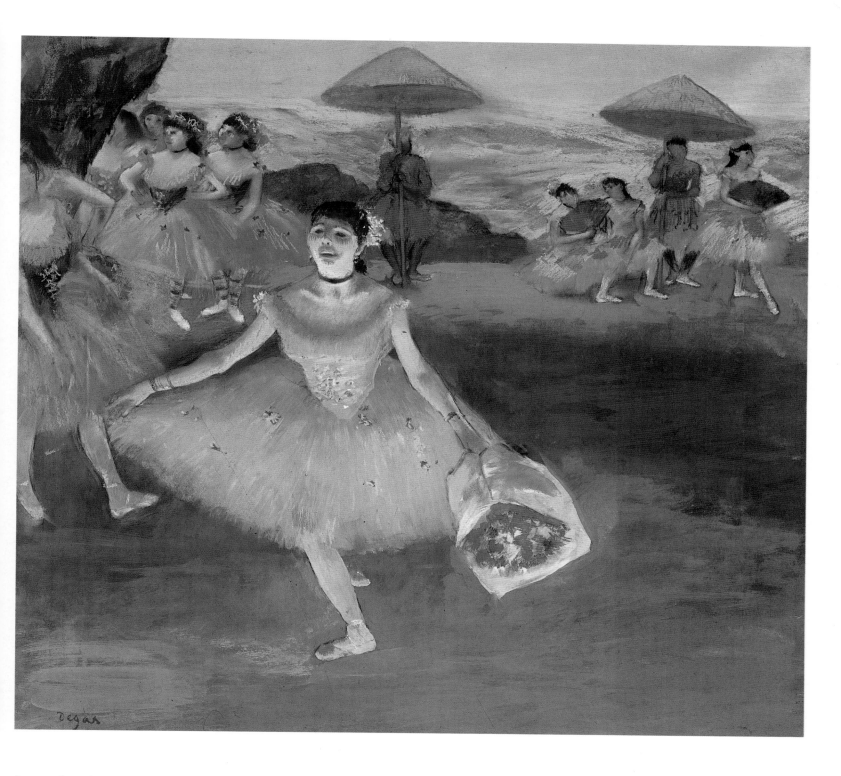

be marketed less expensively than oil paintings. Such considerations became especially important when Degas took over the burden of his father's bankrupt business, following the death of Auguste De Gas in 1874. Pastel was, however, largely considered to be inferior to oil and regarded as a medium for second-class talents. This was partly the result of the inherent ephemeral quality of pastel.

In these particular effects, however, Degas discovered a new expressive potential for depicting the contemporary world of the Opéra and the café-concert. The illusory beauty of lithe young dancers, whom Degas often likened to butterflies, could be exhibited through this means. Similarly, the use of distemper, in which glue acts as the binding

Ballerina with a Bouquet of Flowers
1877, c.; *Pastel and gouache on paper;*
28 3/4 x 30 1/2 in. (72 x 77.5 cm.).
Paris, Musée d'Orsay.
Rather than depicting actual ballet performances, Degas preferred rehearsals or the aftermath of a theater evening, as shown here. The prima ballerina, honored by one of her fans with a bouquet of flowers, is taking a curtain call, her smile frozen in the glaring footlight that illuminates her face from below.

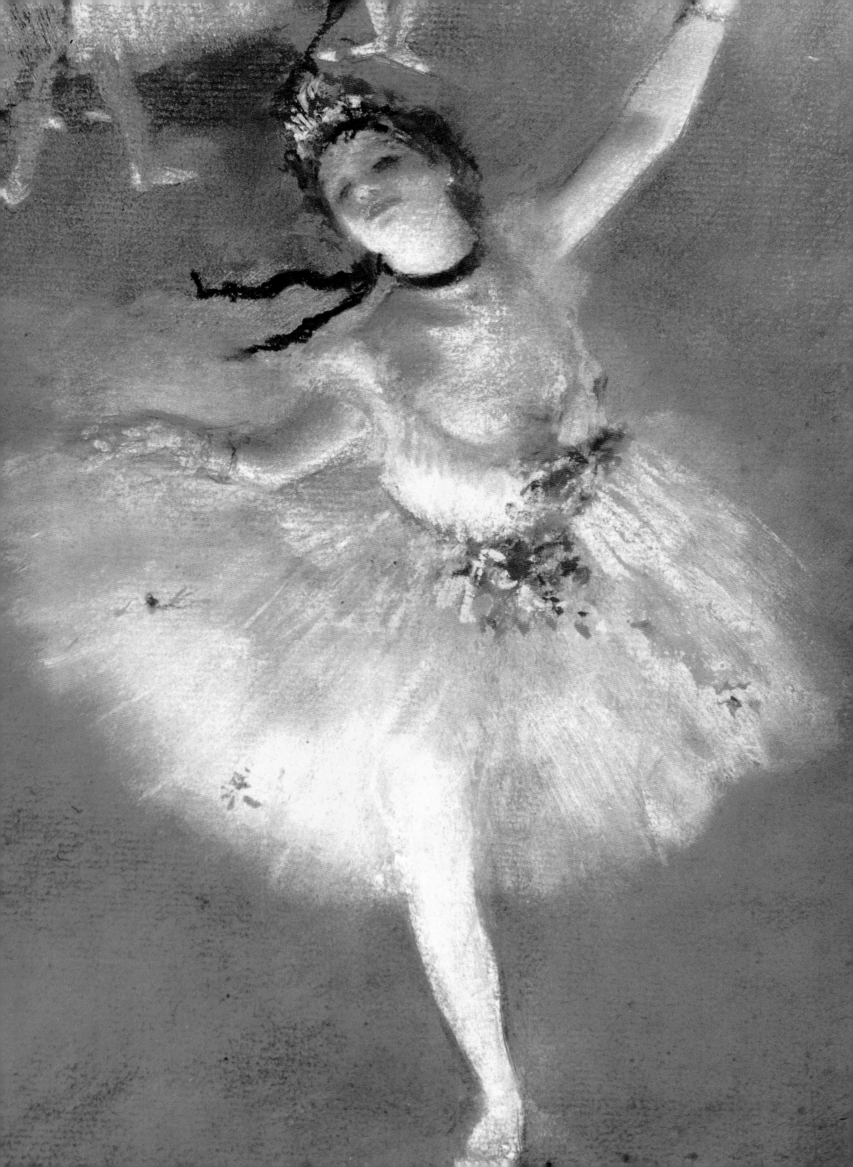

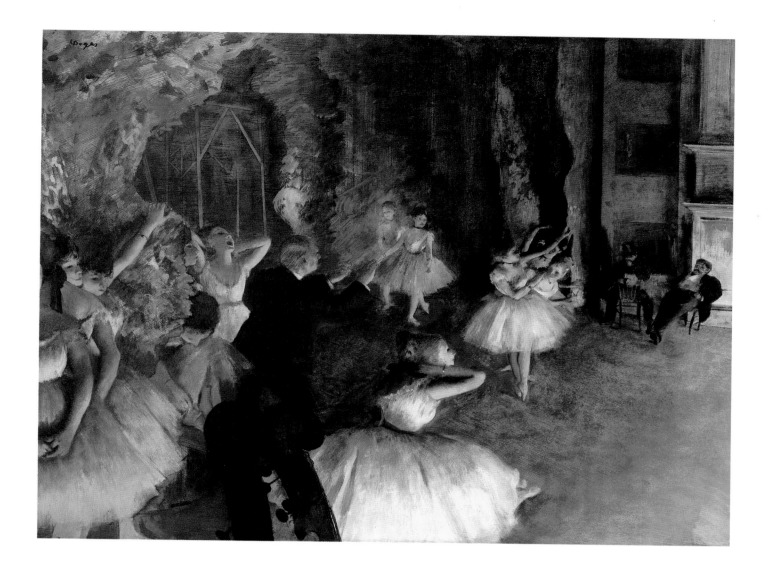

Ballet Rehearsal on Stage

1874; *Essence with trace of watercolor and pastel over pen and ink drawing on paper, mounted on canvas;* 21 3/8 x 28 3/4 in. (54.3 x 73 cm.).
New York, Metropolitan Museum of Art,
Havemeyer Collection.
A dress rehearsal has been interrupted by a man at the center, who converses with two other men sitting on chairs at the edge of the stage. Scrolls of two double basses are protruding from the invisible orchestra pit below. The cool tones are particularly effective in suggesting the artificial effects of light on the stage.

L'Étoile

detail; 1876-1877; Paris, Musée d'Orsay.
The movement of the ballet dancer full of grace and elegance epitomizes not only the art of her performance, but also of the painter's mastery in rendering such a fleeting moment.

medium, underscores the link to the world of theater, where the superficial brilliance of temporary stage flats is achieved with the same, inexpensive medium.

Two closely related works illustrate the transition from one medium to another. In *Ballet Rehearsal on Stage*, now at the Musée d'Orsay, Degas still used oil, but in a monochromatic manner, which has led some to classify it as a drawing. The reason for this treatment was obviously Degas's intention to use the work as a model for an engraver. The second version, with a very similar composition, is in the Metropolitan Museum of Art in New York, and was executed in essence and pastel, which gives the scene its chalky, airy character.

The combination of pastel and distemper was fully exploited in the colorful work *Dancer with a Bouquet of Flowers*. It embodies Degas's infatuation with the effects created by artificial light. The painting's perspective is a slightly elevated vantage point, which permits a glimpse into the wings, where supporting cast members are seen adjusting their costumes. The prima ballerina in the foreground takes her curtain call close to the footlights, which illuminate her face from below. As a result her forehead is cast in a shadow, her smile frozen on her face. The unusual shape of the work, almost square, is

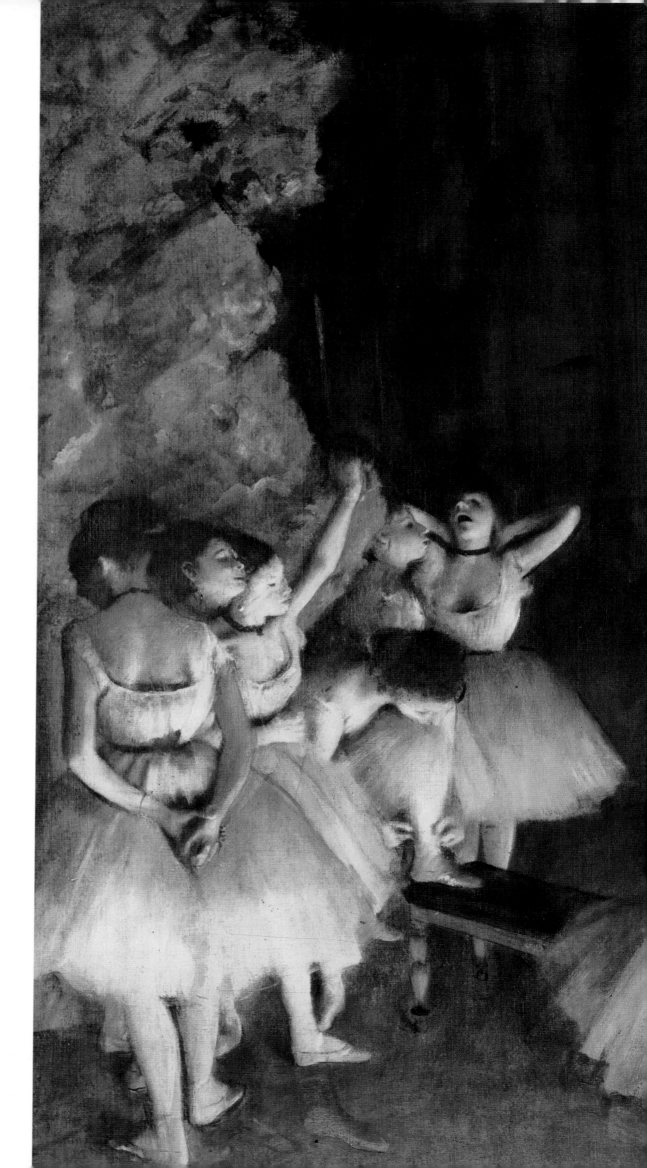

**Ballet Rehearsal
on Stage**
1874; *Oil on canvas;*
25 5/8 x 31 7/8 in.
(65 x 81 cm.).
Paris, Musée d'Orsay.
*The Italian Impressionist
painter Giuseppe de
Nittis remembered this
painting in a letter to
a friend as "extremely
beautiful. The muslin
dresses are so diaphanous
and movements so true
that only seeing it
could give you an idea;
describing it is impossi-
ble." The work was
apparently intended
to be engraved, as the
monochromatic treat-
ment seems to indicate.*

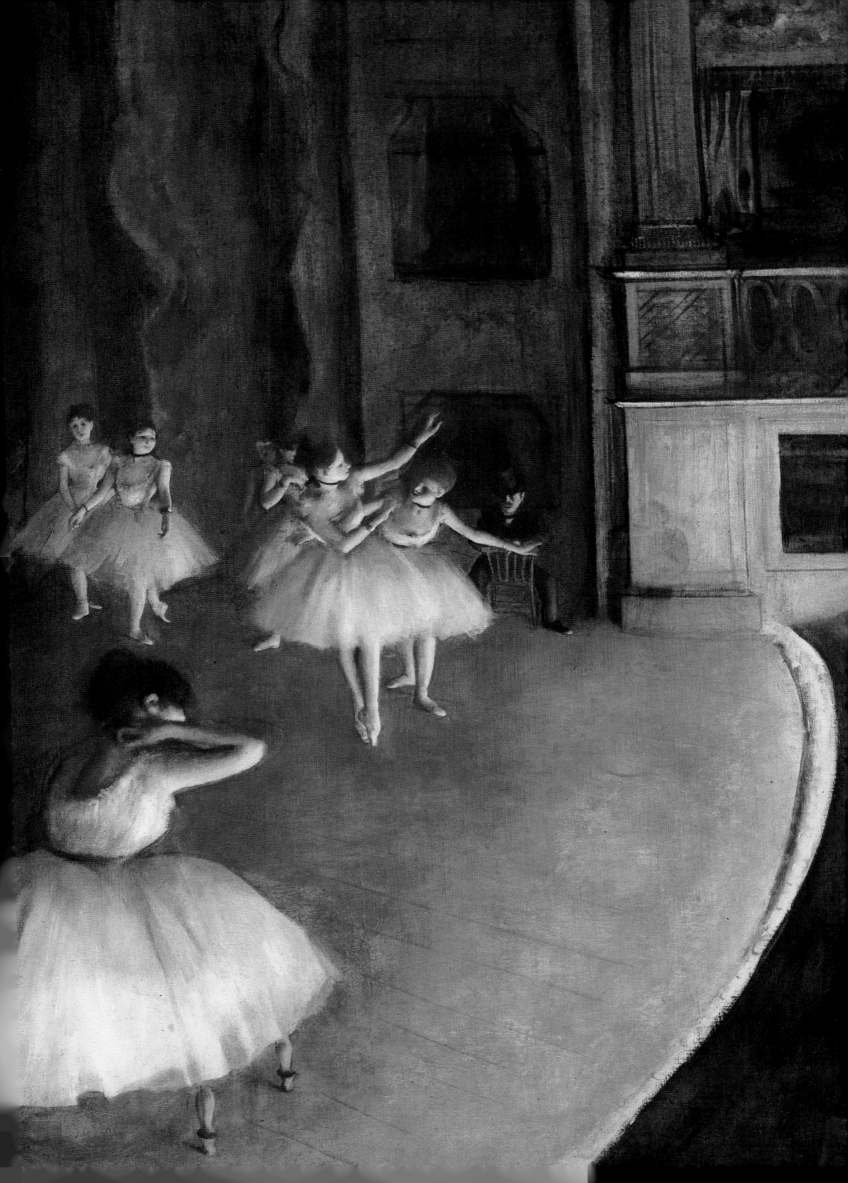

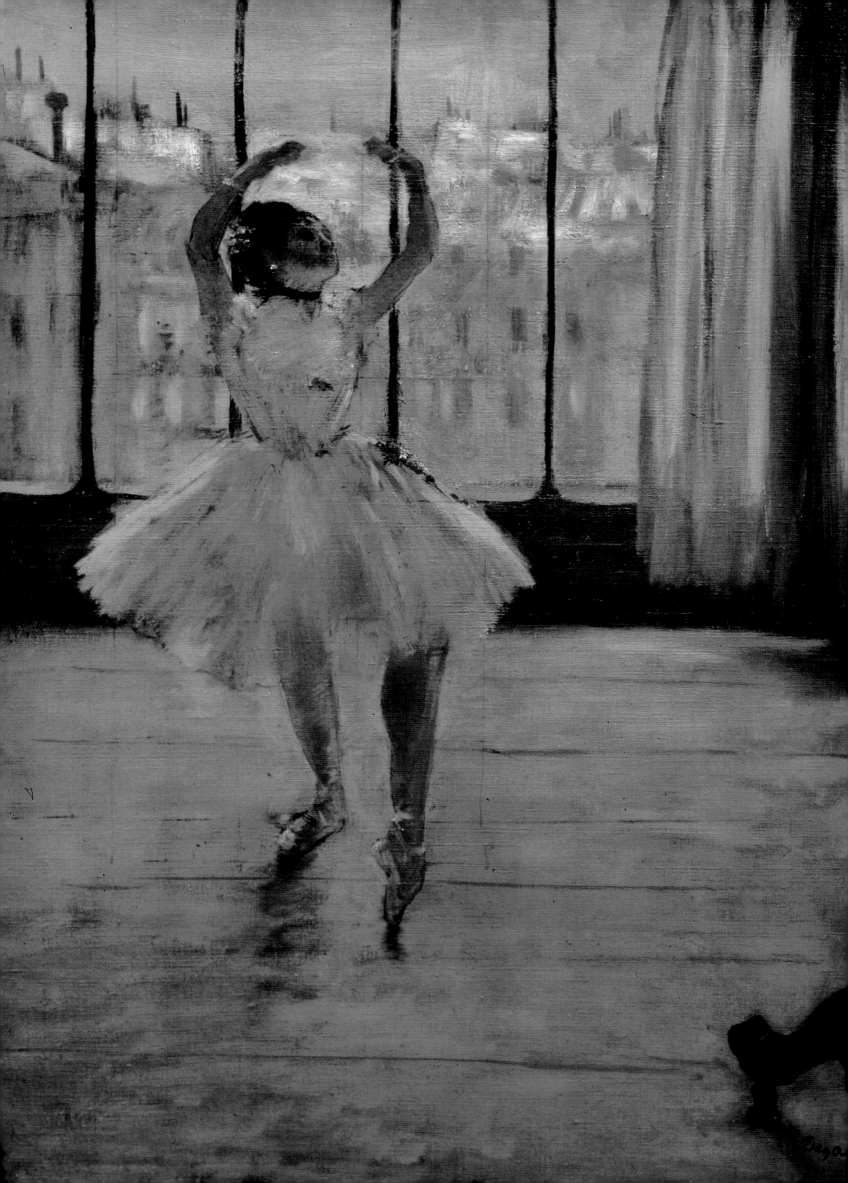

due to the way in which it developed. Executing the piece on paper, Degas added several strips until he had found the right balance for his composition. Such a procedure would have proved nearly impossible had he employed the oil technique on canvas. Few of Degas's ballet scenes represent actual stage performances, and he often used the same figures for different works, indicating that he seldom followed the actual production of a ballet. In this case, at least, Degas borrowed elements from a ballet scene in the third act of Jules Massenet's opera *Le Roi de Lahore*, first performed in Paris in April 1877. This gives not only a clue as to the possible date of this work, but it explains the exotic Hindu costumes and the orange-colored umbrellas of the set.

Another technique that Degas cherished was that of the monotype, in which a design is painted in oil on a sheet of plate glass and paper is pressed upon it; when the paper is peeled off, a proportion of the color adheres to it in the form of a print in reverse. Degas then worked over the design with pastels or other media. Usually not more than one or two of these prints can be made.

The artist adopted this procedure for the famous *L'Étoile*. With a look of rapture on her face, the ballerina completes her performance, taking a sweeping bow that makes her tutu stand out in a swirling movement. The scene is rendered as perceived from a stage box above. The dancer is momentarily alone on the stage, receiving the full attention of both the audience and the viewer. In the wings tutus of other dancers are visible, as well as a male figure in a black suit, perhaps her "protector." The subsequent fame of this work has left its magical aspects intact, though it has diminished the work's novelty—that

Dance: Fourth Position Front, on the Left Leg

1883-1888, c.; *Bronze;* 16 in. (40.6 cm.) high.
Paris, Musée d'Orsay.
Unlike most other sculptures, which capture fleeting movements, the dancer here has found a perfectly balanced equilibrium and a seemingly effortless control over her body. The graceful carriage and extraordinary poise of the figure make this work one of the most popular of Degas's bronzes.

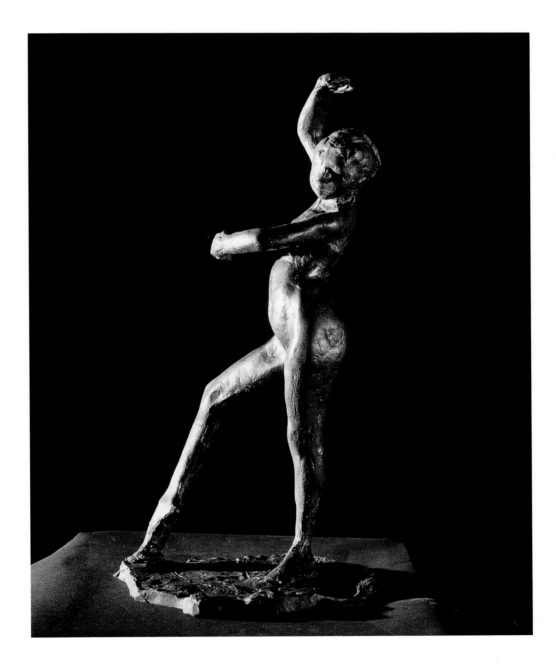

Dancer Posing for a Photograph

1875, c.; *Oil on canvas;*
25 5/8 x 19 3/4 in. (65 x 50 cm.).
Moscow, Pushkin Museum of Fine Arts.
The title for this work appears to be an afterthought of the artist. A dancer is posing in front of a large mirror, of which one can only see part of the frame. Alone in the dance studio with a cool green light coming from the window, she has adopted a classic ballet pose, which becomes a miraculous expression of self-examination.

Blue Dancers

1893, c.; *Oil on canvas;* 33 7/16 x 29 3/4 in. (85 x 75.5 cm.). Paris, Musée d'Orsay.
*The intensity of the pervasive blue and the similar rhythmic arrangement
of the dancer's arms relate this work to a pastel in the Pushkin Museum
in Moscow. Here the emphasis has been shifted toward a higher degree
of abstraction. Color, form, surface, and scale are the principal elements.*

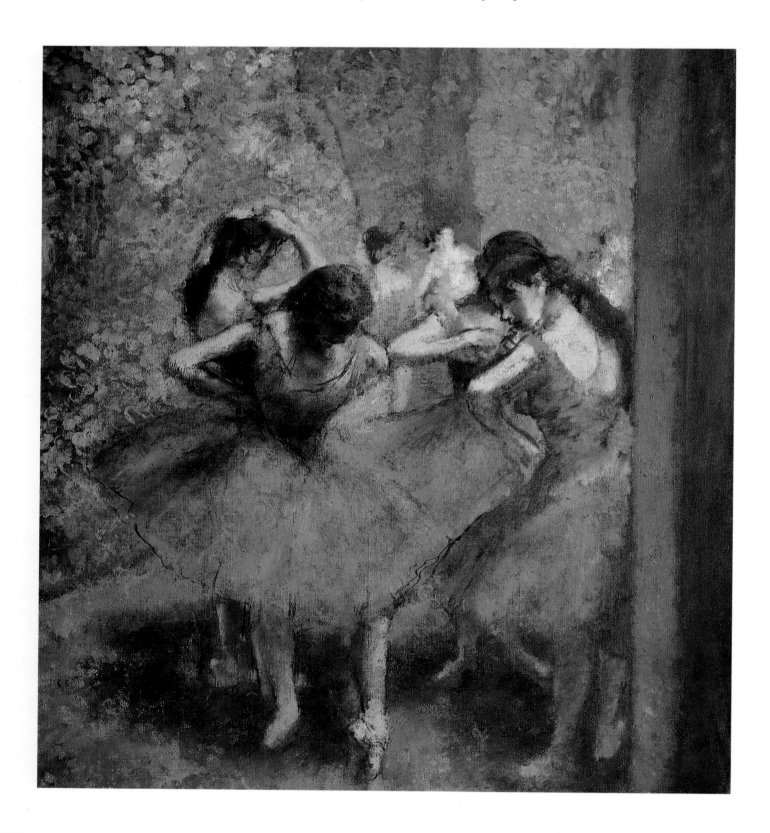

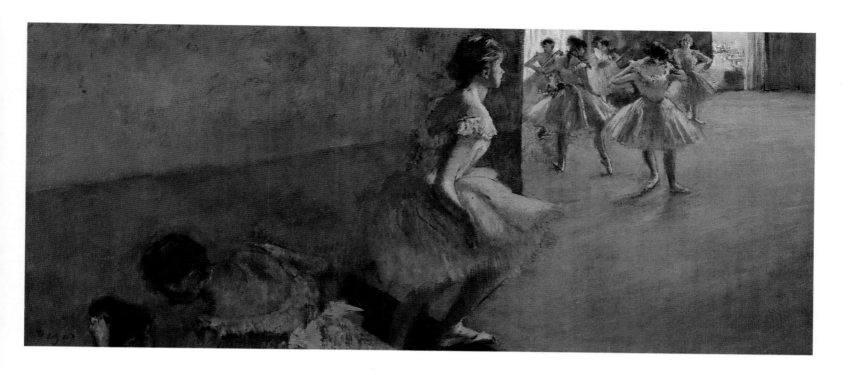

Ballerinas Climbing a Staircase
1886-1890; *Oil on canvas;* 15 3/8 x 35 1/4 in. (39 x 89.5 cm.).
Paris, Musée d'Orsay.
*The austere work atmosphere of a ballet school
is underscored by the complete absence of any
architectural decoration and the decisively
horizontal format of the painting.
The dancers, adjusting their dresses
or bending their bodies, are preparing
for a rehearsal. The room is
probably part of the Paris Opéra.*

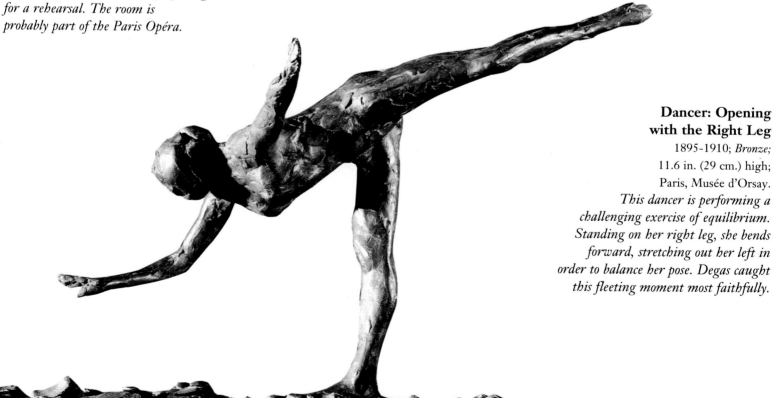

**Dancer: Opening
with the Right Leg**
1895-1910; *Bronze;*
11.6 in. (29 cm.) high;
Paris, Musée d'Orsay.
*This dancer is performing a
challenging exercise of equilibrium.
Standing on her right leg, she bends
forward, stretching out her left in
order to balance her pose. Degas caught
this fleeting moment most faithfully.*

Dancer: Fixing Corsage
1895-1910; *Bronze;* 17 in. (42.5 cm.) high.
Paris, Musée d'Orsay.
*Although actually a nude figure,
the twisted pose is that of a dancer
adjusting her corsage on the back.
The legs are firmly placed on the ground.*

is, the peculiar angle of vision and the vast expanse of space left bare.

Degas further explored the dramatic possibilities of a view from a box near the stage in *The Green Dancer.* As a group of dancers rushes off the stage, the action momentarily stops as a performer salutes the audience on her way to the wings while concurrently being swept away in a whirlwind of legs and tutus. She has a similar grace and charm as *L'Étoile*, but she is not a solo performer. Another group of dancers dressed in orange costumes is already waiting in the back for its turn.

In a painting of dancers dating from around 1900, Degas returned to the oil technique. *Dancers at the Barre* are abstracted figures, compared to their predecessors of twenty years earlier. Lacking any individuality, they are noteworthy for their form and color. A sense of futility and lack of energy seems to pervade this work, perhaps a sign of Degas's ailing health.

An important variation on the theme of dance was achieved with the sculpture of *Little Dancer Aged Fourteen,* which Degas presented at the sixth Impressionist exhibition in 1881. The work was unanimously considered to be an extraordinary creation, "a truly modern effort, an essay in realism in sculpture," according to the critic Charles Ephrussi. The original wax sculpture was dressed in a real bodice, tutu, stockings, and ballet shoes; on her head was a wig with a pigtail tied with a leek-green ribbon, and she wore a similar ribbon around her neck. The wax was tinted to simulate flesh.

The combination of artificial and natural materials—wax, cloth, and hair—was a unique combination and the most remarkable aspect of the statue. It blurred the boundaries between reality and artifice. The sculpture was posthumously cast in bronze in 1921. By that time, the original hair had already been covered with wax.

During his later years Degas modeled a number of small wax sculptures to study the effects of movements of dancers. Although originally not meant to be cast in bronze, they can be found today in a number of museums. They confirm Degas's tenacious quest for the ideal representation of beauty.

Dancer: Looking at Her Right Foot
1895-1910; *Bronze;* 18 1/8 in. (46 cm.) high.
Paris, Musée d'Orsay.
*The painterly handling of the original wax model
has been retained in the bronze cast, thus retaining
a play of light and shadow on the surface of the
figure. Standing on her left leg, the dancer has
abruptly lifted her right foot in a vigorous backward
movement, which is balanced by the raised left elbow.*

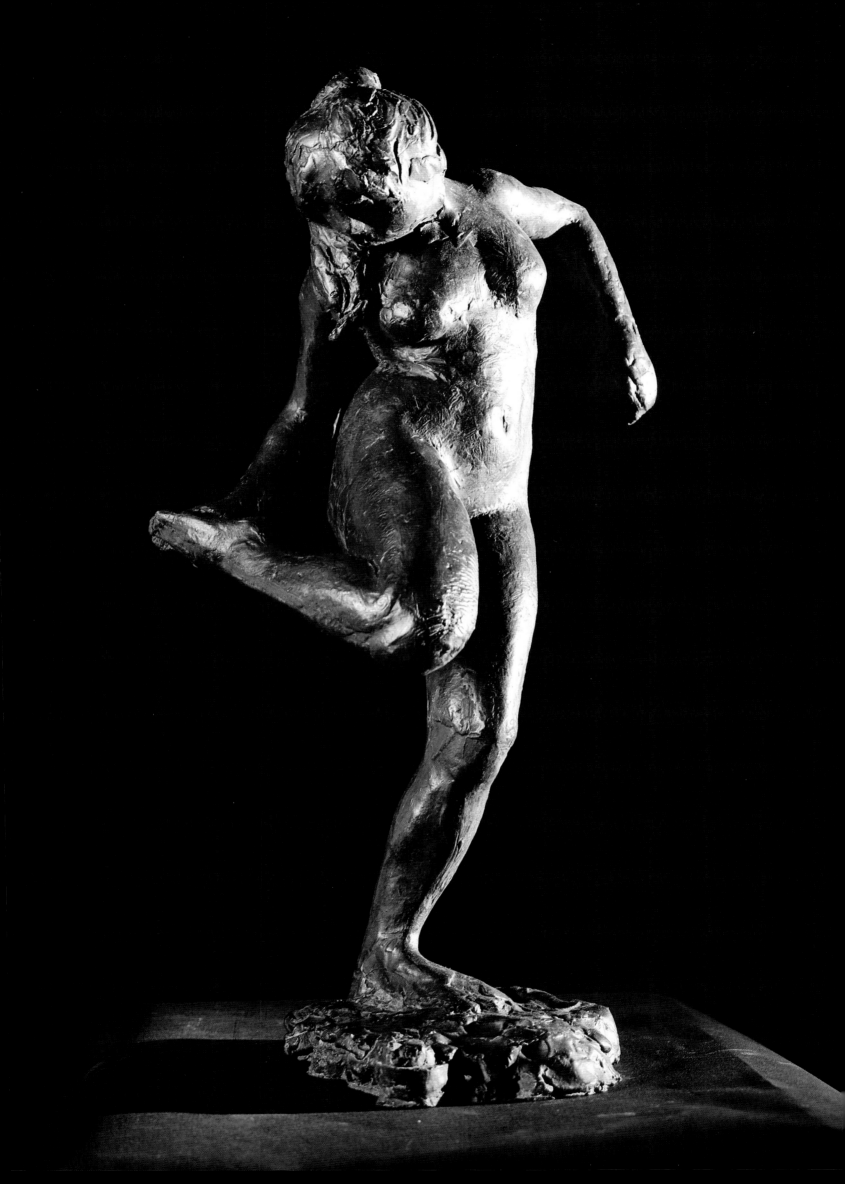

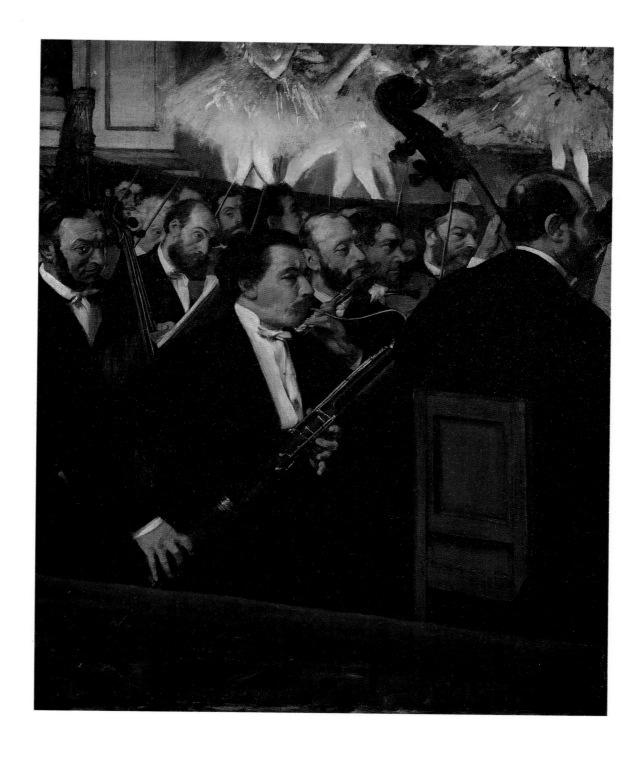

The Orchestra of the Opéra
1870, c.; *Oil on canvas; 22 1/4 x 18 1/4 in. (56.5 x 46.2 cm.).*
Paris, Musée d'Orsay.
*Musicians exhibit various expressions while dancers
perform on the stage. The former owner of the
painting, the bassoonist Dihau, is seen prominently
at the center playing his instrument. Other
musicians and friends of the artist can also
be identified. In the stage box, the likeness of
composer Emmanuel Chabrier is a later addition.*

The Song Rehearsal
1872-1873; *Oil on canvas; 31 7/8 x 24 5/8 in. (81 x 65 cm.).*
Washington, DC, Dumbarton Oaks Research Library.
*Degas was accustomed to hearing musical performances
in private homes from the time of his early childhood.
Here he presents two singers during a rehearsal.
Their theatrical gestures are typical of operatic divas.
The daytime setting, with its clear light and bright
yellow walls, is unusual in Degas's oeuvre. It was
most likely executed during his stay in New Orleans.*

The Song of the Dog

1876-1877, c.; *Gouache and pastel over monotype on paper;* 22 5/8 x 17 7/8 in. (57.5 x 45.4 cm.). Private Collection.
The singer of this café-concert has been identified as Thérèsa (Emma Valadon),
who was one of the great stars of the day. Degas himself called her voice "the most
natural, the most delicate, and the most vibrantly tender" instrument.

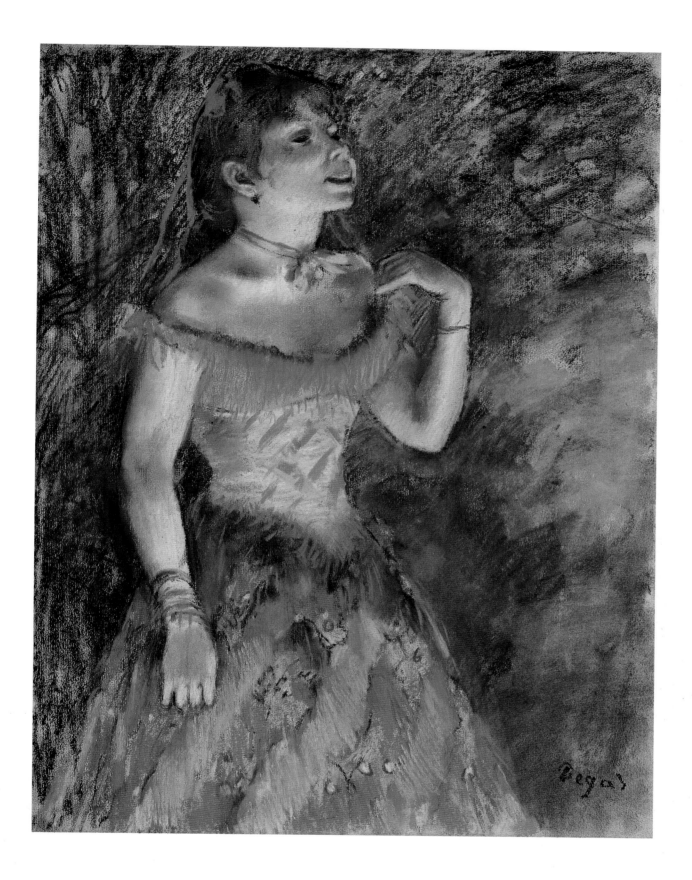

The Singer in Green

1884, c.; *Pastel on light blue paper; 23 3/4 x 18 1/4 in. (60.3 x 46.3 cm.).* New York, Metropolitan Museum of Art. *"Skinny and with the graceful movements of a little monkey, she has just sung her ribald verses and, with a gesture that conceals an entreaty behind her smile, is inviting applause."* Thus this picture was described at its sale in 1898. The vivid yellow, turquoise, and orange evoke the cheap costumes of a café-house stage.

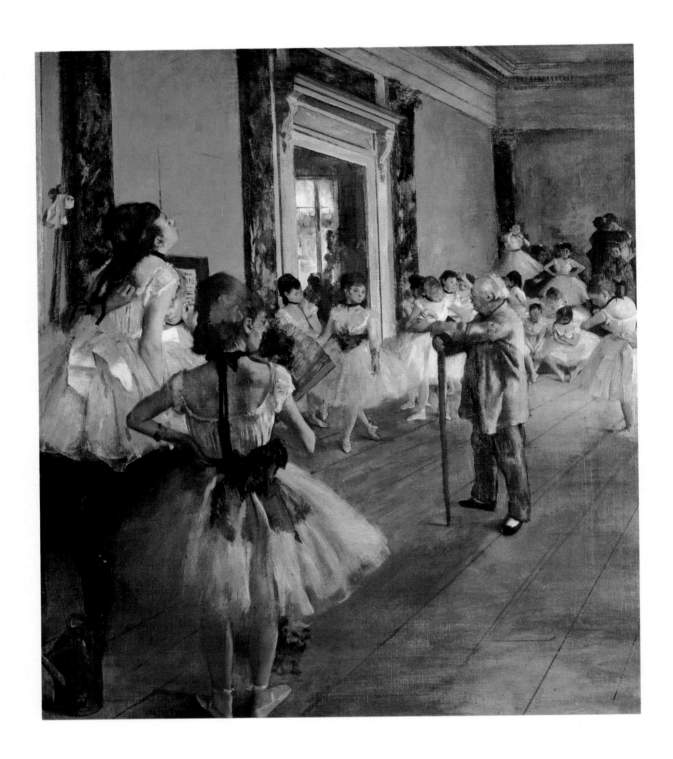

Dance Class

begun 1873, completed 1875-1876; *Oil on canvas;*
33 1/2 x 29 1/2 in. (85 x 75 cm.).
Paris, Musée d'Orsay.
*The present scene appears to represent a break
during a dance class, allowing the students to
relax. The light and almost translucent handling
of the paint make Degas's efforts almost notice-
able. It was his first attempt of a large-scale
dance scene commissioned by the famous
baritone and art collector Jean-Baptiste Faure.*

The Dance Class

1874; *Oil on canvas;* 33 x 31 3/4 in. (83.8 x 79.4 cm.).
New York, Metropolitan Museum of Art
(Harry Payne Bingham Bequest, 1986).
*Related to another version in the Musée d'Orsay, the style
of this canvas is bolder and the effects of light are more
brilliant than in its counterpart. Degas showed a greater
concern for specifics, for instance in the magnificent pose of
the dancer at the center watched over by the old dance master.
Two girls in the front help each other to fix their outfits.*

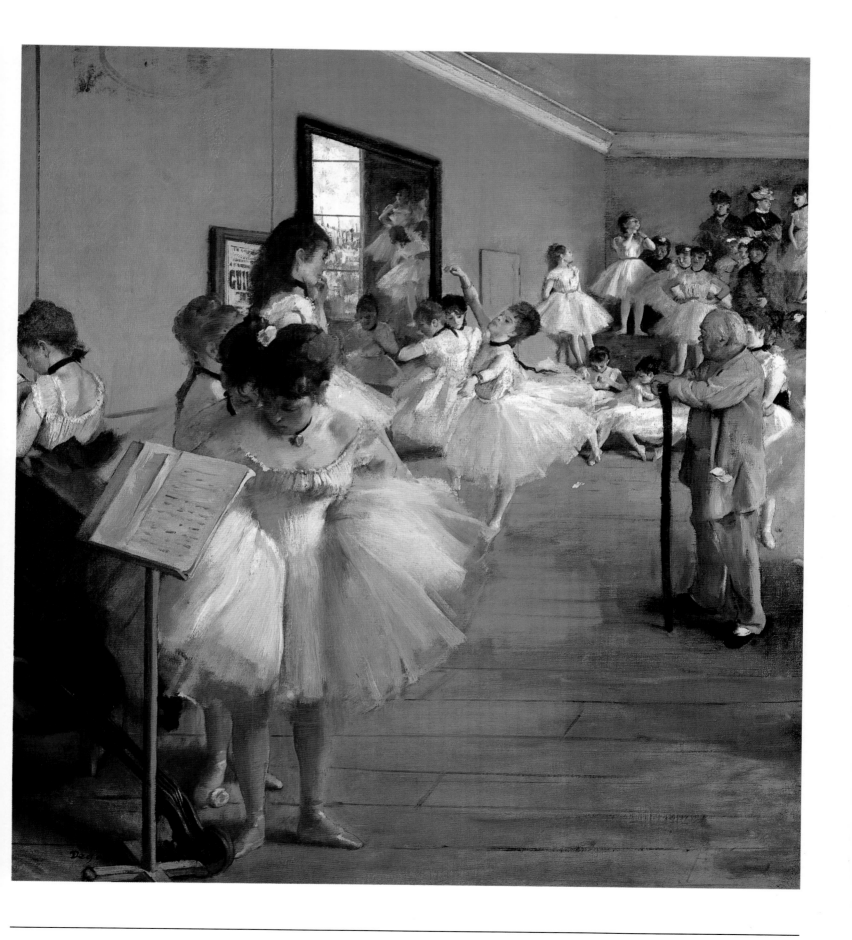

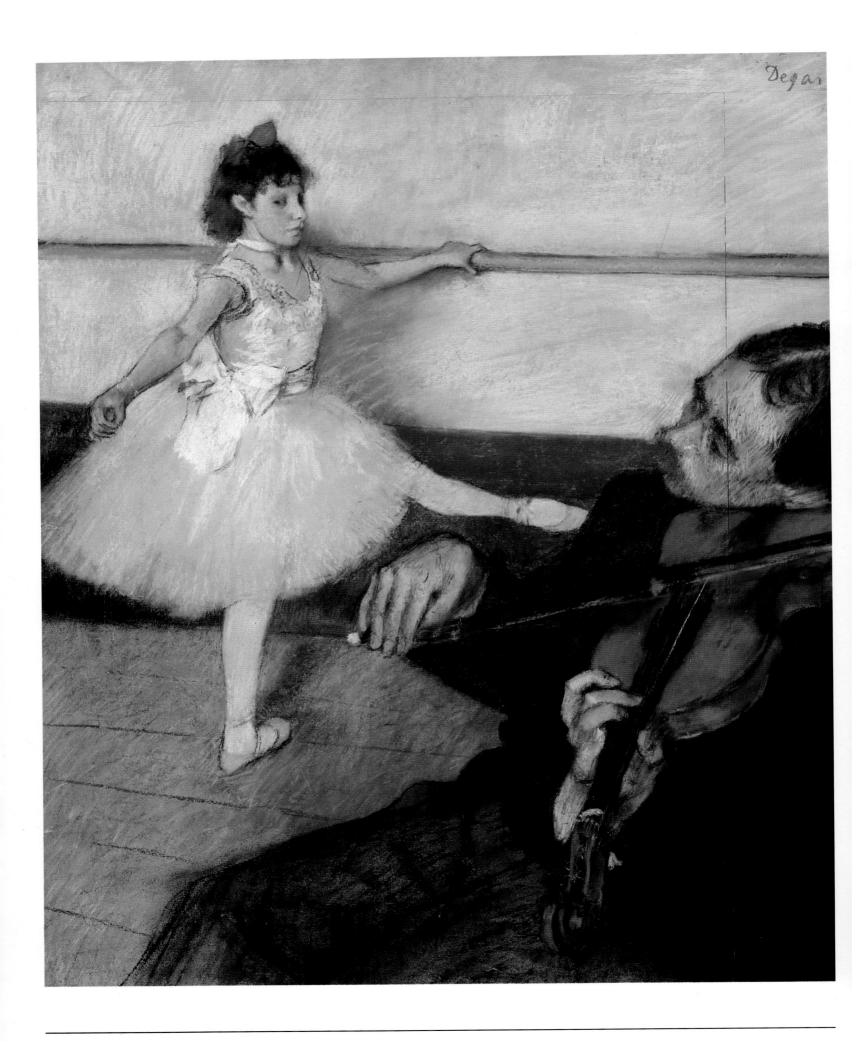

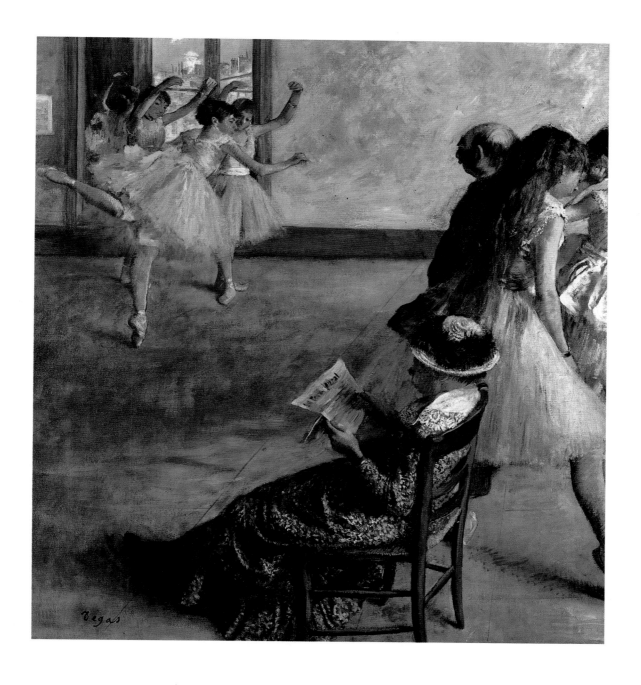

The Dance Lesson

1879, c.; *Black chalk and pastel;* 25 3/8 x 22 1/8 in. (64.6 x 56.3 cm.).
New York, Metropolitan Museum of Art.
Rarely did Degas observe a single dancer with such
precision. Her delicately drawn body dominates the
scene, despite the violinist's overwhelming presence.
Her right leg raised, she is attentively listening to the
music while awaiting her signal. The musician, by
contrast, is rendered with more powerfully drawn outlines.

The Dance Lesson

1881, c.; *Oil on canvas;* 32 1/8 x 30 1/8 in. (81.6 x 76.5 cm.).
Philadelphia, Museum of Art.
The painting's first owner was Alexander Cassatt,
brother of the artist Mary Cassatt, who received the
work after many delays and retouchings in Philadelphia
in September 1881. It offers a casual look into a room
where two ballerinas are rehearsing a specific movement
while two others are standing on the right adjusting
their outfits. The woman in a blue dress reading a
newspaper is an ironic addition to the events.

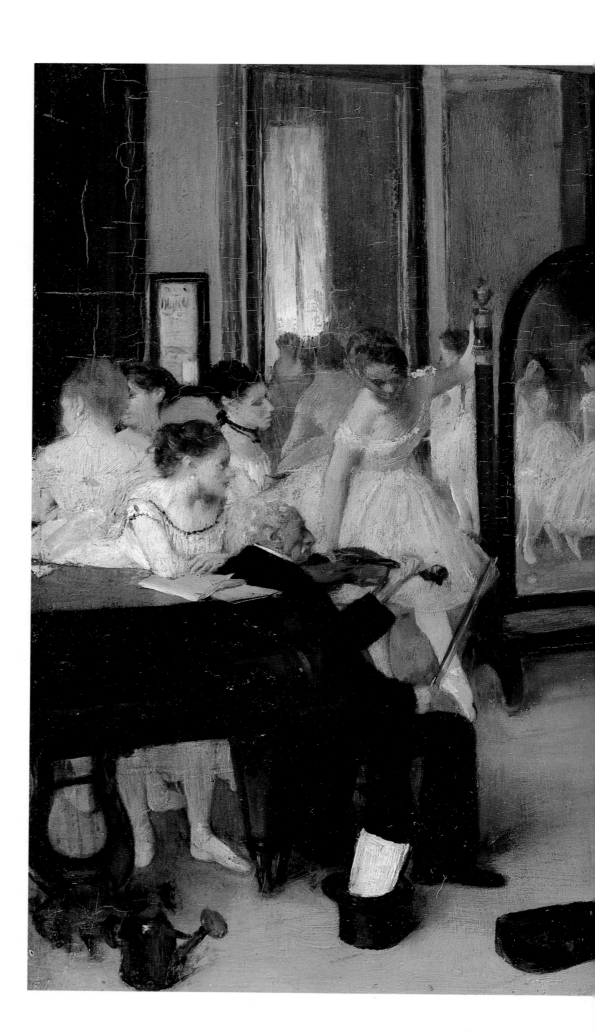

The Foyer (Dance Class)
1871; *Oil on panel;*
7 3/4 x 10 5/8 in. (19.7 x 27 cm.).
New York, Metropolitan
Museum of Art.
*Since Degas did not have access
to the backstage of the opera
until about fifteen years after
he finished this painting, he
must have studied the various
poses of the ballerinas in his
studio, to which he frequently
invited dancers. The one at
the center before the mirror
is Joséphine Gaujelin, also the
subject of one of Degas's portraits.*

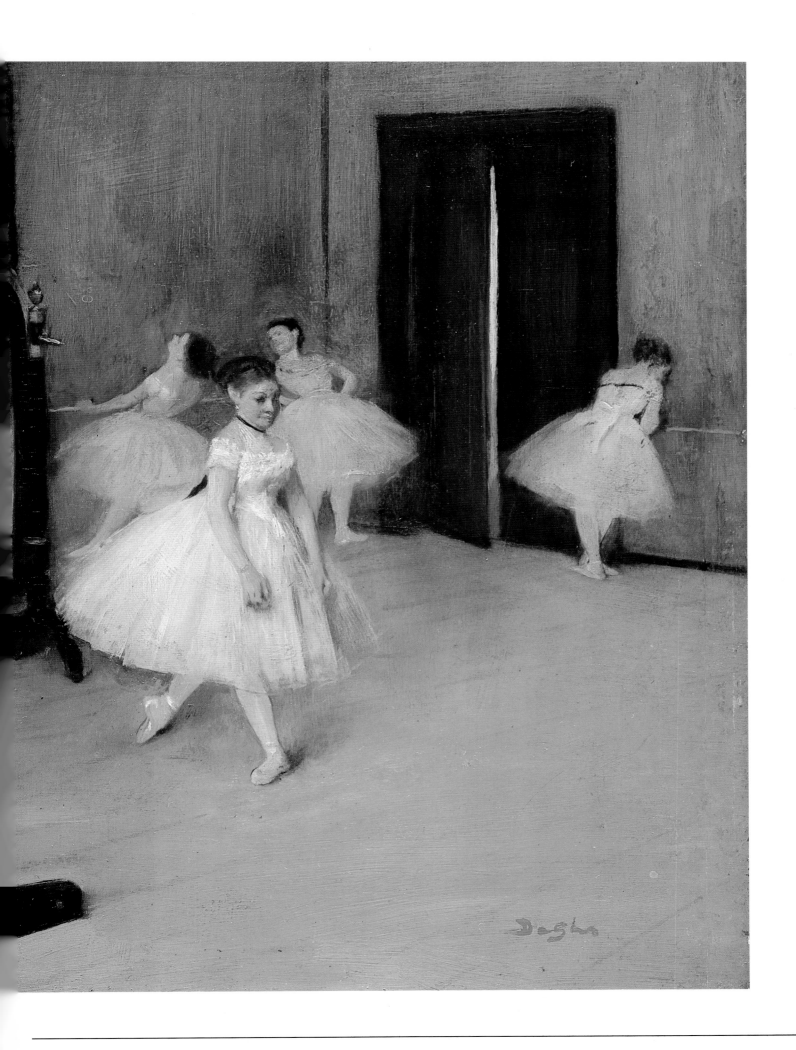

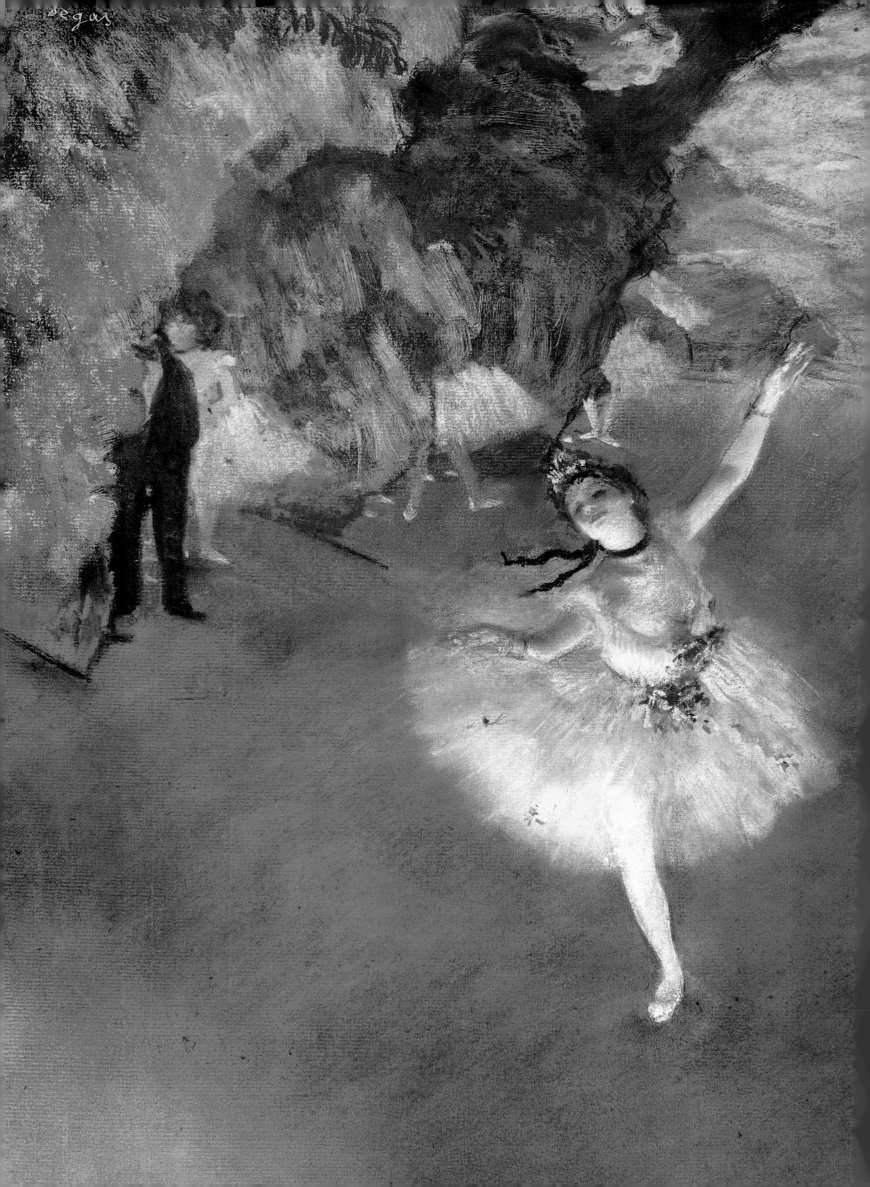

Fin d'arabesque

1877, c.; *Pastel, essence and oil on paper;*
26 x 14 3/8 in. (65 x 36 cm.).
Paris, Musée d'Orsay.
In a graceful gesture a ballerina
bows down to take a curtain call
in front of an invisible audience
after the performance of a solo
part. She is holding a bouquet
of flowers in her right hand,
which must have been given
to her by one of her admirers.
Other members of the ensemble
can be seen in the wings, where
they are awaiting their turn.

L'Étoile

1876-1877; *Pastel over monotype;*
22 7/8 x 16 1/2 in. (58 x 42 cm.).
Paris, Musée d'Orsay.
The magical moment of a ballet
star's solo performance is seen
from a stage box. The empty space
around the dancer differentiates
her from the others, who are
awaiting their turn in the wings.
The male figure dressed in a
black tuxedo is a typical example
of a "protector." His face hidden
by the stage sets, he remains
anonymous to the viewer.

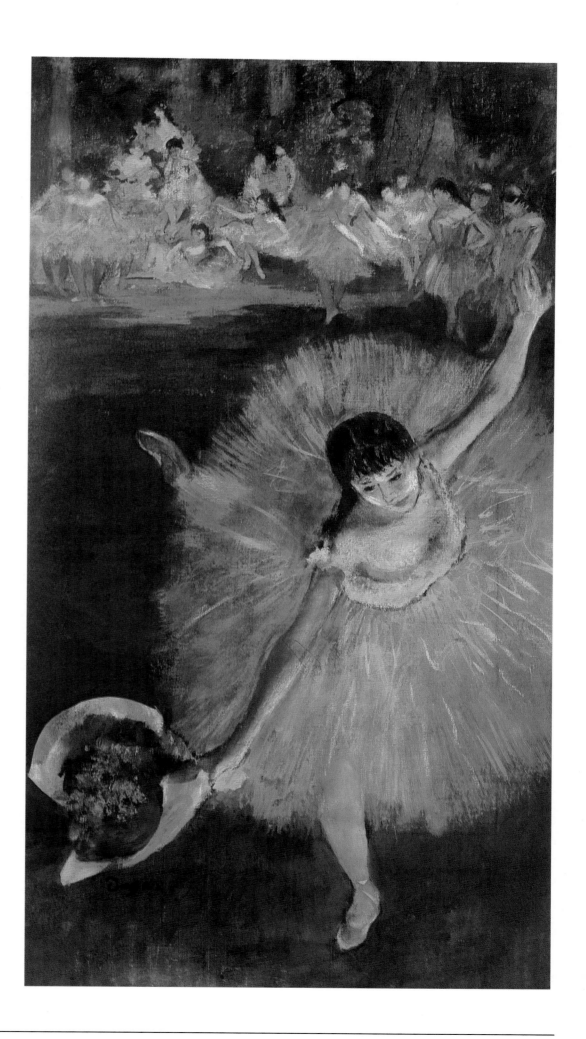

**The Green Dancer
(Dancers on the Stage)**
1880, c.; *Pastel and gouache on
paper; 26 x 14 1/4 in.
(66 x 35 cm.).*
Madrid, Thyssen-Bornemisza
Museum.
*The green dancer in the
foreground presenting an
arabesque is part of a larger
group of performers observed
from a box. Their diagonal
movement is counterbalanced
by the horizontal frieze
of dancers dressed in orange,
who await their cue at
the rear of the stage.*

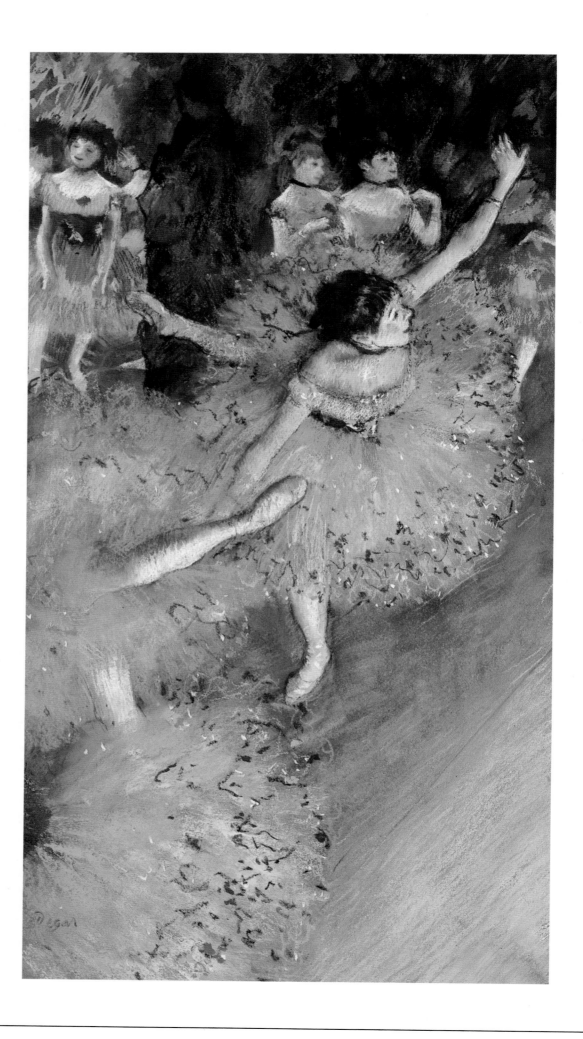

Four Ballerinas Behind the Stage

1898, c.; *Pastel on paper*; 26 x 26 3/8 in. (66 x 67 cm.).
Moscow, Pushkin Museum of Fine Arts.
*The typical gestures of ballerinas—stretching their limbs
or adjusting their outfit—are the focus of this charming,
intimate scene. It is entirely possible that Degas used the
same model for all four figures, in order to examine every
possible angle, and then compressed his studies into one group.*

**Ballerina and Woman with Umbrella
on a Bench (L'Attente)**
1882, c.; *Pastel on paper*; 19 x 24 in. (48.2 x 61 cm.).
Malibu, California, The J. Paul Getty Museum
(owned jointly with the Norton Simon Museum,
Pasadena, California).
*Traditionally, the subject of this pastel has been
interpreted as a young dancer from the provinces
who is waiting with her mother for an audition.
The older woman contrasts strikingly with
the dancer, rubbing her sore ankle. Both figures
remain anonymous in their individual solitude.*

Dancers at the Barre
1900, c.; *Oil on canvas*; 51 x 38 in. (130 x 96.5 cm.).
Washington, DC, © The Phillips Collection.
*Two dancers with their backs to the viewer are exercising
at the barre, stretching their legs. The greenish-blue
tutus are complemented by a glowing orange wall behind
them. It is perhaps the degree of abstraction that is most
startling about this painting. Degas seems to echo Stéphane
Mallarmé's observation that a dancer is a work of art.*

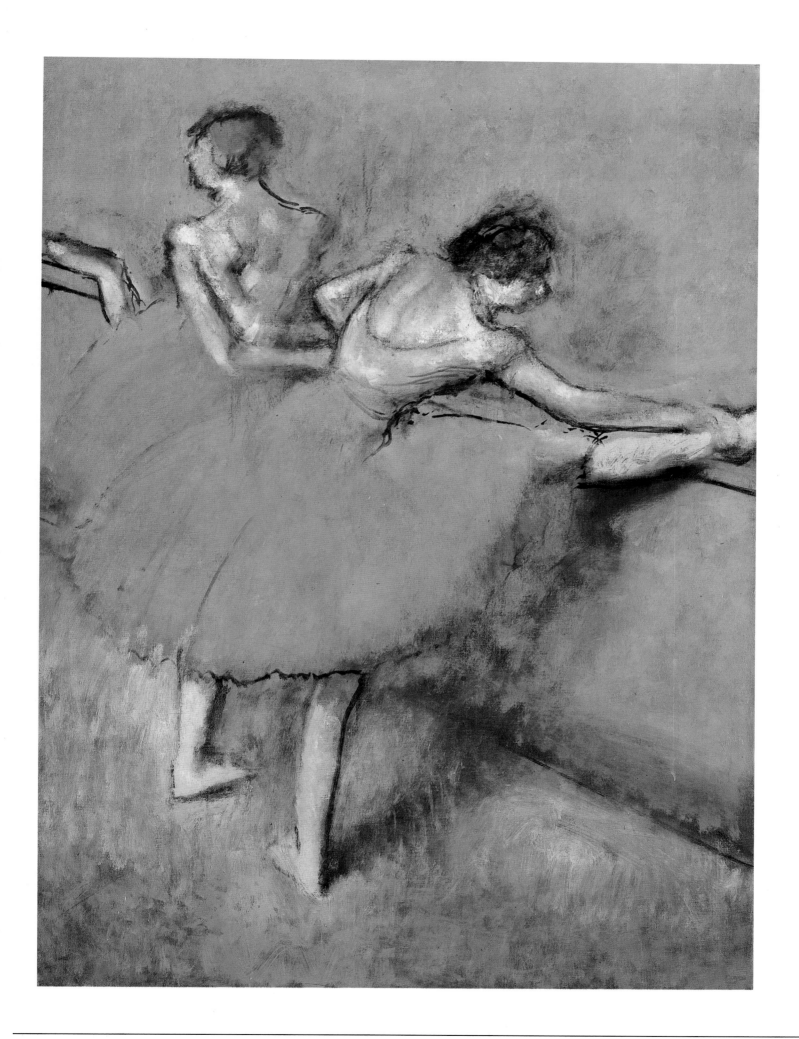

Grande Arabesque
1885-1890; *Bronze*; 15 3/4 in. (40 cm.) high.
London, The Tate Gallery.
The position of the dancer leaning forward is known as
a grande arabesque. The grace and perfect balance reveal
the artist's intimate knowledge of the classical ballet. Other
sculptures explore the same attitude in different positions.

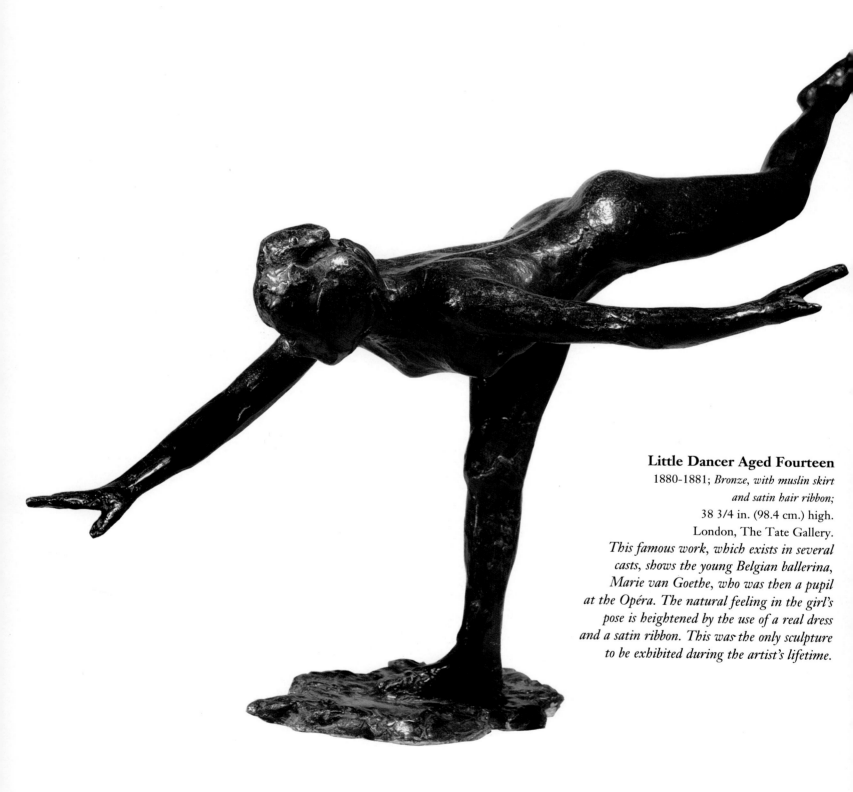

Little Dancer Aged Fourteen
1880-1881; *Bronze, with muslin skirt*
and satin hair ribbon;
38 3/4 in. (98.4 cm.) high.
London, The Tate Gallery.
This famous work, which exists in several
casts, shows the young Belgian ballerina,
Marie van Goethe, who was then a pupil
at the Opéra. The natural feeling in the girl's
pose is heightened by the use of a real dress
and a satin ribbon. This was the only sculpture
to be exhibited during the artist's lifetime.

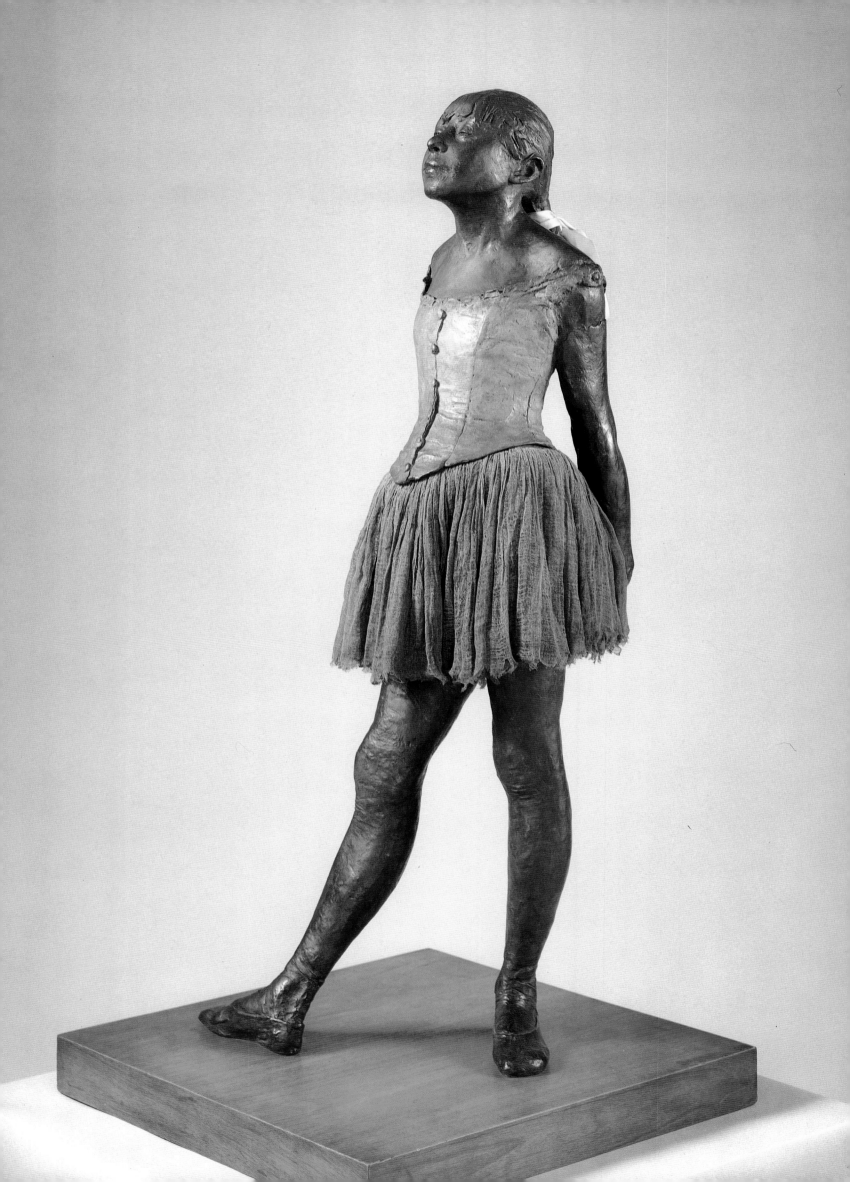

CHAPTER 4

THE BATHERS

Toward the mid-1880s a marked shift took place in the course of Degas's art. His compositions became more simplified, the space became shallower, the viewpoint was brought down to near eye level, and attention was focused on a single figure or figure group. Degas returned to an early approach to the human form, which he had left behind since the 1860s, when he had copied the Italian masters. Humor and anecdote are now conspicuously absent. It appears as if Degas had gone through a process of clarification, a catharsis, that led him to a new style.

Rediscovery of Drawing

This becomes most evident in a series of large pastel nudes, where only one or two figures at the most dominate. In fact, his compositions are usually so cropped that there is no space for anything else. Colors are more muted and the technique has become straightforward and simple. Some works are actually almost monochromatic. Consequently, Degas focused again on the strength of drawing, as in his youthful works. This decision was probably a reaction to the high-keyed palettes of Monet, Renoir, and Camille Pissarro, which Degas rejected. Instead, he distilled and condensed in his bathers a new, synthetic classicism based on line.

Manet was the only artist with whom Degas had maintained a competitive relationship over the years. With Manet's death in 1883, their secret rivalry had come to an end. When Degas finally saw Manet's nudes, which he had not viewed before, he might have felt compelled to reclaim this field for himself. The critic Gustave Geffroy, writing in 1894, compared Degas's nudes to those by other French artists (including Manet's *Olympia*) and concluded: "Degas had another comprehension of life, a different concern for exactitude before nature. There is

certainly a woman there [in Degas's pictures], but a certain kind of woman, without the expression of a face, without the wink of an eye, without the decor of the toilette, a woman reduced to the gesticulation of her limbs, to the appearance of her body, a woman considered as a female, expressed in her animality, as if it were a matter of a superior illustration of a zoological textbook."

Indeed there is something animalistic about these

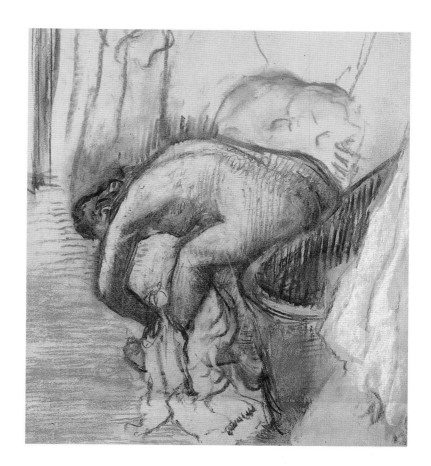

After the Bath

1903; *Pastel on paper;* 24 x 20 in. (61 x 51 cm.).
São Paulo, Museu de Arte.
This is one of the late works by the artist, when his eyesight had already deteriorated. However, he was still active then, producing works of great color and charm. Here a bather is shown after her bath, absorbed in her own world and completely oblivious of the viewer.

Breakfast After the Bath

detail; 1895, c.; Paris, Private Collection.
The flesh of this bather, who has just stepped out of the bathtub, has been defined with energetic pastel strokes thus underlining the woman's strong and youthful body. The movement of her raised arms, which are about to dry her hair with a towel, adds even more vigor to her presence.

provocative nudes, or rather something infinitely natural in the strictest sense of the word. Unity is achieved through synthesized drawing as a result of a multitude of sketches. The figures do not even hint at the efforts on the part of a model in posing long hours. The nudes are present in the most rudimentary form of their existence, not seen through the keyhole, but showing themselves without inhibitions.

The strong and almost independent contours of Degas's nudes impressed not only critics but also younger artists like Gauguin, who admired the expressive properties of form, line, color, and feeling. Pastel allowed Degas to apply color in a linear manner, thus fusing color with drawing.

Color and Imagination

In his late works of the 1890s color began to reemerge, taking on an importance equal to that of line and applied in an equally independent manner. Degas's high-keyed, antinaturalistic palette, and strong, abstracting line brought him close to Symbolism at the end of the decade. At the same time, his imagination found increasingly greater expression in his work. In fact, Degas often told young artists that drawing from memory liberates

fantasy from the tyranny of nature. The space and surroundings of his late-period bathers is frequently theatrical and artificial, the line increasingly forceful, the colors often strong and harsh. But the greatest change occurred in the bodies. The aging figures are struggling wearily with the fragility of their limbs and the weights of their torso, but they still possess an innate power and strength that allows them to struggle against infirmities.

These late works have often bothered critics, who saw in them nothing but the output of a deteriorated, senile artist with failing eyesight. It is indeed not easy to understand why an artist like Degas, who had placed so much emphasis on the individual in a social environment and who apparently believed in the capacity for human perfection, should have expressed subjects like loneliness, anguish, frustration, and futility. At the same time, these works express also the power and force of the human will.

Explorations in Pastel

Among the more familiar works in the bather series is the 1886 pastel *Le Tub*. A nude woman, a figure of frail beauty, is taking a bath in a shallow tub under a pale early morning light. Crouching like the classical figure of

Woman Drying Her Arms

1884; *Pastel on paper;*
23 1/4 x 25 5/8 in.
(58 x 64 cm.).
São Paulo, Museu de Arte.
Sitting on a sofa, over which she has draped a large peignoir or towel, the woman is drying her arms after the bath. Her position is slightly awkward, or at least uncomfortable, but her body creates a voluminous space. The floor with its blue, red, and ocher pastel tones is the most colorful part of this work.

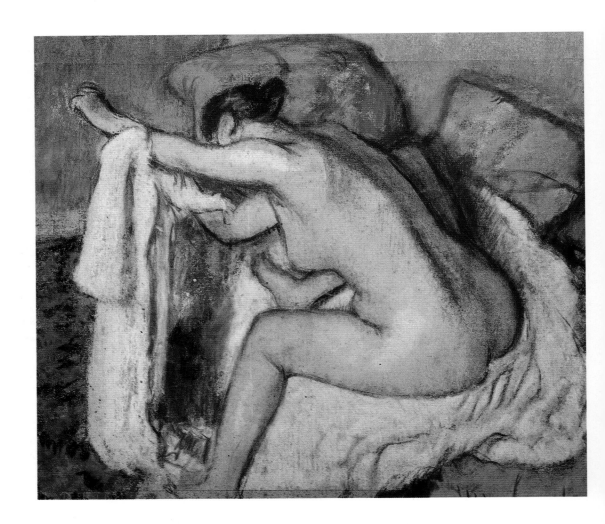

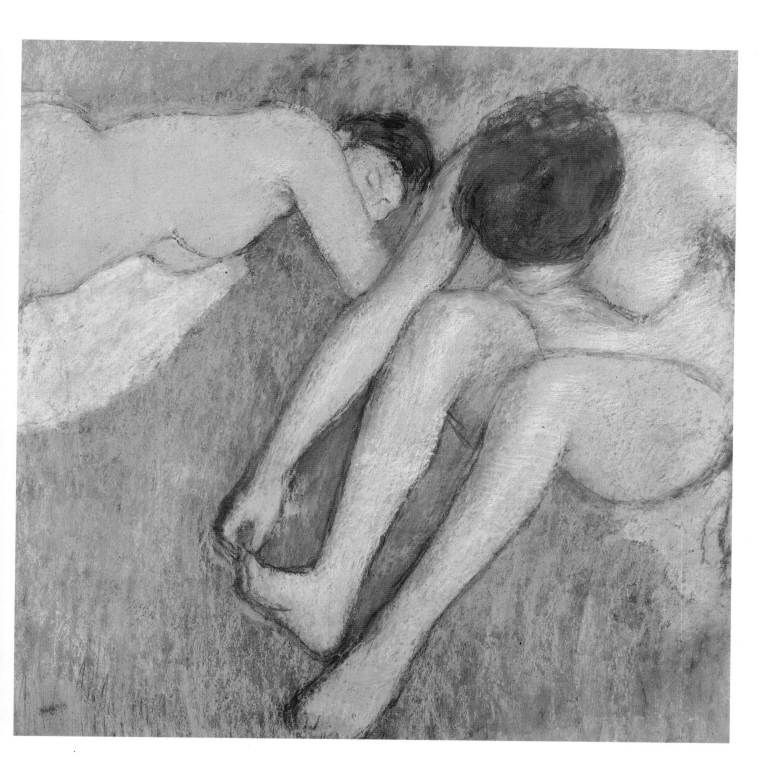

Venus, she follows her ritual with calm and dignity. On a marble-top dresser nearby are displayed the utensils of the bather's toilette. The intrusive viewpoint from above is different from most other bather pastels. The slightly earlier *Woman in a Bathtub, Her Left Leg Raised* has a more light-hearted tone. The bathtub is placed at the center of the room and obviously does not have full plumbing, which was still a luxury at that time. Her left leg stretched out, the bather is carefully sponging her leg. The modest decor of the room indicates the woman as a member of the working class.

Occasionally the bathers or nudes are shown in company of a maidservant, who might be bringing in a cup of morning coffee or combing the woman's hair. *Breakfast After the Bath* of 1895 is an ambitious work not only

Two Bathers on the Grass
1896, c.; *Pastel on paper;*
27 1/2 x 27 1/2 in. (70 x 70 cm.).
Paris, Musée d'Orsay.
Two women are resting on the green grass; one seems to be sleeping, the other is examining her right foot. The artist's tendency to simplify the figures anticipates works by Matisse. The outdoor setting for such a scene is quite unusual in Degas's oeuvre—not so, however, his rich and sumptuous use of the pastel.

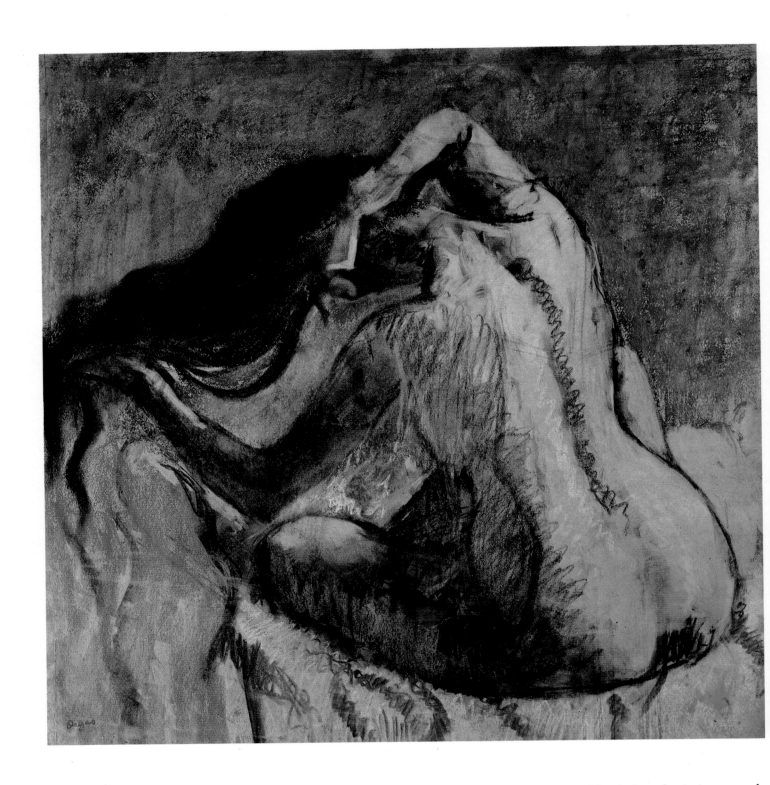

Woman Combing Her Hair

1897, c.; *Pastel and charcoal on cardboard;*
27 3/4 x 27 3/4 in. (70.5 x 70.5 cm.).
Zurich, Kunsthaus.
The ritual of a woman combing her hair had long fascinated Degas, who interpreted the subject in all its various aspects. Until the end of his artistic career in 1912, he relentlessly pursued his own way of representing "reality."

in its brilliance of colors and high degree of finish, but also in its unusually large size. It is in fact among the largest of Degas's pastels. With forceful movements, the bather has just stepped out of her tub and is about to dry her long, luxuriant hair. Her body reflects the same colorful light as the wall and bathtub behind her. The splendid setting, with its variety of colorful, heavy fabrics, is almost Oriental. Yet the effect is mitigated only by the quiet figure of the maidservant, who has just arrived with a blue cup filled with coffee. Her purple blouse complements the green wall above her head, while the apron is almost of the same white color as the woman's towel. In creating *Woman at her Bath* (which is actually an oil painting), the artist indulged in exotically beautiful colors. Particularly striking are the

purple and rose towels against a green and orange wall. The orange glow on the bather's body seems to be a reflection from the water in the tub. A barely defined maidservant is carefully pouring water over the bather's neck using a purplish-blue pitcher. The viewer's eyes are relentlessly drawn· back into the picture plane by the figure's abrupt contours. The image is a highlight of a decorative and sensuous enjoyment of color.

Late Works

Two works of women having their hair combed illustrate the changes in Degas's work during these years. The earlier version, dating from 1886 to 1888, is a highly finished work. Degas probably intended to exhibit it at the eighth Impressionist exhibition in 1886. The extraordinary figure of the bather, who resembles Marie van Goethe, the model for the *Little Dancer Aged Fourteen*, is beautifully proportioned and supremely refined in execution. Countless strokes with the pastel modeled the body subtly into relief. The chaise longue serves as a strong diagonal element, providing depth of space for the scene. The various gold tones of the wall have also been used for the chaise longue. The white peignoir floating down onto the floor finds its continuation in the apron of the maid, who is combing the woman's henna-red hair. The woman appears to enjoy this private moment of narcissistic pleasure in a luxurious and comfortable environment.

The second work, completed several years later, is an almost monochromatic orgy of red and orange. The position of the apparently pregnant woman having her hair combed is uncomfortable, if not painful. The frailty of the woman's body is obvious. Her right arm is lifted to her head as if she were suffering from migraine, while the left is raised in a protective gesture. Her heavy orange hair terminates in the figure of the attentive maidservant, who stands with great serenity and stability in marked contrast to her suffering mistress. Degas obviously enjoyed working within such a restrained range of color—again it is oil—indulging in the various shades of orange and red, drawing black outlines around the figures and the drapery on the left, and adding a break with the amber-colored comb and brush. The serenity of the earlier work has disappeared, but the image has gained a forceful expressiveness instead. This daring painting, which is usually described as unfinished, has qualities that have attracted other painters since Degas's death. Henri Matisse was for some years its owner. Degas himself, acknowledging the difficult aesthetic of the work, anticipated that it might never find a caring collector.

The bather in the 1896 work *After the Bath*, today in a private collection, is based on a photograph of a nude made probably by Degas himself. The figure seems to writhe in pain. Her twisted body is partially leaning, par-

tially kneeling on a small sofa covered with a white towel. The bathtub in the foreground echoes the bather's stretched body, the head has succumbed to the shadow. At the same time, despite the anguish conveyed, there is a certain eroticism in this figure—not in the usual sense, however. Her vulnerability is moving, and the erotic response is transformed into compassion. This is certainly one of the most modern images Degas ever created. The intense cobalt blue of the wall and the orange-red of the rug and the woman's hair establish a stark mood.

Even in his latest works, which are admittedly more difficult to appreciate than his previous accomplishments, Degas managed to express his own powerful language cogently, boldly, and valiantly.

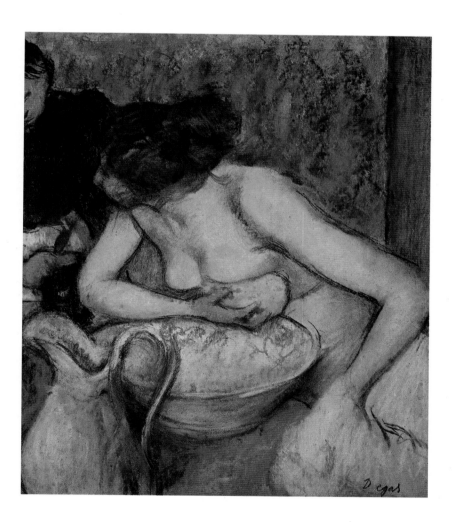

The Toilette

1897 c.; *Pastel on paper*; 24 x 19 3/4 in. (60.9 x 50 cm.).
London, formerly Christie's.
As a variant to the bather series, Degas painted a number of works of women at their toilette, mostly combing their hair. It seems that Degas used repeatedly the same model, which has been identified as Marie van Goethe. She was a ballet dancer, and was also the model for the famous sculpture of the Little Dancer Aged Fourteen.

**Bed-Time
(Le Coucher)**
1883, c.; *Pastel on
monotype on paper;*
9 x 17 1/2 in.
(23 x 44.5 cm.).
London,
The Tate Gallery.
*A young woman is
about to go to bed
and is pulling the
sheets over her body.
Degas frequently
reworked second
impressions of his
monotypes—the
results being paler
than the first
attempts. Here
the night scene has
been altered to a
daytime image.
The monotype shows
through in a few
places, the rest of the
paper being covered
with pastel colors.*

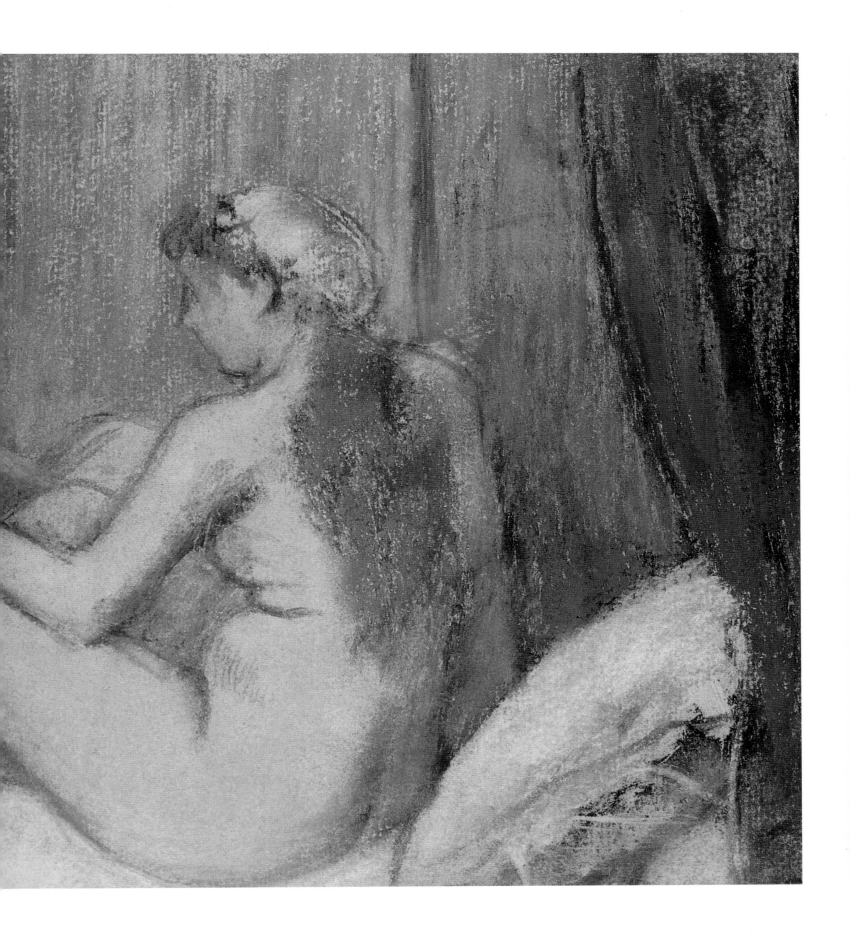

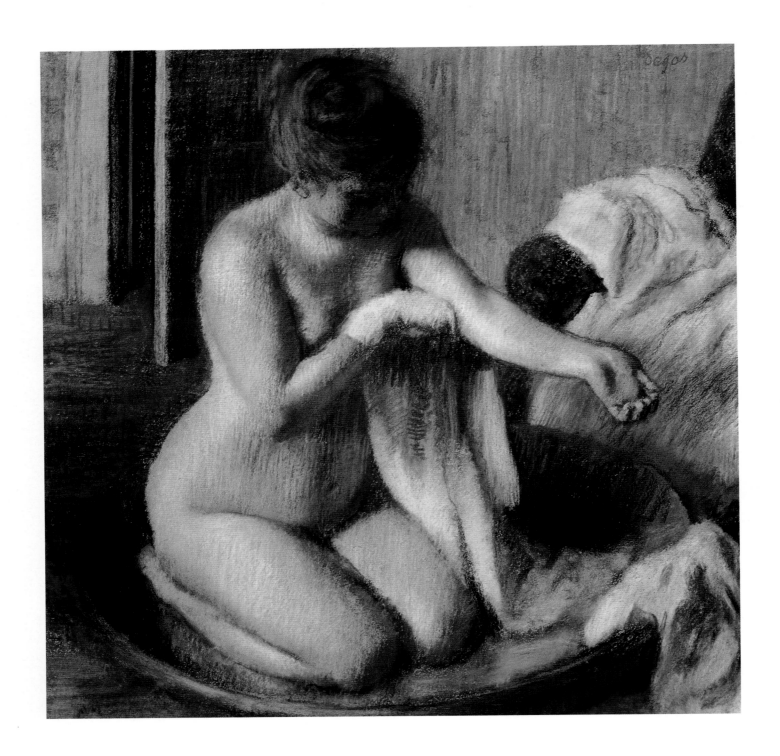

Woman in a Tub

1883, c.; *Pastel on paper;* 28 x 28 in. (70 x 70 cm.).
London, The Tate Gallery.
In his many versions of women bathing, Degas
depicted the same bathtub that was in his studio.
He would announce to his visitors that he took a
bath himself in it every morning. Degas's relation-
ship to his own body and that of his models was a
straightforward and certainly not a sentimental one.

Woman Sitting Drying Her Back

1885, c.; *Pastel on paper;* 33 x 28.8 in. (82.5 x 72 cm.).
St. Petersburg, Hermitage.
This pastel is one example of Degas's works in which
the demarcation line between drawing and painting
has vanished. A sharp outline seems to push the form
out of its plane, making the viewer feel all its intrinsic
corporeality. Squared for transfer, this pastel was apparently
intended for further elaboration in a different medium.

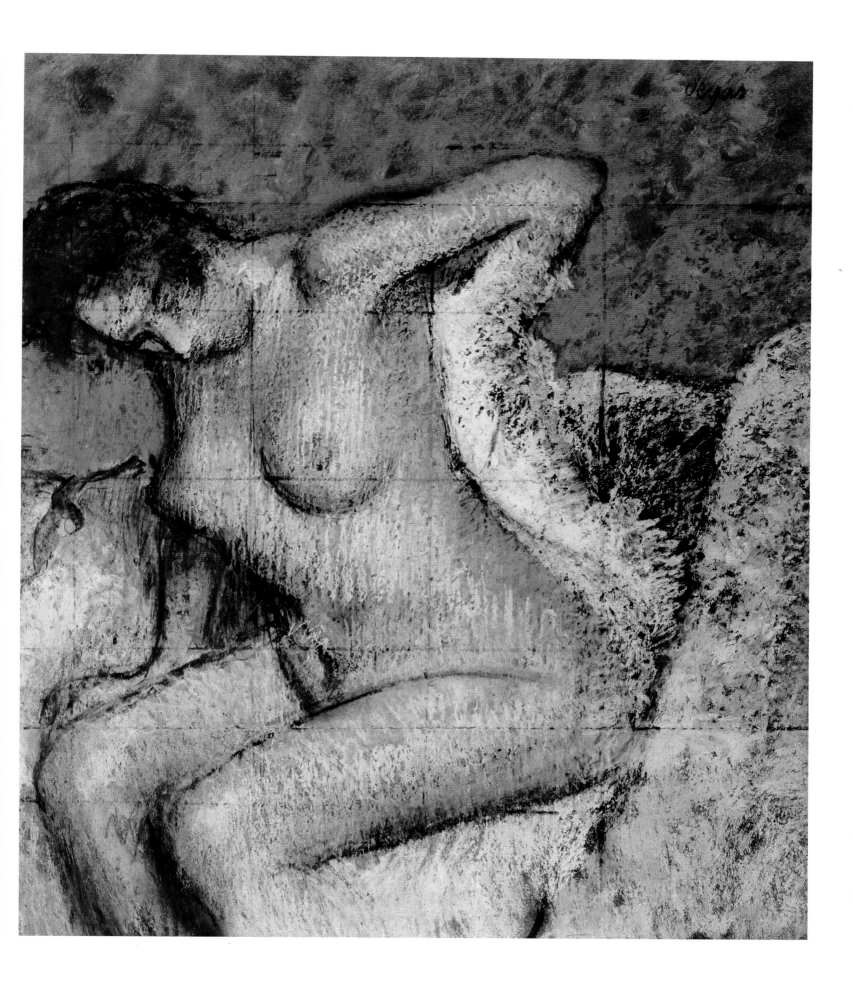

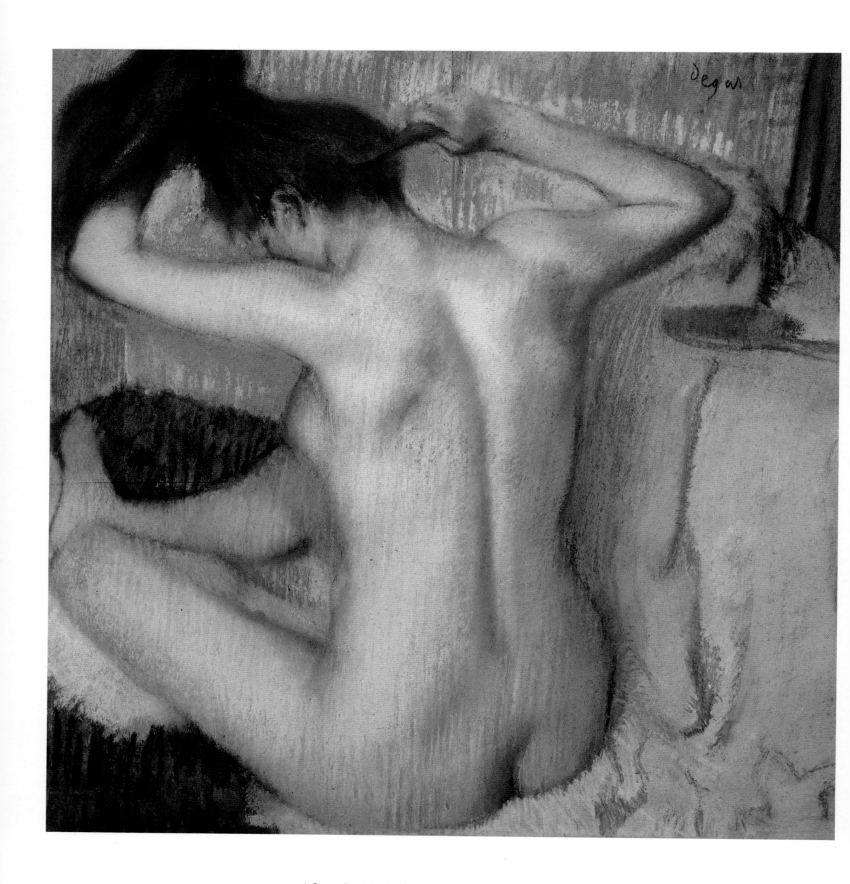

After the Bath: Woman Combing Her Hair
1885, c.; *Pastel on paper;* 20 7/8 x 20 1/2 in. (53 x 52 cm.). St. Petersburg, Hermitage.
The viewer is looking from above onto the woman who is sitting on the floor carefully combing her long hair. The clearly defined contours and elegantly linear rhythms still reflect a fidelity to Ingres's manner. Thanks to a complex, unusual vantage point, Degas widened the narrow space of the scene.

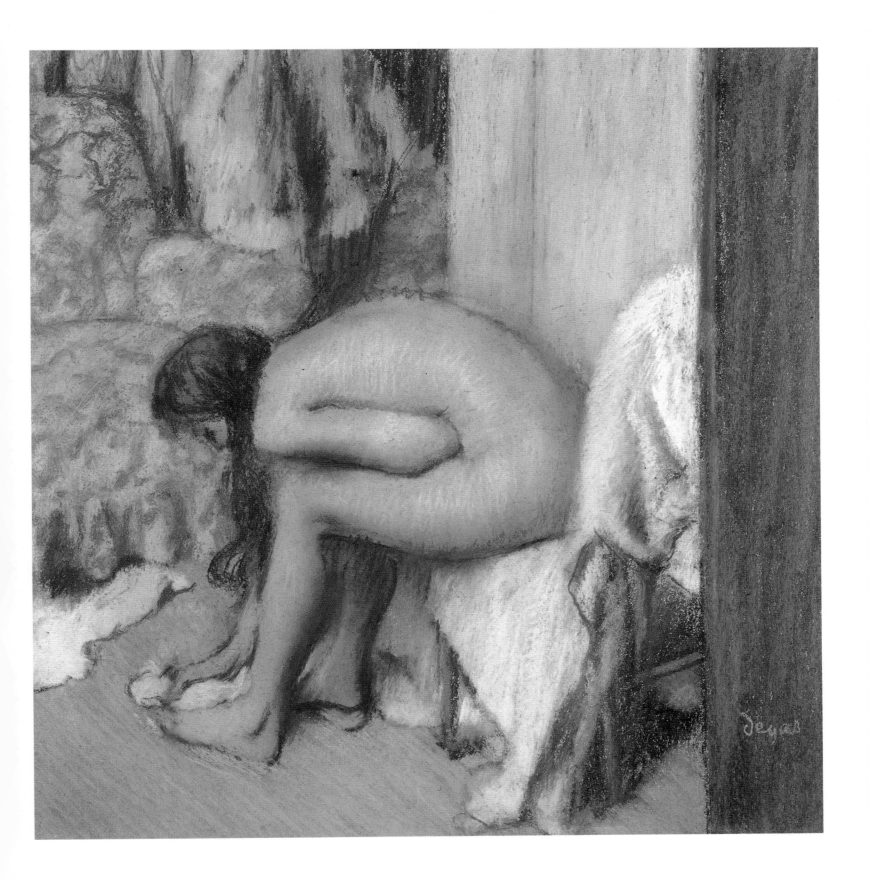

After the Bath, Woman Drying Her Feet
1885-1886, c.; *Pastel on paper;* 21 3/8 x 20 5/8 in. (54.3 x 52.4 cm.). Paris, Musée d'Orsay.
*Curved in an embryonic position, the bather is bending over to dry her feet, thereby pressing the torso hard
against her legs. The sinuous shapes are neither sensuous nor particularly appealing, but they are descriptive.
Degas always remained faithful to his sitters, and he can therefore rightly be regarded a Realist.*

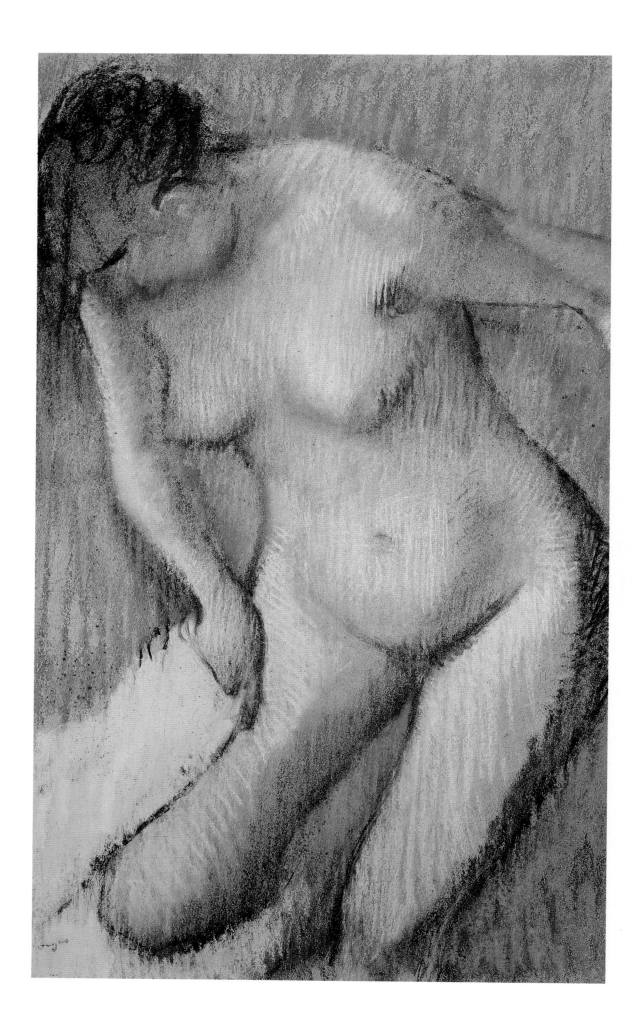

**Woman Drying
Her Right Leg Seen
from the Front**
1886; *Pastel on paper;*
28 7/8 x 19 5/8 in.
(72 x 49 cm.).
Rome, Galleria Nazionale
d'Arte Moderna.
*The heavy pastel strokes
on the woman's body are
clearly visible and attest
to the artist's occasional
impetuousness during
the process of drawing.
The head is barely
defined, but expressive.
Degas balanced beautiful-
ly the body's movement,
creating an image of
almost classical charm.*

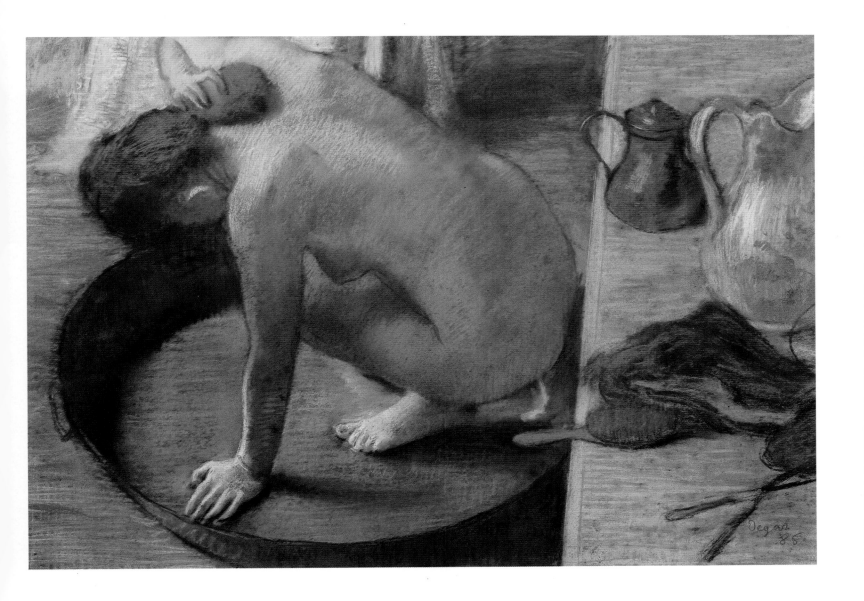

Le Tub (Woman Bathing in a Shallow Tub)
1886; *Pastel on paper;* 23 7/8 x 32 5/8 in. (60 x 83 cm.).
Paris, Musée d'Orsay.
Exhibited at the Impressionist exhibition in 1886, this nude
bathing in the delicate, cool morning light was particularly well
received by the critics. One of them likened it to a lovely Gothic
statue. On the chest of drawers, her accessories have been carefully
laid out, allowing the viewer to anticipate what will happen next.

Woman at Her Bath
1895, c.; *Oil on canvas;*
28 x 35 in. (71 x 89 cm.).
Toronto, The Art Gallery
of Ontario.
The strong, almost exotic
colors of the violet and
rose bath towels animate
this composition, in
which a bathing woman
is being assisted by a
maidservant pouring
water out of a blue jug
over her shoulders.

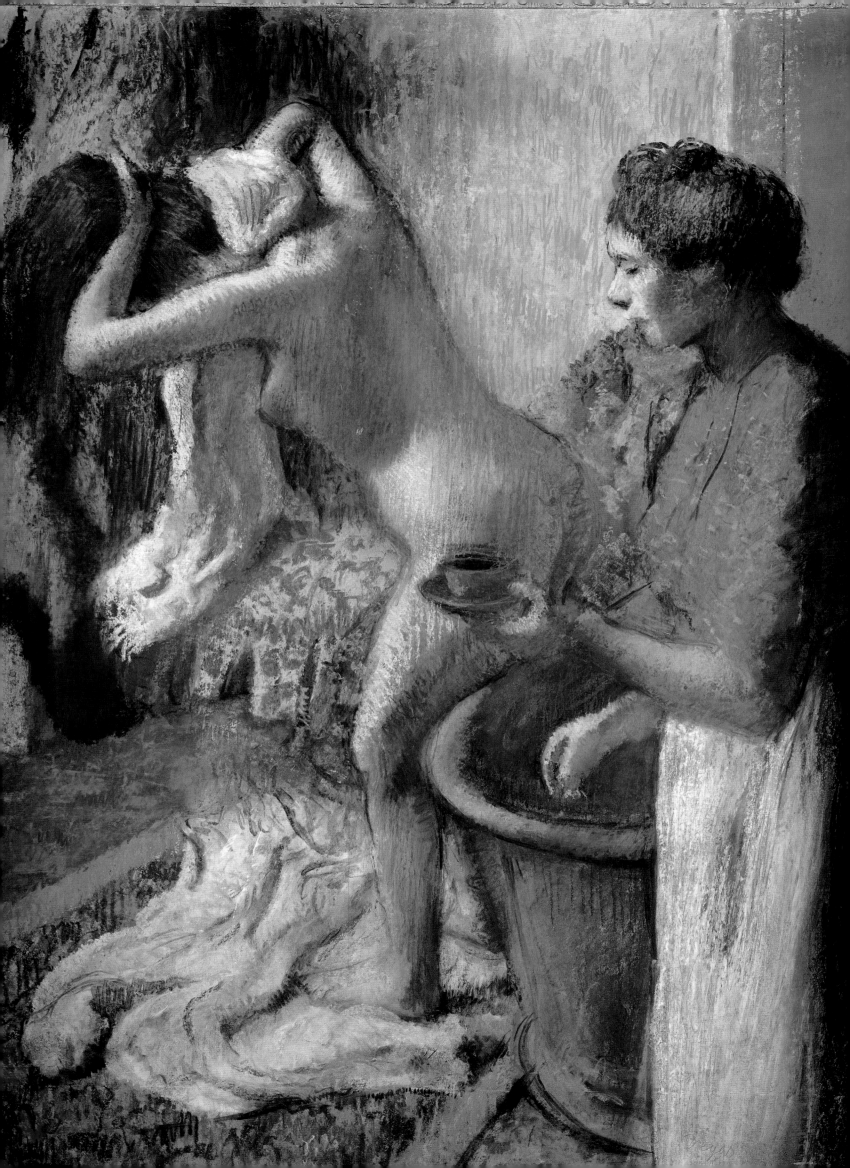

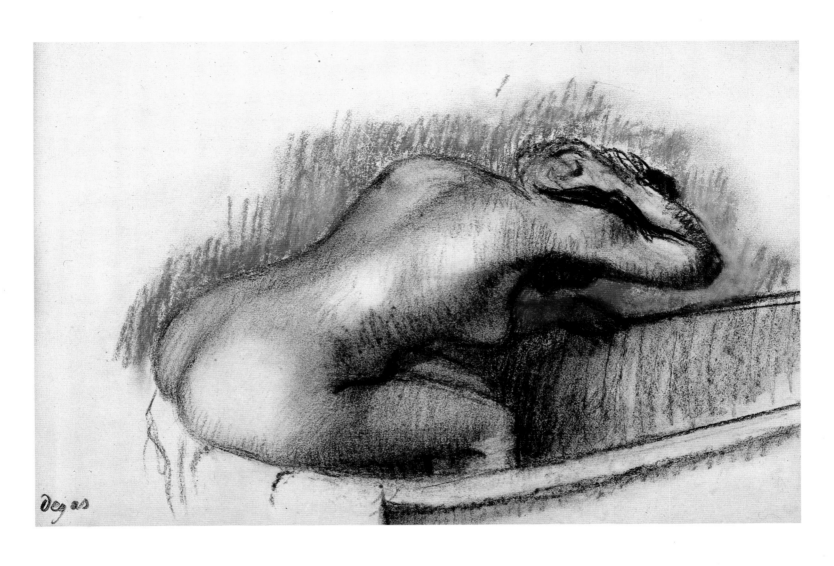

Woman Washing Herself in the Bathtub
1895, c.; *Pastel over charcoal on paper;*
12 1/2 x 18 5/8 in. (31.8 x 47.4 cm.). Paris, Musée d'Orsay.
*This rapid sketch depicts a woman sitting on the edge
of a tub sponging water over her neck. The tub cuts
obliquely across the picture plane, creating a sense of
space. The woman's body is the most defined part of
this work, while large areas of the paper are untouched.*

Breakfast After the Bath
1895, c.; *Pastel and brush on paper;*
47 5/8 x 36 1/4 in. (121 x 92 cm.).
Paris, Private Collection.
*A rich web of unbroken color has been created
by adding many layers of pastel, rubbing and
smearing them together. The curved back of
the bather underscores her energetic movement,
which finds its counterpart in the calm gesture
of the maidservant bringing a cup of coffee.*

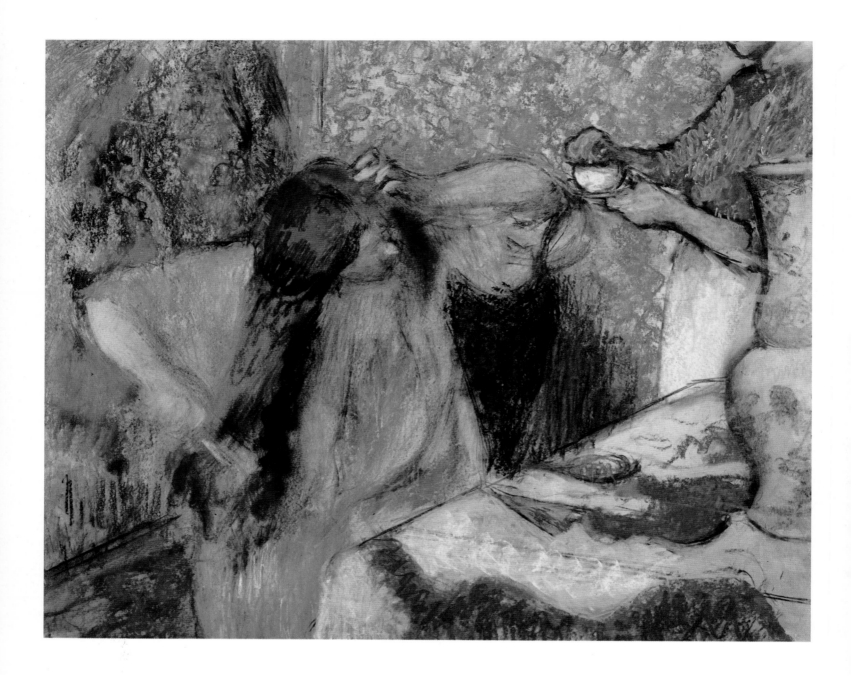

Woman at Her Toilette

1894, c.; *Pastel on paper;* 37 5/8 x 43 1/4 in. (95.6 x 109.9 cm.).
London, The Tate Gallery.
A woman sits comfortably in front of her dressing table combing her long hair. Her head is bent side-ways, while her arms form a harmonious arabesque. The dressing gown is of the same greenish yellow as the wall behind, so that they blend together. On the right a maid arrives with a cup of morning coffee.

After the Bath
1896; *Oil on canvas;*
45 1/2 x 38 1/4 in. (116 x 97 cm.).
Paris, Private Collection.
In his later works, Degas tended more and more toward abstraction. He was less interested in graphic lines and anatomical correctness than the interplay of form and color.

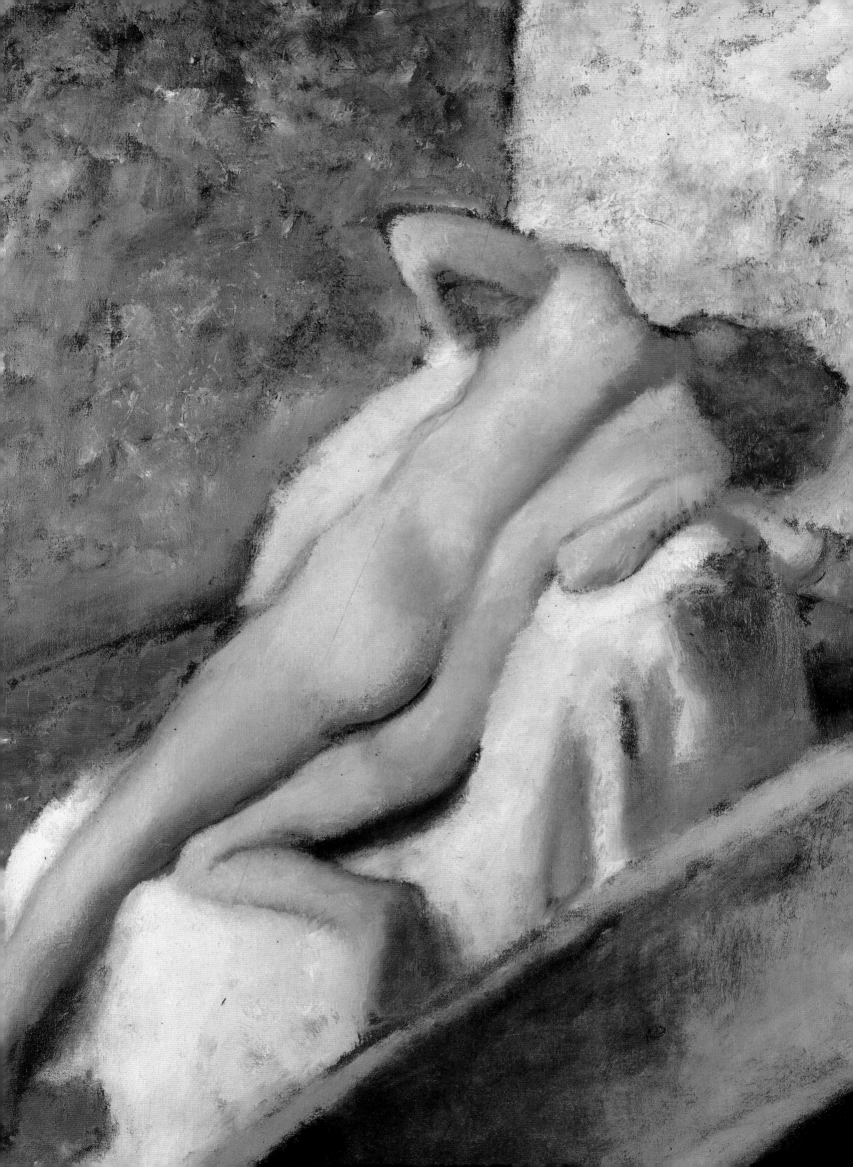

The Bath

1895, c.; *Oil on canvas*; 32 x 46 1/4 in. (81.3 x 117.5 cm.).
Pittsburgh, Pennsylvania, The Carnegie Museum of Art.
*Behind a heavily canopied unmade bed, a woman is getting
ready to enter a bathtub. The orange-colored fabric contrasts
with the cool blue of the wallpaper, while the white linen serves
as a resting area for the eyes. The composition is almost equally
divided in half by the curtain hanging down at the bedside.*

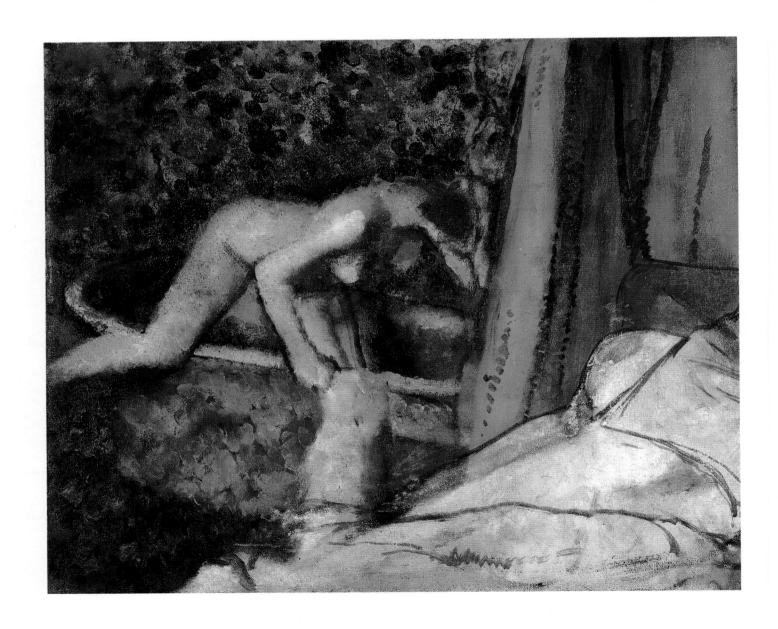

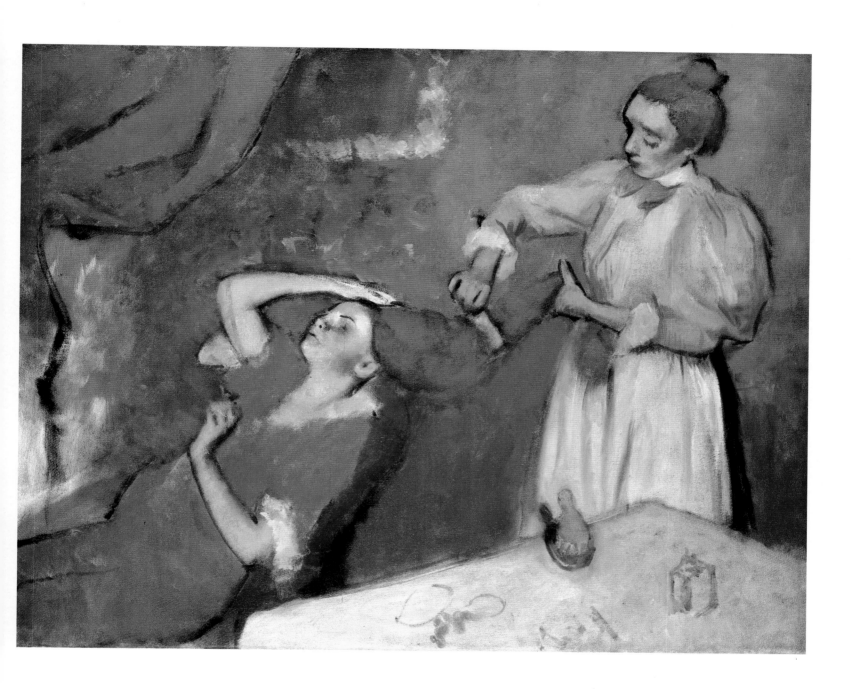

Woman Having Her Hair Combed (La Coiffure)
1896, c.; *Oil on canvas*; 49 x 59 in. (124 x 150 cm.).
London, National Gallery of Art.
The striking red color of this painting intrigued the artist Henri Matisse,
who was the owner of it for several years. Degas himself realized how
difficult and complex this work was and anticipated that it would not find
a buyer. Today, however, it is its high degree of abstraction and sensuous
treatment of the surface which make this work especially attractive.

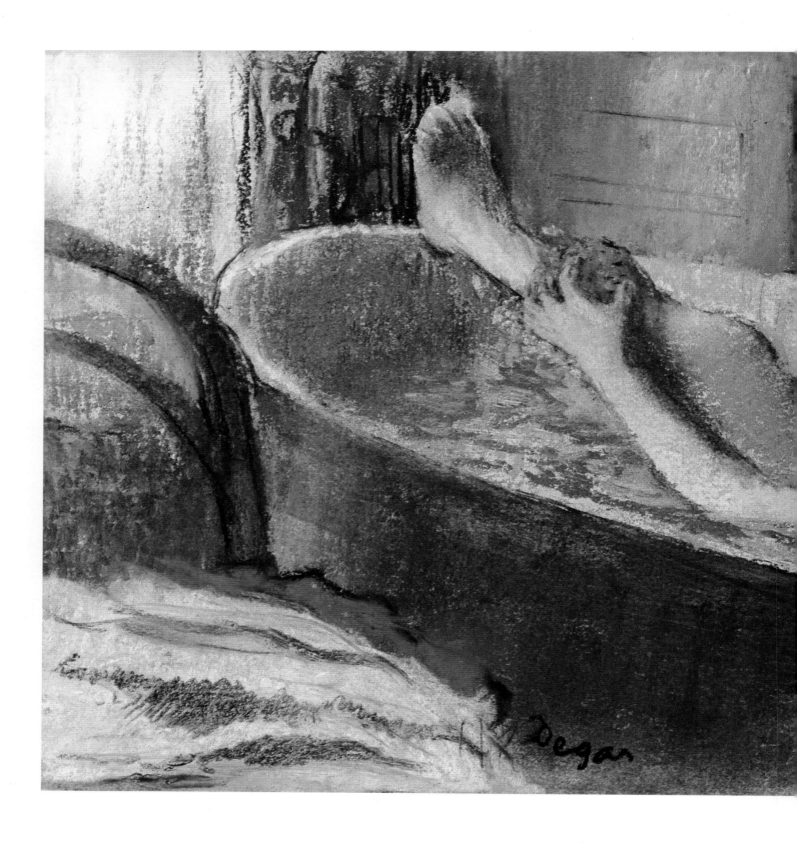

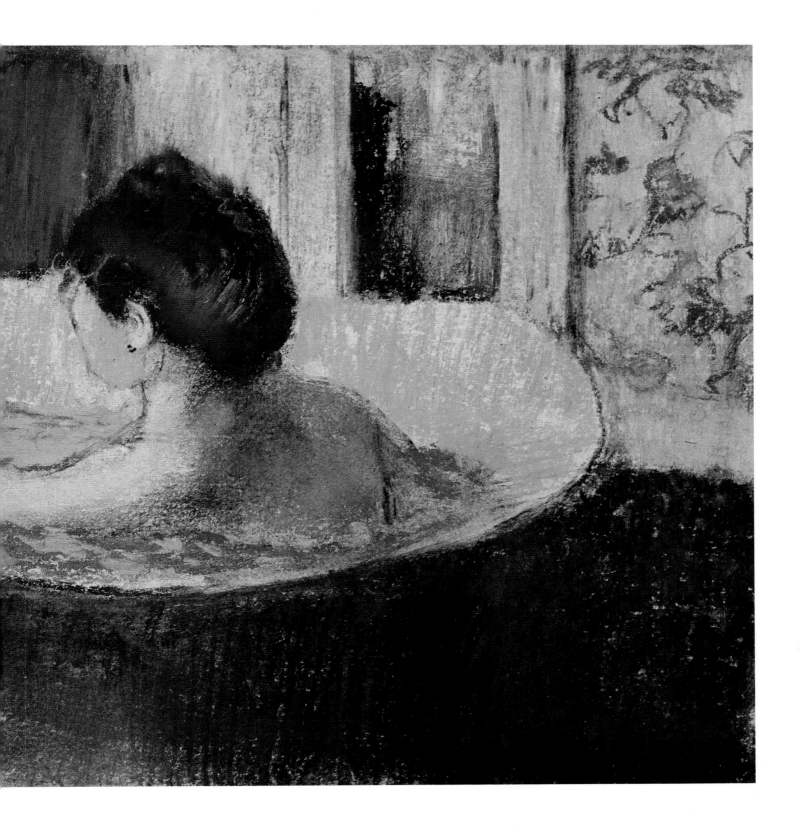

Woman in a Bathtub, Her Left Leg Raised
1883-1884, c.; *Pastel over monotype;* 7 3/4 x 16 1/8 in. (19.7 x 41 cm.). Paris, Musée d'Orsay.
*A woman is taking her bath in a freestanding tub, which obviously cannot have been
filled by means of interior plumbing, a luxury at the time. The environment is simple,
but the figure, probably a model or young working woman, expresses dignity.*

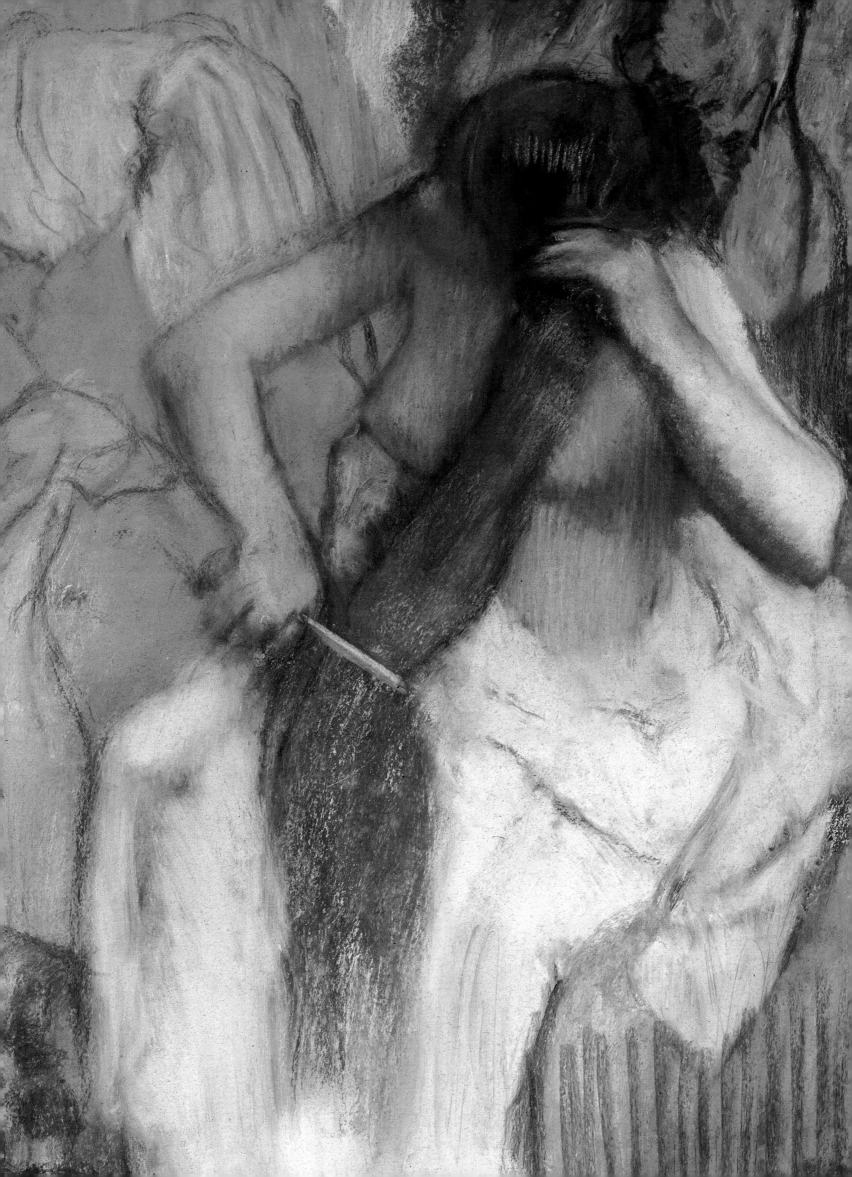

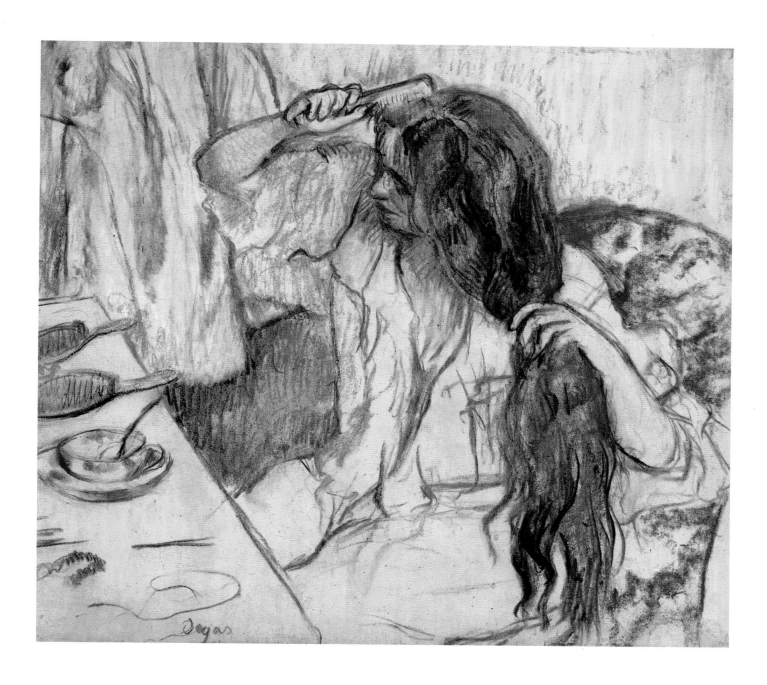

Woman at Her Toilette

1889, c.; *Pastel on paper;* 22 3/8 x 23 5/8 in.(56 x 59 cm.).
St. Petersburg, Hermitage.
*A strongly pronounced graphic quality has replaced
the expressive power of color here. The work merely
hints at the objects, rather than molding them. As in
a photograph, the viewer is looking down on the model.
Degas has chosen a specific vantage point to increase
the tension and complexity of the depicted space.*

Woman Combing Her Hair

1890-1892, c.; *Pastel on paper;* 32 1/2 x 23 3/8 in. (82 x 57 cm.).
Paris, Musée d'Orsay.
*Degas created an image that seems to be based on sound.
The bather combs her hair as if she is playing an instrument,
a violoncello, for example. She has bent her head sidewise as if
listening. The nudity of her body is partially concealed by her
hair, but the image is as chaste as a classical Greek sculpture.*

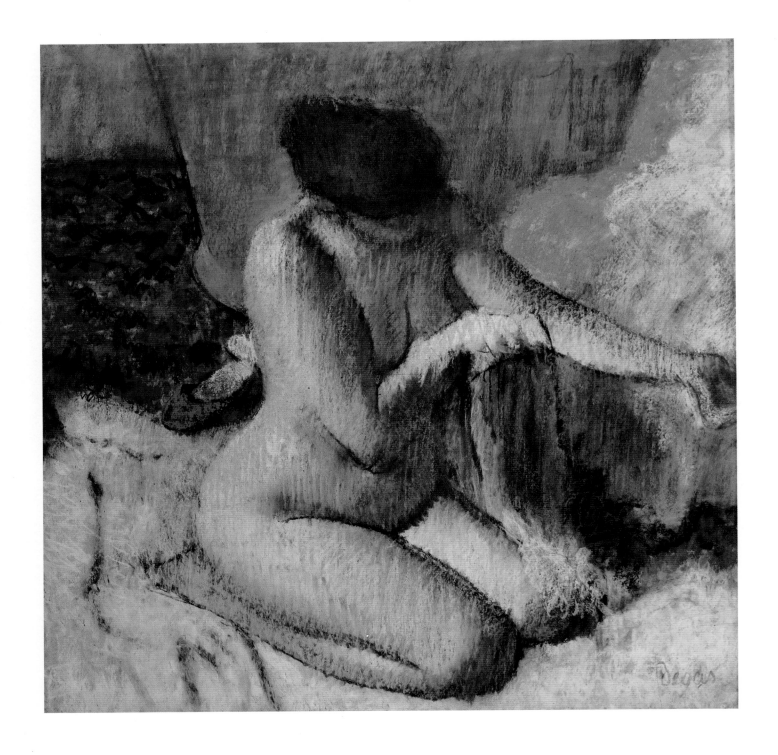

After the Bath, Kneeling Woman Drying Her Left Elbow
1895, c.; *Pastel on paper*; 27 5/8 x 27 5/8 in. (70 x 70 cm.).
Paris, Musée d'Orsay.
A woman is sitting on a towel on the floor drying her left elbow
after a bath. On the yellow chair to the right, another white towel
or a robe has been placed. A bluish curtain in the back and a pair
of purple slippers behind the figure bring her more to the foreground.
Thick strokes of pastel define the body with light and shade.

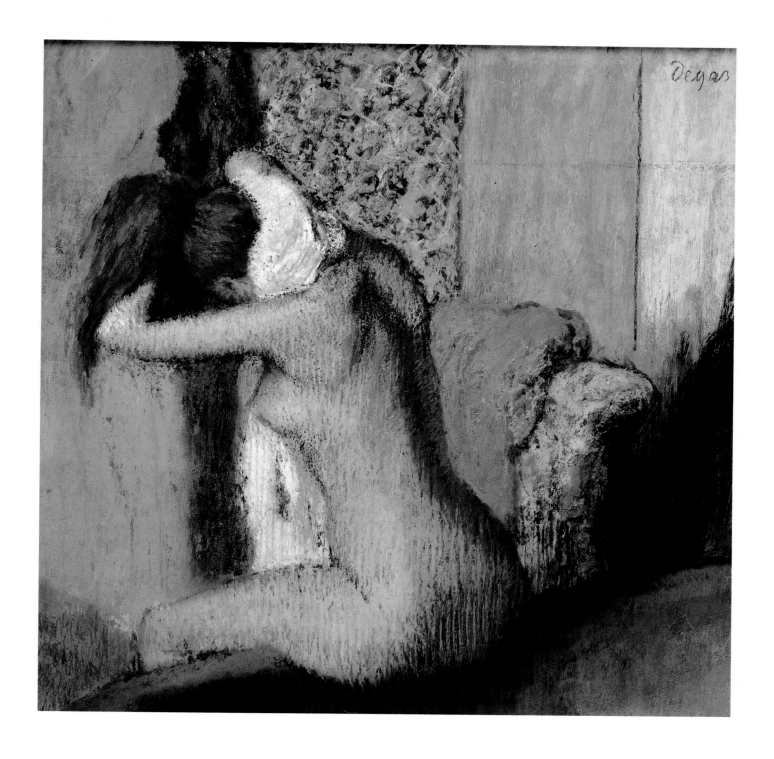

After the Bath, Woman Drying Her Neck

1895, c.; *Pastel on paper*; 24 1/2 x 25 5/8 in. (62.2 x 65 cm.).

Paris, Musée d'Orsay.

A woman is seen drying her hair and neck after having
finished her bath. She is still sitting on the edge of
the tub, from which she emerged some moments earlier.
A series of vertical color fields animates the background,
where one can distinguish a chair and an orange robe.

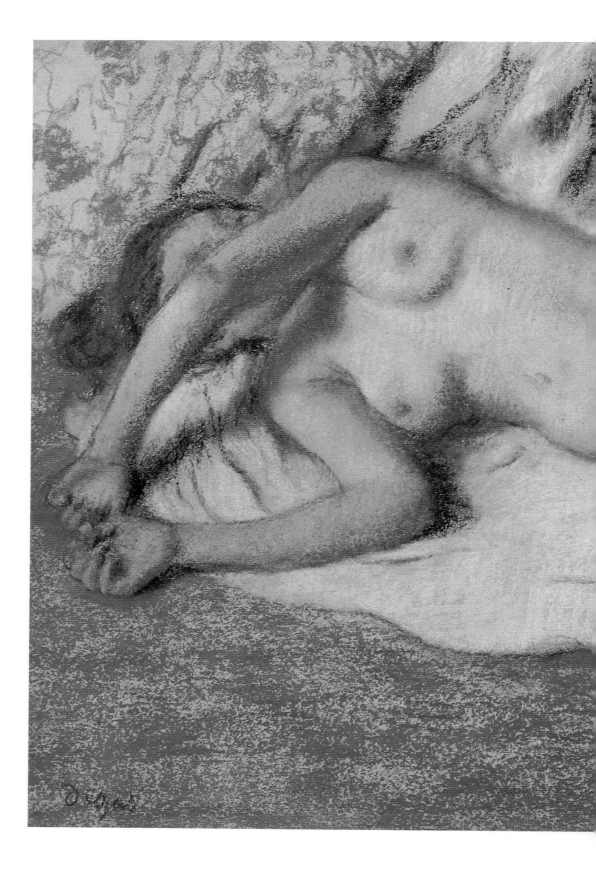

Reclining Bather

1886-1888; *Pastel on paper;*
18 7/8 x 34 1/4 in. (48 x 87 cm.).
Paris, Musée d'Orsay.
This bather is perhaps Degas's
most expressive nude of the
mid-1880s and unusual in
her position. Resting after
a bath on a towel draped on
the floor, the gesture of hiding
her face with her arm has
led some to believe that
the work might have been
intended to depict the after-
math of an act of violation.
Unable to communicate
with this woman's face, the
viewer becomes an intruder
upon an intimate moment.

CREDITS

The Armand Hammer Collection, The Armand Hammer Museum of Art and Cultural Center, Los Angeles, CA, p. 106

The Art Museum, Princeton University, Princeton, NJ, Lent by the Henry and Rose Pearlman Foundation, p.10

Atheneumin Taidemuseo, Helsinki, Finland, Art Resource, New York, p. 118 (top)

The Baltimore Museum of Art, Baltimore, MD; The Cone Collection, formed by Dr. Claribel Cone and Miss Etta Cone of Baltimore, Maryland, BMA 1950.302, p. 37

The Carnegie Museum of Art, Pittsburgh, PA; Acquired through the generosity of the Sarah Mellon Scaife family, 68.18, p. 139

Cincinnati Art Museum, Cincinnati, OH; Bequest of Mary E. Johnston 1967.1430, pp. 136-137

Courtauld Institute Galleries, London, England, p. 79

© The Detroit Institute of Arts, Detroit, MI; Bequest of Robert H. Tannahill, p. 129

Folkwang Museum, Essen Germany, Art Resource, New York, pp. 11, 91 (top)

Collection of the J. Paul Getty Museum, Malibu, CA, pp. 49 (top), 82 (detail), 99

Hawaii Academy of Arts, Honolulu, HI, Art Resource, New York, p. 51

Hermitage, St. Petersburg, Russia, Art Resource, New York, pp. 13, 16 (detail), 54, 85, 116

Indianapolis Museum of Art, Indianapolis, IN; Gift in memory of Daniel W. and Elizabeth C. Marmon, ©1994, p. 107

The Israel Museum, Jerusalem, Israel, pp. 50, 67

Kunsthaus, Zurich Switzerland, pp. 24 (bottom), 132

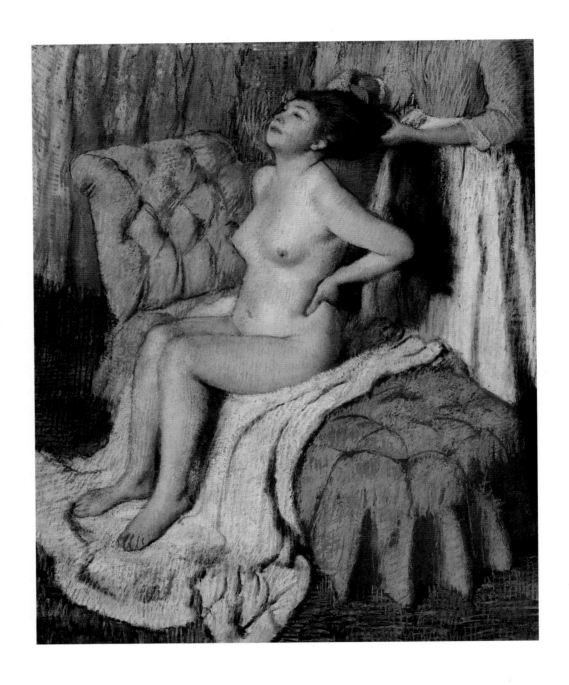

Woman Having Her Hair Combed

1886-1888, c.; *Pastel on light-green paper*; 29 1/8 x 23 7/8 in. (74 x 60.6 cm.).
New York, Metropolitan Museum of Art.

The degree of finish in this work exceeds that of nearly all the nudes from around
the mid-1880s. Outlining the form with charcoal and chalk, Degas filled in the
composition with broad planes of color, predominantly gold, white, and pink.
The nude figure is beautifully proportioned and supremely refined in execution.